AFRICA

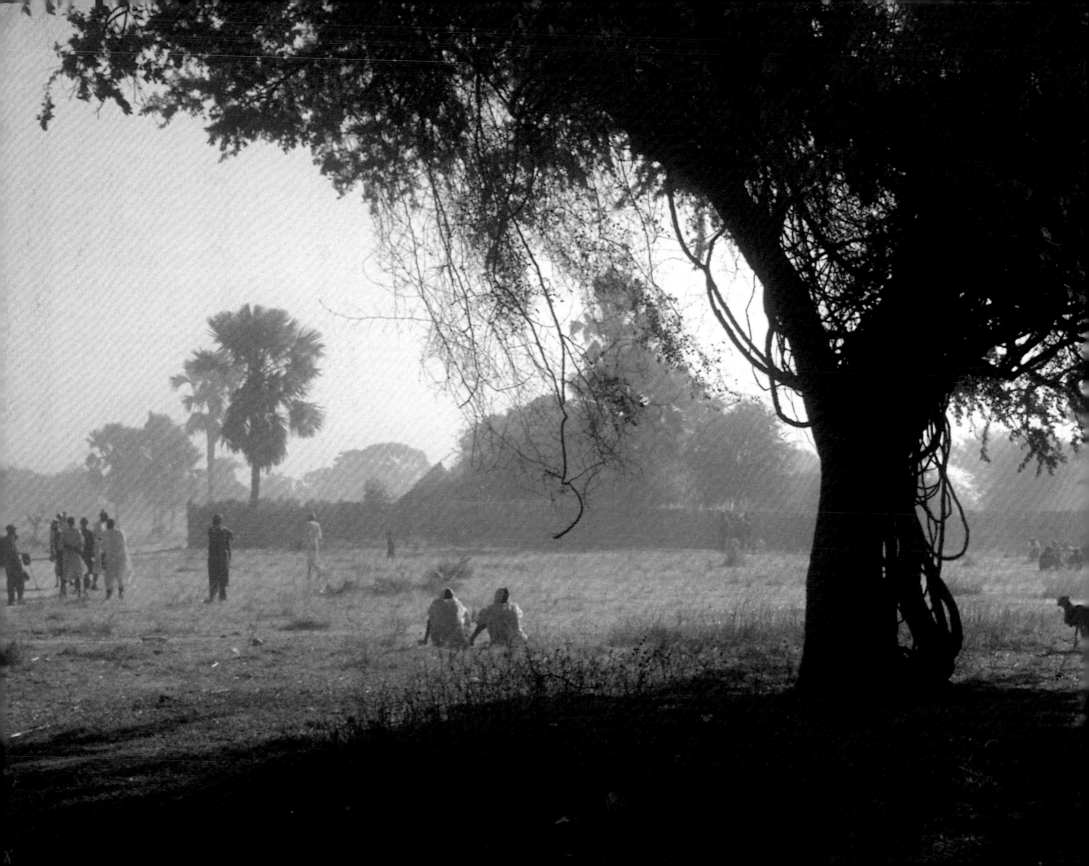

AFRICA

THE HOLOCAUSTS
OF RWANDA AND SUDAN

LUCIAN NIEMEYER

FOREWORD BY
BILL RICHARDSON

UNIVERSITY OF NEW MEXICO PRESS ✹ ALBUQUERQUE

12 11 10 09 08 07 06 1 2 3 4 5 6 7

Printed in China by Everbest Printing Company Ltd. through Four Colour Imports, Ltd.

Design and layout: Melissa Tandysh

Library of Congress Cataloging-in-Publication Data

Niemeyer, Lucian.
 Africa : the holocausts of Rwanda and Sudan / Lucian Niemeyer.— 1st ed. ;
foreword by Bill Richardson

 p. cm.
 ISBN-13: 978-0-8263-3865-5 (cloth : alk. paper)
 ISBN-10: 0-8263-3865-8 (cloth : alk. paper)
 1. Genocide—Rwanda. 2. Genocide—Rwanda—Pictorial works.
 3. Refugees—Rwanda. 4. Refugees—Rwanda—Pictorial works.
 5. Genocide—Sudan. 6. Nuba (African people)—Social conditions.
 7. Genocide—Sudan—Pictorial works. 8. Nuba (African people)—
Social conditions—Pictorial works. 9. Rwanda—Social conditions—
Pictorial works. 10. Sudan—Social conditions—Pictorial works. I. Title.
 DT450.435.N54 2006
 304.6'63'0967571—dc22

 2005019885

Frontispiece: Dust storm in Wedweil, SUDAN.

Page vi: Group in Marial Bai.

This book is dedicated to the

John Eibners, Ann Buwaldas, Brad Phillips, Charles Jacobs, Richard Lloyds, Richard Niemeyers,

and other NGOs who have their moral compasses intact.

———————— IN MEMORIAM TO ————————

JOHN GARANG, VICE PRESIDENT OF SUDAN—

HE LOVED THE SUDANESE PEOPLE AND THEY LOVED HIM,

JULY 30, 2005

CONTENTS

Foreword | ix

Preface and Acknowledgments | xi

Rwandan Refugees: A Story of Life | 4

Rwandan Refugees: *A Story of the Trip* | 9

The Sudan Slave Story | 54

Sudan Oil Field Genocide | 97

Nuba Mountains, Sudan | 133

Epilogue | 169

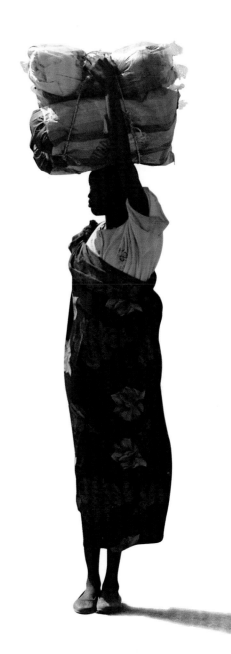

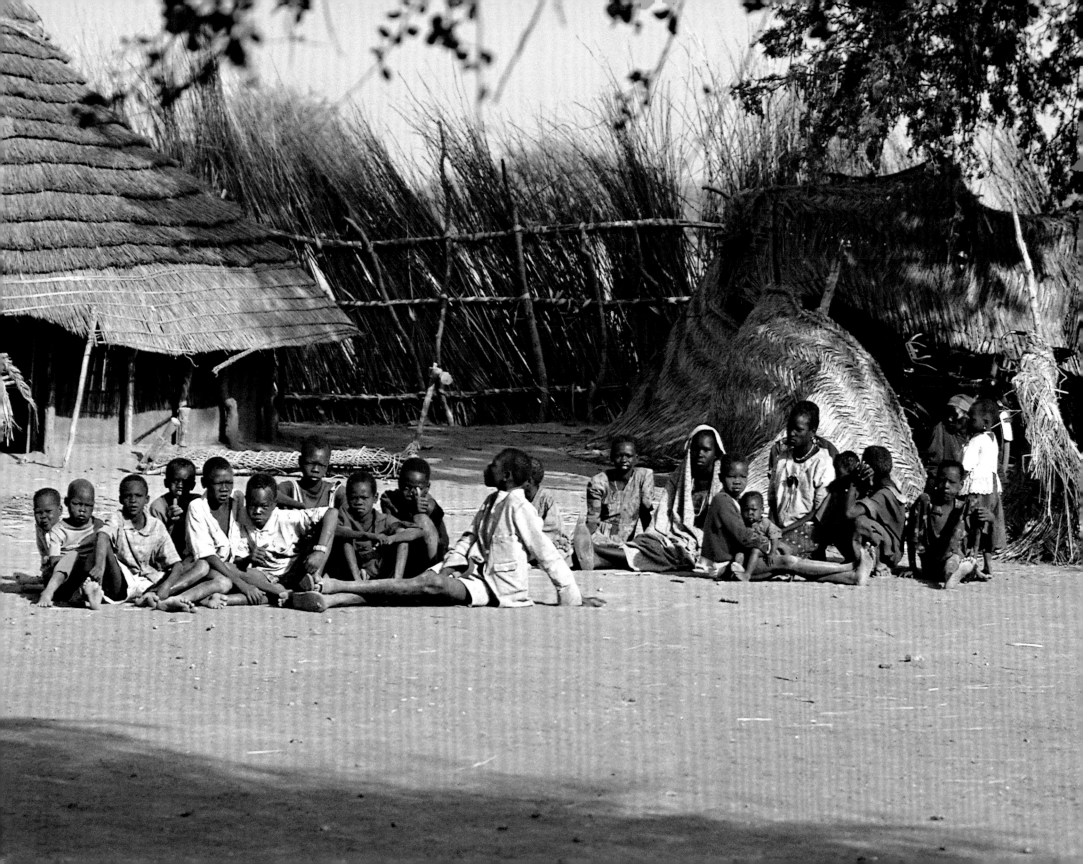

FOREWORD

Africa is a magnificent and diverse continent full of majesty and mystery. Unfortunately, recent waves of genocide have also spread misery to millions of Africans. In these pages Lucian Niemeyer has bravely and sensitively documented the horror and cruelty of the genocides of Rwanda and Sudan. His powerful photos and words instantly close thousands of miles of distance and bring his audience directly into the tragedies.

We know genocide and slavery are unacceptable states of our humanity, yet they are allowed to persist. The global community must do a better job in responding to the suffering of so many. Africa deserves more of the world's attention and strategic intervention. Indeed, it is necessary that we better understand and address the root causes of genocide so that it may be genuinely eradicated from all nations.

I commend Mr. Niemeyer's work and hope that by him sharing the faces of genocide, we may see our role in ending these tragedies more clearly.

Bill Richardson

Governor of New Mexico

and former U.S. Ambassador to the United Nations

January 2005

Santa Fe, New Mexico

PREFACE AND ACKNOWLEDGMENTS

Ethnic cleansing, slavery, and genocide are atrocities that the world abhors. Yet even in this time of rapid communications and travel, news of these atrocities is seldom widely known or recognized until long after the horrors are perpetrated. A mandate by world powers in 1948 to move decisively to stop these actions has only resulted in fearful world leaders acknowledging that these holocausts are really taking place, almost always after the fact. The tenet that the United Nations was formed to precisely identify and stop these kinds of base human behaviors has been lost. Instead the United Nations has morphed into a bureaucratic nightmare, lost in protocol and ineffectiveness with few exceptions. The world's churches, too, have ignored their responsibility to call attention to these atrocities and to provide the help needed to solve the problems. They, too, have lost their moral compass. The conscience of the world is being governed by political correctness rather than humanitarian needs. The countries of Europe have ignored the Gulag and the Holocaust, relegating them to a corner of history that they have conveniently forgotten. Far East countries have decided that these affairs are too far away and pay little attention. The front line of knowledge and human aid to ease the starvation, slavery, and killing has been relegated to unselfish nongovernmental organizations (NGOs), which raise money, medicine, bring in food, and generally report the situation to the world that does not want to hear about the turmoil and problems.

The malaise of slavery, ethnic cleansing, and genocide finds its roots in a segment of society that looks down at another segment of society as inferior. We have all heard about the Nazis calling the Jews of Europe rats, vermin, and inferiors who needed extermination. That has been so in Russia, Germany, Sudan, Cambodia, Uganda, Rwanda, and so many other places where genocide has occurred. Well over two million southern black Christians, Muslims, and animists in the Sudan have died, the great majority civilians, in a genocide that few in the world have heard about. Since 1983, ethnic cleansing and a religious holy jihad (since 1992) have created a holocaust that rivals the two great genocides in Europe (the Holocaust and Stalin's Gulag). Yet so many people of the world ask, "How can that happen in today's world?"

In the Sudan a Swiss organization has recovered more than 110,000 slaves, paying an average of $35 per person, who have been in slavery an average of six to eight years. In the Nuba Mountains the Arab Muslim fundamentalists practiced an age-old custom of taking blacks into slavery, forcing conversion of many to Islam, and then decided to wipe out the fifty tribes by genocide, similar to the situation in Darfur in the west. In the oil region Christian flags lead the defensive southern blacks into battle, where they fight for survival against columns of sophisticated armaments including tanks, artillery, and gunships. The southern troops arm themselves with weapons from the fallen of the north. It is a matter of survival. The goal of the north, whose headquarters is in Khartoum, is to create an Arab Muslim state. Their strategy is to displace the southern population from wells and food, creating an enormously effective death zone. When that does not succeed, the north resorts to direct killing.

Yet the world does not call it genocide, ethnic cleansing, or slavery. I am not sure what it calls it—civil war, abductions, local insurrections? The platitudes are quite resounding as millions die. Rwanda was a reverse genocide in 1994, yet with the same roots. Here the ethnic Hutus, long relegated as inferior, rose up and created a bloody genocide against the Tutsis, killing 500,000. Cholera in the refugee camps killed another 300,000, while 500,000 died in the flight and aftermath. Years later the world identified it as genocide. World leaders at the time of the catastrophe knew precisely what was going on but were powerless to act, their moral characters not strong enough to expose their careers or their countries.

These four stories, "Rwandan Refugees: A Story of Life," "The Sudan Slave Story," "Sudan Oil Field Genocide," and "Nuba Mountains, Sudan," present four different aspects of holocausts in the last twenty years. These accounts appeared in abbreviated newspaper versions in the *Delaware County Sunday Times* and the *Santa Fe New Mexican*.

The images depict people who have survived the holocaust, for it is their tragedy. They have to pick up the pieces of their broken society. Invariably it is the women, children, and elderly who suffer the most. It will take many generations of peace to overcome the damage that these holocausts have caused. History has told us that. That is why the resolve of the world must be to not tolerate slavery, ethnic cleansing, or genocide.

This must be a basic departure point for a civilized world. No hiding behind words, NIMBY, or political correctness, just resolve to prevent these atrocities from happening.

These stories, including the images, would not have been possible without much help and sacrifice, first from Dr. Richard Niemeyer, who first asked me to accompany him to record the state of the refugee camps in Zaire in August of 1994. The trip was dangerous and eye-opening. World Vision was our home there. Thanks to all of the NGOs that participated in the terrible aftermath and carnage that took place in the already impoverished Goma area. After this trip I was invited to accompany Congressman Joseph Pitts from Pennsylvania to Indonesia to document Christian persecution under the auspices of Jubilee Campaign headed by Ann Buwalda of the United States. The "provocateurs" were Muslim extremists who we now know as "al-Qaeda." Through Congressman Pitts's office, I was introduced to Senator Brownback's (Kansas) staffer, Sharon Payt, who arranged for me to travel with the Swiss organization Christian Solidarity International (CSI), headed by John Eibner and Gunnar Wiebalck, to document Sudan slavery. Charles Jacobs (of the American Anti-Slavery Group) introduced me to Brad Phillips of the Persecution Project Foundation, who was going to the front lines in the Sudan delivering food and medicine to the southern black Christians. He invited me and my wife to document the Sudan oil field genocide. In early 2004 I used Mr. Phillips's contacts to go alone to the Nuba Mountains. Others who have helped me along the way include Karen Finkler; Kie Eng Go; Heather Stewart; Henry Chuir Riak, Anglican Bishop of Wau; Rebecca Garang and her husband John Garang; Jeff Barthel and Kevin Ashley of 748; Isaac KuKu of the Nuba; Peter Gatdet, commander in the SPLA; Rob Dean of the *Santa Fe New Mexican*; and so many others.

In my journeys I used Leica SLR 5 and 7 cameras with lenses ranging from 35mm to 400mm. I used a neutral film, Agfachrome 100, and no filters or flash. No corrections were made to the images other than cropping and normal balances. All four of these stories are in large color print exhibitions, consisting of forty images each with text panels, and are available upon request to qualified venues.

I thank my wife Joan, who has been so patient when I have been out of communication in danger zones. She accompanied me on one trip, which was an enormous feat. She has encouraged me to document these events, and I appreciate her unselfishness. I thank Luther Wilson of the University of New Mexico Press, who gave me room to present a most provoking history. I thank Melissa Tandysh, who gave life to these powerful and complicated stories, and I thank Maya Allen-Gallegos, who edited my work so carefully. I thank my maker for guiding me to these events, which has allowed me to document them. I hope that I have told them honestly and correctly. These persecuted people must not have died in vain or be forgotten.

Lucian Niemeyer

Santa Fe 2005

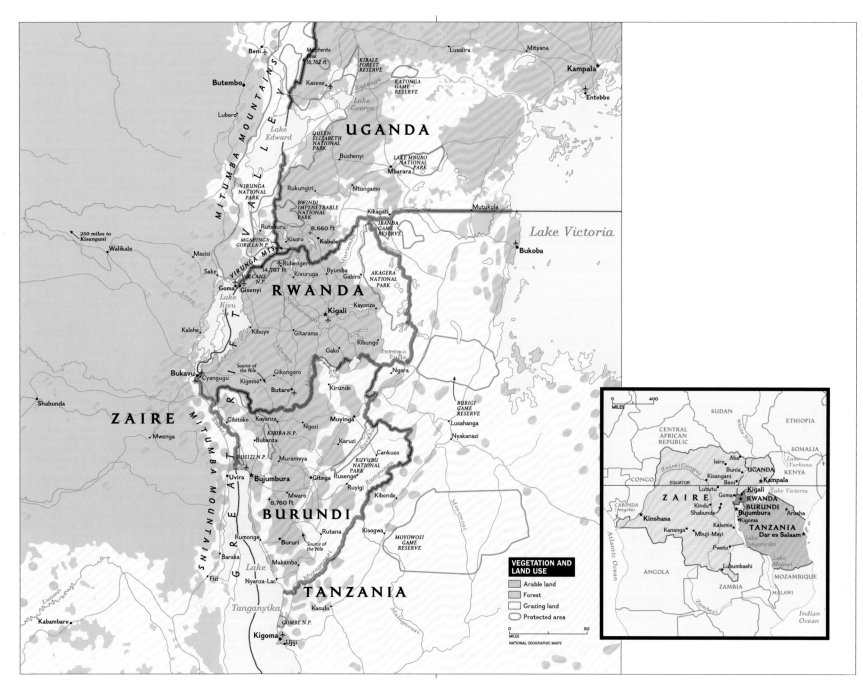

Rwanda.

Ngs Cartographic
Division/National
Geographic Image
Collection. #522265

**VEGETATION AND
LAND USE**

Arable land
Forest
Grazing land
Protected area

MILES

NATIONAL GEOGRAPHIC MAPS

UGANDA

RWANDA

ZAIRE

BURUNDI

TANZANIA

Beni
Butembo
Lubero
Margherita Peak 16,762 ft
Kasese
Lusalira
Mityana
Kampala
Entebbe

KIBALE FOREST RESERVE
KATONGA GAME RESERVE

Lake George

Lake Edward

QUEEN ELIZABETH NATIONAL PARK
Bushenyi
LAKE MBURO NATIONAL PARK
Mbarara

VIRUNGA NATIONAL PARK
Rukungiri
Ntungamo

BWINDI IMPENETRABLE NATIONAL PARK
Kikagati
Mutukula

Lake Victoria

250 miles to Kisangani
Walikale
Masisi
Sake
MGAHINGA GORILLA N.P.
Rutshuru
Kisoro
Kabale
8,660 ft
IBANDA GAME RESERVE

Bukoba

VIRUNGA MTS.
14,787 ft
Ruhengeri
VOLCANS N.P.
Kiviruga
Byumba
Gabiro
AKAGERA NATIONAL PARK

Goma
Gisenyi
Lake Kivu
Kibuye
Kigali
Kayonza

Kalehe
Gitarama
Kibungo
Gako
Ruvumo Falls

Bukavu
Cyangugu
Source of the Nile
Gikongoro
Kigeme
Butare
Kirundo
Ngara

Shabunda
Cibitoke
Kayanza
Ngozi
Muyinga
Lusahanga
Nyakanazi

BURIGI GAME RESERVE

Mwenga
Bubanza
Karuzi
Cankuzo

KIBIRA N.P.
Muramvya
RUVUBU NATIONAL PARK

RUSIZI N.P.
Rusengo

Uvira
Bujumbura
Gitega
Ruyigi
Kibondo

8,760 ft
Mwaro

Rumonge
Rutana
Kisogwa

Baraka
Bururi
Source of the Nile
Makamba
MOYOWOSI GAME RESERVE

Fizi
Lake Nyanza-Lac

Tanganyika
Kasulu

Kabambare
GOMBE N.P.
Kigoma
Ujiji

MITUMBA MOUNTAINS
GREAT RIFT VALLEY

0 400 MILES

SUDAN
CENTRAL AFRICAN REPUBLIC
ETHIOPIA
SOMALIA
CONGO
UGANDA
Lake Turkana
Isiro
Aba
Bunia
Kisangani
Beni
Kampala
EQUATOR
Zaire (Congo)
Goma
RWANDA
Kigali
Kindu
BURUNDI
Shabunda
Bujumbura
Kigoma
KENYA
Lake Victoria
Arusha
TANZANIA
Dar es Salaam
Kinshasa
CABINDA (Angola)
ZAIRE
Kalemie
Kananga
Mbuji-Mayi
Atlantic Ocean
Pweto
ANGOLA
Lubumbashi
ZAMBIA
Lake Tanganyika
Lake Malawi
MALAWI
MOZAMBIQUE
Indian Ocean
Zambezi

RWANDAN REFUGEES:
A STORY OF LİFE

IN A VALLEY OF DEATH BENEATH A VOLCANO

Mugunga Camp, Goma, Zaire (Congo)–September 7th, 1994

There is a place in Africa, in Zaire, called the Valley of Death. Here, on a lava flow carbon dioxide gas emits when it rains, creating an atmosphere that kills humans. An active volcano spews its sulfur fumes and ashes each day, providing a glow in the sky at night. Thus this area was not inhabited except for a few intrepid, poor settlers who eked out a living raising goats and small gardens. Here, four months ago, more than 200,000 refugees from Rwanda found empty ground and settled their weary, hungry bodies after walking with their families for months. Along with the retreating, beaten Hutu army, the refugees fled the genocide and the threat of retaliation from the victorious, minority Tutsi army. They fled carrying nothing: no goods, no food, no housing, and no animals to give them sustenance. They fled in fear. They arrived with nothing but the clothes on their backs. Here in Mugunga, they are packed ten persons to each ten-by-fifteen–foot area, shoulder to shoulder, campfire to campfire, sleeping on black lava rock in small, straw hovels covered with blue plastic sheeting provided by the United Nations and no food, no water, no toilets. There was a cholera epidemic, but water systems provided by the international community have resolved the terror of this disease. Now the camp is awaiting the next disease. It is just too crowded. The outside world has provided

food, latrines, water, and other life-sustaining services, but the refugees can do nothing, so they mill, gamble, and visit. Here a population waits. There is no work, no means of providing. The people, once proud, albeit poor, are waiting to become statistics. The next epidemic . . . the rains . . . an eruption . . .

Yet in the midst of this human disaster is a beacon of hope on a hill. For here is an orphanage run by Esther, a nurse from Nairobi. Children of the victims of the more than one million deaths from genocide and cholera are being taken care of by the angels of mercy: Rwandan and Zairian women, schoolteachers, Irish nurses and Irish builders, an Australian engineer. They carved a camp for 458 children out of lava. Here a life-giving NGO provider has had the vision to create laughter and hope out of misery and death. Each day children arrive with new horror to explain, sullen, hungry, diseased. Here comes a fifteen-year-old Tutsi girl. Her parents, aunts, and uncles were killed in Rwanda, and her four brothers and sisters were separated in their flight. The oldest is sick and has been cared for by the fifteen-year-old. She hears that her brothers are in the orphanage and walks from the Kibumba camp to see if it is true. In a heart-wrenching scene they are reunited, dry tears telling the story of the horror. The younger girl, leaving the protection of a soldier, walks back to Kibumba, twenty-three miles each way, to gather her ill sister in order to reunite the remains of the family. For what future . . . at least they are together. Here comes a boy of eight, who has walked alone for four months through Rwanda after his family was killed. He arrived starving, diseased, and insect infested, unable to vocalize his terror. Here he has been nourished, his cheeks have filled out, his legs and body healed. He doesn't laugh yet, but give these angels and storytellers with their motherly arms time. Here the pied piper calls the children into songfests. Children from the outside peer over the plastic sheet walls to watch hope being given to victims. Here, the Hutu and Tutsi struggle does not create new victims. In this place, hope has a future among these angels of mercy. In this Valley of Death beneath the volcano in Zaire.

A Place with No Future and Little Means of Escape

Kibumba Camp, Goma, Zaire (Congo)–September 6th, 1994

In a valley below a towering, smoldering, glowing volcano, an observer finds Kibumba Camp made up of straw hovels covered with blue or white plastic sheets. As far as the eye can see, these hovels each have a campfire burning with a pot of gruel or beans to be eaten by the poor, homeless, Rwandan refugees. The smog created by the campfires is enhanced by the fumes, ash, and dust from the volcano, which is relieved only when the air is cleansed by rain. This camp near Goma, Zaire, is one

of three centers for refugees who fled Rwanda following the slaughter of half a million Tutsi by the rival Hutu army. The small Tutsi army then drove the larger Hutu army out of Rwanda. More than a million civilians followed, fearing reprisal by the Tutsi. The continuing feud contributes to one of the most terrible human disasters known to man. The estimated death toll has risen to 1.2 million, following starvation on the flight, cholera, and death in the camps. Today Rwandans in this camp of more than 200,000 have no homes, no incomes, and little of worth combined with great fear. Here, packed like cattle in pens, they are waiting for the next epidemic . . . waiting for the volcano to spew its deadly lava . . . waiting . . . waiting . . . waiting. Waiting for food, for water, for vitamins, for a doctor.

While the world community and NGOs have provided treated water from Lake Kivu, food, and latrines carved out of lava, the disaster of the loss of human life, dignity, family structure, endeavor, and identity is mind-boggling. Fear of retaliation prevents the refugees from returning to Rwanda. The need for refugee survival has caused the destruction of cornfields, stripping of banana trees, stealing of animals, and clear-cutting of the landscape for firewood and foliage for the building of hovels. It looks as if a giant scythe has leveled all to be seen. Now the women and children have to go far afield to obtain wood for the ever-burning campfires. It is human misery at its lowest. Yet, another tragedy is worse.

In the Kibumba Zone in Zaire, 29,000 Hunde and Kumu tribespeople had been eking out a poor living from the lava soil. A few years ago a small influx of Zairian Hutus joined them. These people had lived in peace on the edge of starvation. Their family units were strong and their leaders, chosen from the wisest, had created a balanced life with a rich tribal heritage. The average human lifespan in this area was about forty-five years, so life had not been easy without medicine or good water. This is how it had been for years, the people living without amenities, yet having dignified and fruitful lives. Children under fourteen accounted for 60 percent of the population. All had their duties in the poor, dusty villages. That is, until 200,000 refugees descended like a horde of locusts on this quiet land. In days, age-old balances were toppled. Corn crops were razed, animals stolen, bananas eaten, water systems polluted, and the economy ruined by the black market speculation in Goma. The Zairian currency inflated to over 2,500 shillings per dollar. Locals who sold their meager crops for minimal pots and essentials were abruptly excluded from the market. These tribes, left out of the worldwide support network for the refugees, face starvation and ruin. No one is there to tell their story. The government in Zaire is so poor that they cannot help. Unless some NGO or government decides to help these 29,000 civilians, they too will become statistics of the Rwandan exodus. Small compared with the larger Rwandan catastrophe, it is an important nuance of the whole picture. Innocent for sure . . . blameless, yes, the injustice of a terrible, dark feud continues to devastate and haunt humans throughout the area and the world. For here is no justice, no order, and little future. Here, the dignified, tall chief's face reflects the horror that he

cannot prevent for his people. Here, hundreds of thousands of refugees have snuffed out the future of a peaceful people. Here 12,000 adults cannot explain to their children the hopelessness that they all face. There is an overwhelming sadness in this place. Here, human dignity has been torn asunder with a roar as loud as the potential eruption that will again pour lava on this area. In this place in Kibumba, in Zaire, there is no future and little means of escape.

A Human Drama of Epic Proportions

Mugunga Camp, Goma, Zaire (Congo)–September 5, 1994

As a poor, little, dusty city beside beautiful Lake Kivu, Goma is on center stage of a human drama of epic proportions. The city is dominated by an active volcano, which just a few years ago poured lava throughout the area and then flowed through Goma into the lake. Today this glowing, hissing volcano continues to spew ash and sulfur, reminding all that it is waiting and ready to erupt at any time. Lava, ash, and fine dust permeate everything everywhere, wreaking havoc on machines and respiratory systems. Zaire is one of the world's poorest nations and Goma is destitute. Its people survive with a minimum of amenities. Beauty is rare here—only the few hardy birds and flowers that exist everywhere in this central African nation can be found. A stable economy is nonexistent.

In the past five months a torrent of refugees has flowed through this city, fleeing the violence in Rwanda and fleeing with the Hutu army, responsible for 500,000 Tutsi civilian deaths. Hutu civilians witnessing the genocide, wanton murder stemming from an age-old tribal feud, expect massive Tutsi reprisals.

The Tutsi army, less than one-fourth of the Hutu army, drove them out of Rwanda in anger. The Hutu army, ashamed of its weakness, wearing the mantle of disgrace and of atrocities committed, is anxious to reorganize and wage battle on the Tutsi army now firmly in control of Rwanda. The terror of the civilians in the camps is pervasive and the Hutu soldiers play it like a harp. Civilians numbering 1.2 million fled Rwanda, spreading out like a fan on Goma's flanks and settling in open fields. To the Mugunga Camp, home of more than 200,000 refugees, the settlers brought no food, no livestock, no carts, no goods, no clothes except what was on their backs . . . nothing except 30,000 soldiers from the beaten army. Into this Valley of Death they came, and they placed their emaciated bodies on a large lava flow, known for the deadly carbon dioxide released when it rains. They created hovels of straw as far as the eye can see. The lack of clean water created a cholera epidemic. Starvation, typhoid, dysentery, malaria, AIDS, blackwater fever—they are all here en masse. Another 700,000 civilians died in the flight and the early camps.

Excavations carved into the lava mantle hold mass graves with as many as 40,000 bodies. World organizations moved into this breach, providing treated water from Lake Kivu, plastic sheeting for hovel protection, food, vitamins, latrines, and medical help. They all came: the United Nations, French, Dutch, Swedes, Germans, Americans, Irish, British, Canadians, Australians, World Vision, CARE, Blessing, Samaritan's Purse, Gaol, Oxfam, Southern Baptist Relief, Doctors Without Borders, Ladies of Charity. The camp stabilized with an amazing efficiency that spoke of individual dedication. They prevented continued mass starvation, more epidemics, and death.

Added to this equation is the potent force of the age-old feud between the minority Tutsi (15 percent) and the larger Hutu (85 percent). The Hutu army, driven from Rwanda, is shamed and disenfranchised. In the camps they are arrogant and ruthless, stealing food from the civilians. They begin to reorganize, establishing power bases in the camp. Creating fear and dissension, they spread rumors of massive reprisal if the civilians return to their homes. One Hutu woman returned to her home in Rwanda, and after a long journey she came back to the camp to convince her family that it is safe. She is immediately killed by the soldiers. The soldiers, wanting to avenge their disgrace, recover buried arms and conduct raids in Rwanda, then retreat into the camp in anonymity. The pot continues to simmer each day as realizations bring new anger. World organizations come into this seething cauldron, producing miracles each day with stories of individual courage and unselfishness. An orphanage is created on a hill in the middle of the camp.

Food distribution centers are established; medicine delivery is scattered throughout the valley. Water is treated and tanks are built and distributed; latrines are dug and the dead are buried. Early in the provider support effort, stories of courage and character are the norm. The soldiers wishing to reestablish their authority challenge the providers, demanding that they be the distributors of food and sheeting. A large group surrounds the distribution point. A single black man from California, Ellis Franklin, is confronted by angry soldiers demanding that they be in charge of distribution. With dignity, Ellis tell the crowd that either the provider will do the distribution or it will withdraw. After hours of a noisy stalemate, the crowd finally tells Ellis to continue with the distribution. The soldiers fall silent and sullen. Each day they test Ellis's resolve, waiting. One man against a horde of disenfranchised soldiers. Each day Ellis's determination stands out like a beacon, bringing order and raising the level of humaneness in the camp. Ellis, with his quiet resolve and purpose, has created order out of anarchy and saved many lives. Again and again such nobleness manifests itself in this human hell by those unselfish souls who risk all for their fellow man.

Since I have returned, the United Nations and Zairian government have taken steps to remove the army from the Mugunga Camp and to monitor the border. Yet the coming rains, increasing boredom, and anger over the shame create a tinderbox that bespeaks of more tragedy and death in this poor, remote Mugunga Camp in the Valley of Death beneath the volcano near Goma, Africa.

RWANDAN REFUGEES: EPILOGUE

Fast forward from September 1994 to November of 1997. In these three years, in excess of 1,200,000 Hutus fled Rwanda following the genocide of more than 500,000, mostly Tutsi, and the holocaust has taken its toll. Well over one million civilians have died . . . the old . . . the young . . . the infirm . . . the women. It made no difference in this tribal strife. In the refugee camps in Zaire, the disenfranchised Hutu army had reorganized, assuming authority and driving most of the world providers from the camps. The United Nations and other caregivers were ordered out, giving the Hutu army the role of distributing life-giving human services such as food, water, and vitamins. The abuse of power intensified. The emboldened Hutu army continued to keep the pot boiling by launching raids into Rwanda under the cover of darkness, then retreating back to the cover of the civilian camps, where the soldiers blended in, keeping the civilian population hostage to the crisis. The camps were in constant fear. For more than two and a half years, the civilian population lived in these makeshift, ugly, minimal camps. There was no work and nothing to do each day, just existing, waiting, and dying. In these idle camps of horror, the death rate was matched by the birthrate. The dead were constantly being replaced by the newly born. The population experienced a monumental loss of dignity. The environment, poor before, was devastated by women and children looking for firewood. Now miles away, the wood took days to retrieve, so as to keep the campfires

going to cook their weak gruel. Local Zairians were devastated by the crumbling economy, already among the poorest in the world. Zairian soldiers who had not been paid for months extracted a living from the already starving civilian populace. Anarchy ruled and it was a cruel existence for a great number of people.

Then the newly empowered Hutu army decided that it would eliminate the Zairian Tutsi population and the simmering cauldron boiled over. The Zairian Tutsi population organized a rebel coalition and drove the Rwandan Hutu army from the three camps into the Zairian interior, with the Zairian army in front of it. The civilian Hutu population fled with the army, and after a period of starvation, they walked and were bussed back to their homes in Rwanda. Meanwhile, the rebel coalition continued to force the Zairian army back. Finally, surrender by the corrupt Mobutu government created a change of authority and a new name, the Democratic Republic of the Congo. More than 800,000 civilians from the three camps have returned to their homes in Rwanda. Many found that new Tutsi settlers had assumed their small ranchettes. The Tutsi have recognized many of the genocide perpetrators among the returnees and now single them out. The impact of the massacre and the cruel aftermath in Rwanda and what is now Congo will take generations to resolve.

Central African society is made up of tribes and families. Governments, quite often corrupt, are tolerated as long as

families and tribes are maintained. In this latest chapter of the Hutu and Tutsi struggle, families and tribes in local towns and communities have suffered the deadliest destruction that African society can endure. Recovery from the April 1994 genocide and its aftermath will take generations of people living in a peaceful environment to overcome. Too many mothers, children, and elderly have died, and they will be remembered by the broken families and tribes. Peace will not come easily. It is incumbent of the world community not to tolerate genocide in any form or place or for any reason. The whole world community suffers under its terrible legacy.

The events in central Africa have told us so, again.

These feet carried this refugee out of Rwanda–KIBUMBA, ZAÏRE.

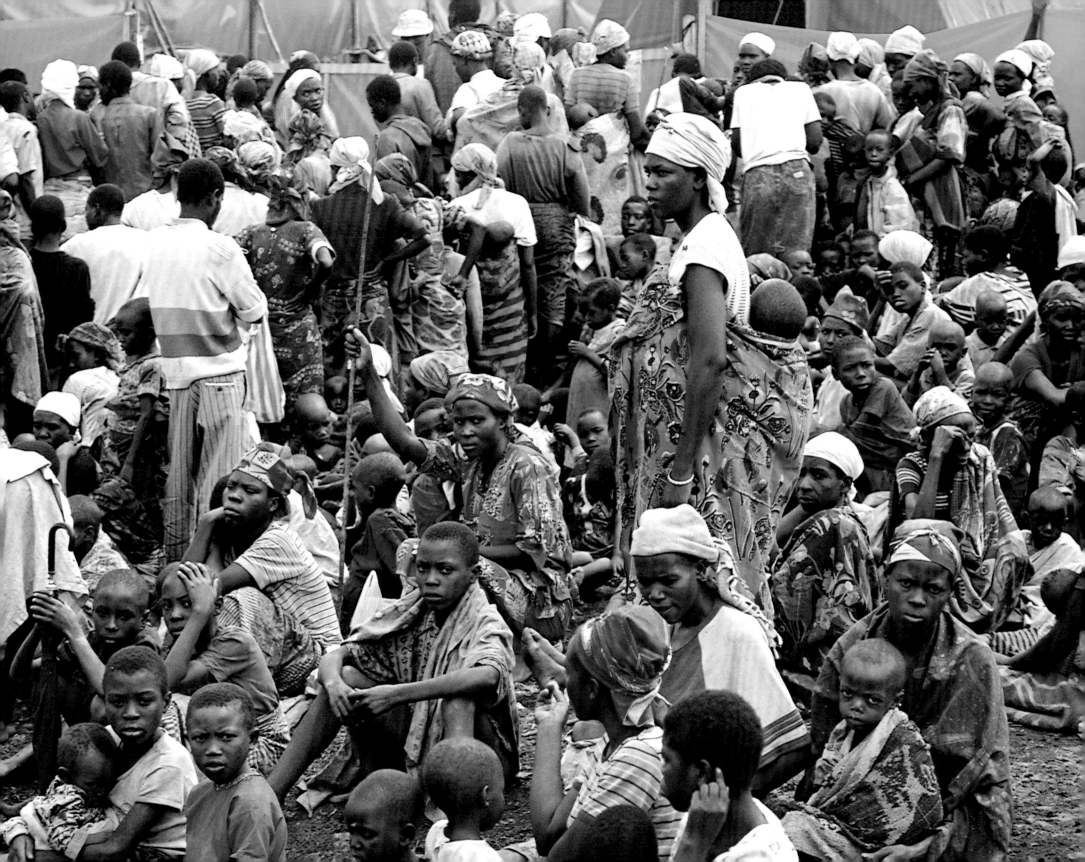

RWANDAN REFUGEES:
A STORY OF THE TRİP

IN MAY OF 1994 DR. RICHARD NIEMEYER, A MEDICAL DOCTOR AND DISTANT COUSIN, CALLED ME UP AND ASKED IF I wanted to join him on a trip to Rwanda in late August. He wanted to assess the problems of the refugees so he could determine how he could help. He had done work in Kenya some years before and felt a special empathy for the people of Africa. He wanted me to document what we saw, hoping that the images and the story would generate sensitivity in the United States to the plight of the refugees, and consequently help alleviate the situation.

We traveled to Nairobi, Kenya, and then boarded a plane to Entebbe, Uganda. But the plane to Entebbe had mechanical problems, and we had to return to Nairobi until the plane was repaired. After some time, we again took off for Uganda. Consequently, we arrived later in the evening then we'd planned. We did not have hotel reservations, and everything was closed in Entebbe. We hitched an hour-long ride to Kampala and stayed in a very primitive hotel, where the pilot of a small plane would meet us for our flight to Goma, Zaire, the location of three large camps of refugees who had fled Rwanda.

We flew into Goma in a six-passenger plane. One of the passengers was a nurse from Nairobi who worked for World Vision. Since we had no prior accommodation plans, she suggested that we might stay with World Vision and visit the camps via their transportation. When we arrived in Goma, we were told we had to obtain a seven-day visa and that it would cost $150 for each of us. The nurse said that was far too much and suggested we leave the passports with the airport official and World Vision would do the negotiations. This was our first taste of the corruption there.

We went to World Vision's enclave near the Rwandan border and were invited to stay. Richard found a room and I slept in a tent. We visited three camps: Mugunga, Kibumba, and Kitali. Each camp had more than 200,000 refugees living in straw huts, which were crammed together in a ten-foot square area. All three were primitive and anarchy prevailed. Each morning the dead were placed beside the road where Gaol, the Irish relief provider, would pick the bodies up in a dump truck and take them to a common grave for 40,000, hewn out of lava.

◀ Women waiting for
doctors—MUGUNGA.

The first day we went to Mugunga where World Vision distributed food and ran an orphanage. The shock of the primitive conditions had an incredible impact on us. Treated water from Lake Kivu and latrines had been made available just recently. A cholera epidemic had just subsided, but death was everywhere. The next day we hitched a ride to Kibumba. Annie Liebowitz was there photographing for the *London Times*. The third day we went to Kitali via several hitched rides. Unfortunately, we went too far and we got off the truck away from any providers and were immediately surrounded by a mob. But coming the other way slowly through the throngs of people was another truck that helped us out of a compromising situation.

When we left the camp the next day, Richard informed me that he would like to go to Kigali, the capital of Rwanda. I told him that I had to do more work in the other two camps if I was to make something out of the trip, so he said that he would clear the passport in Goma and meet me on the plane in Nairobi or in the United States. He asked me if I had enough money, and I said yes, but I only had $150 on me, in the middle of Africa. Nevertheless I continued to work in Mugunga and Kibumba.

One evening I went for a walk and accidentally crossed over the Rwandan border, where I was immediately surrounded by Rwandan soldiers. My first thought was that I did not have a passport and that I was in Rwanda illegally. A soldier had a new Nikon around his neck. He motioned that he needed a battery. I indicated that I did not have one, and then he asked for film. I hand signaled that I would give it to him if I could get some pictures. I took two pictures, gave him a roll of film, and quickly walked back over the border, waiting to hear a staccato burst.

At the end of the week, I made arrangements to fly with a Canadian cargo plane, under the auspices of the United Nations, back to Nairobi, avoiding two extra days of travel through Entebbe. When I got to Nairobi, I delivered a letter to World Vision and asked to be directed to an inexpensive hotel where I could stay until leaving for the United States the next day. I was given an address, went to the hotel, and checked in. Just as I was finished checking in, I heard "Lucian." There was Richard, whom I had left half a continent away! The next day we went on an incredible safari where we were charged by a rhino just prior to boarding the plane back to the United States.

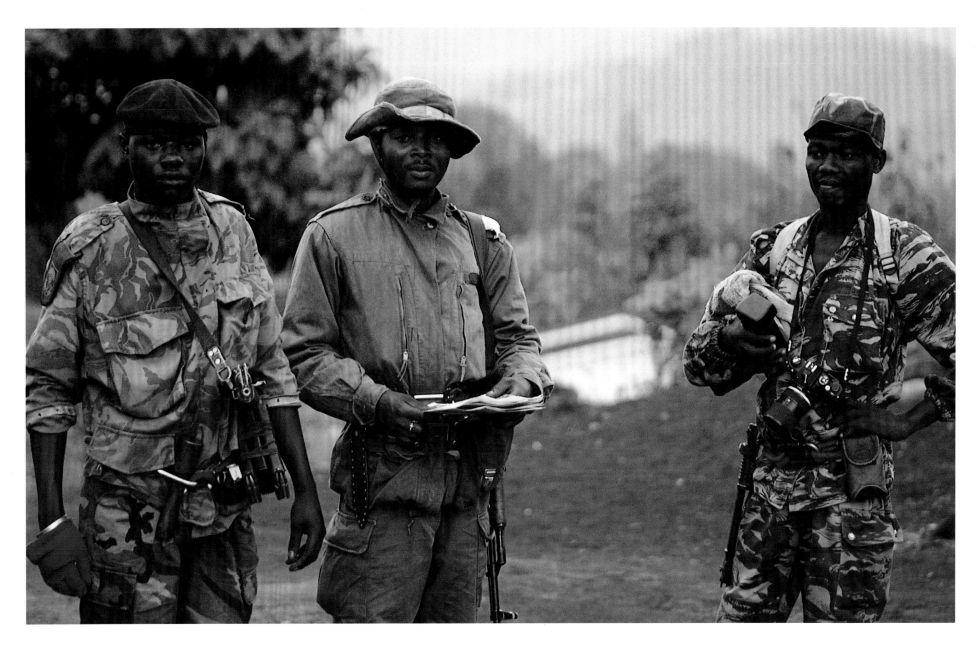

▲ Rwandan soldiers at the Rwanda/Zaire border–GOMA.

Kibumba refugee camp of more than 200,000–ZAIRE. ▶

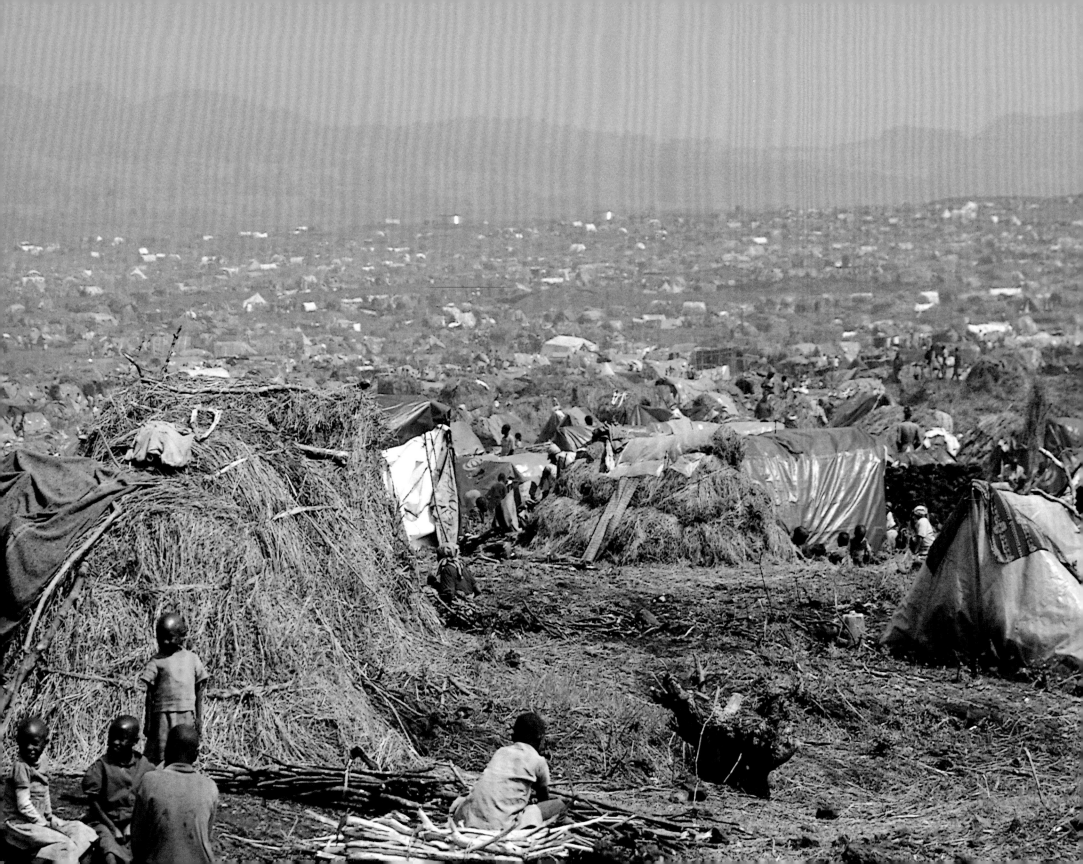

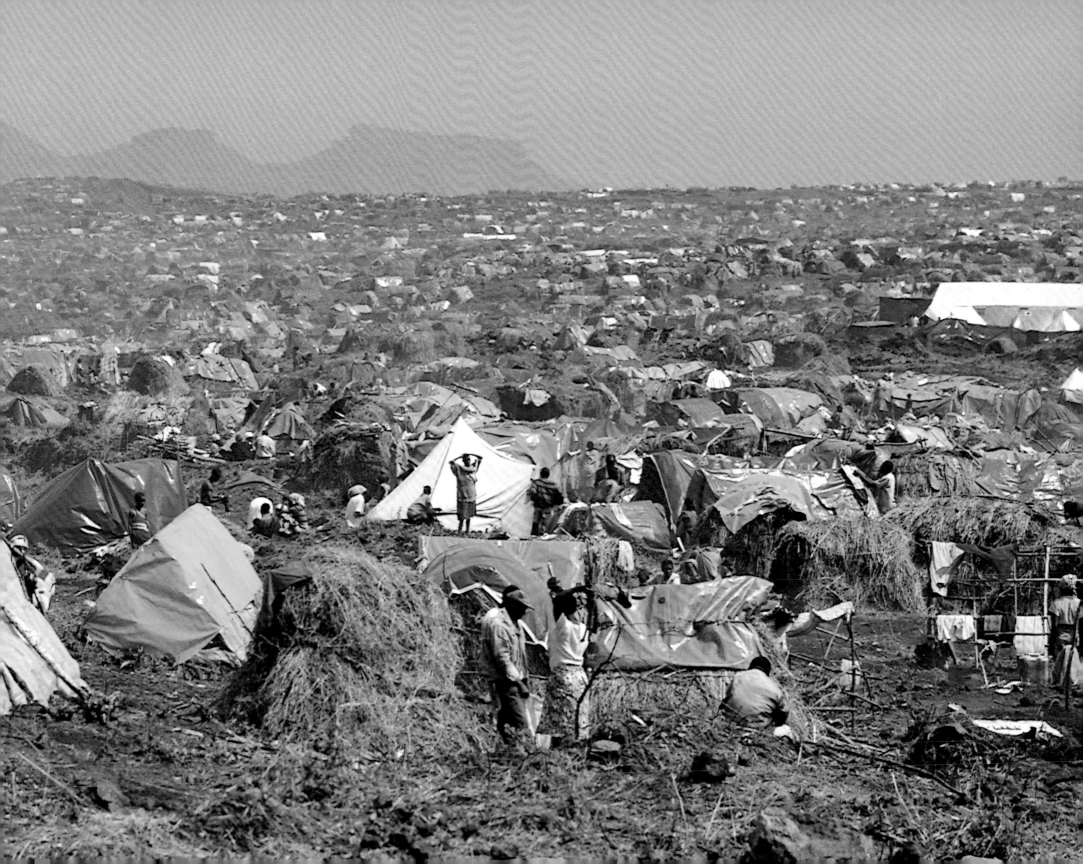

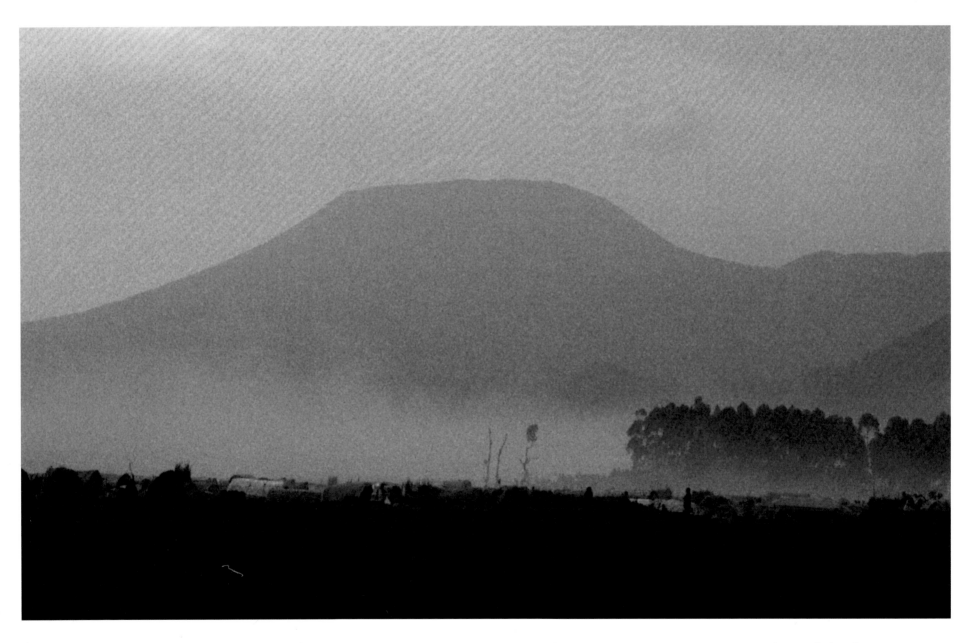

▲ The volcano over Goma that blew in 2004, destroying the town again.

Cooking on the lava flow–MUGUNGA. ▶

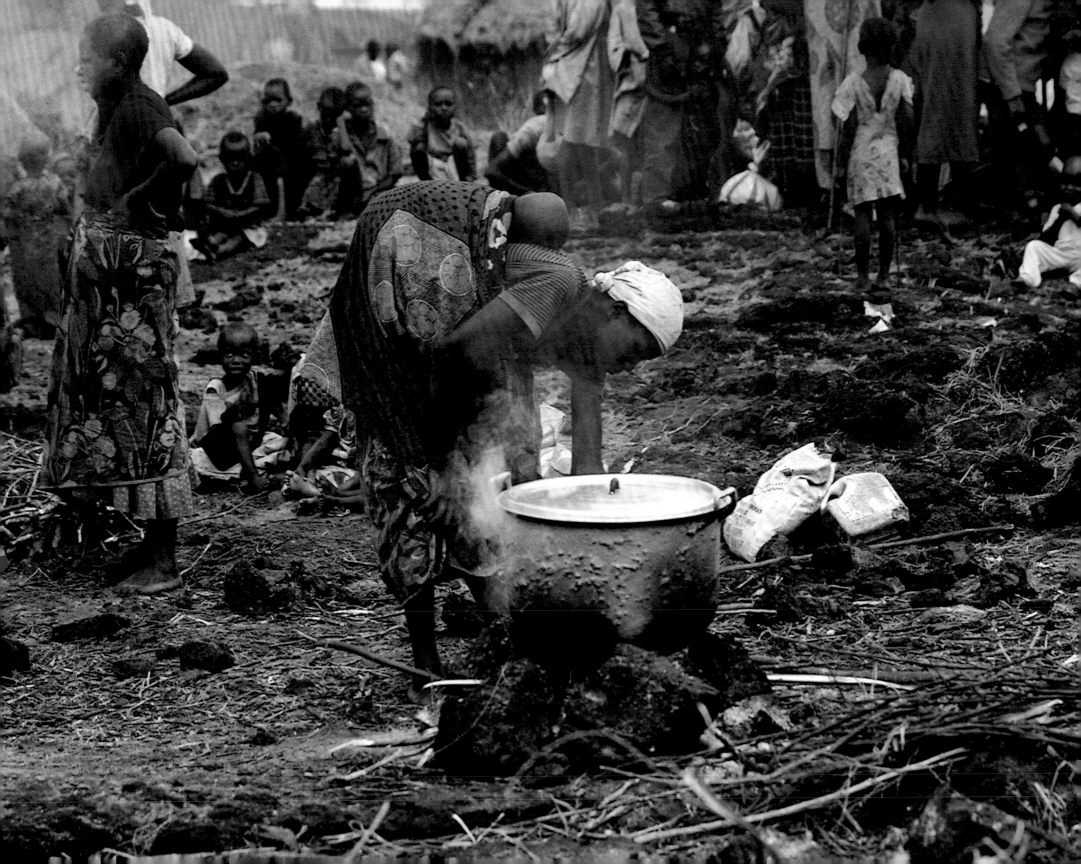

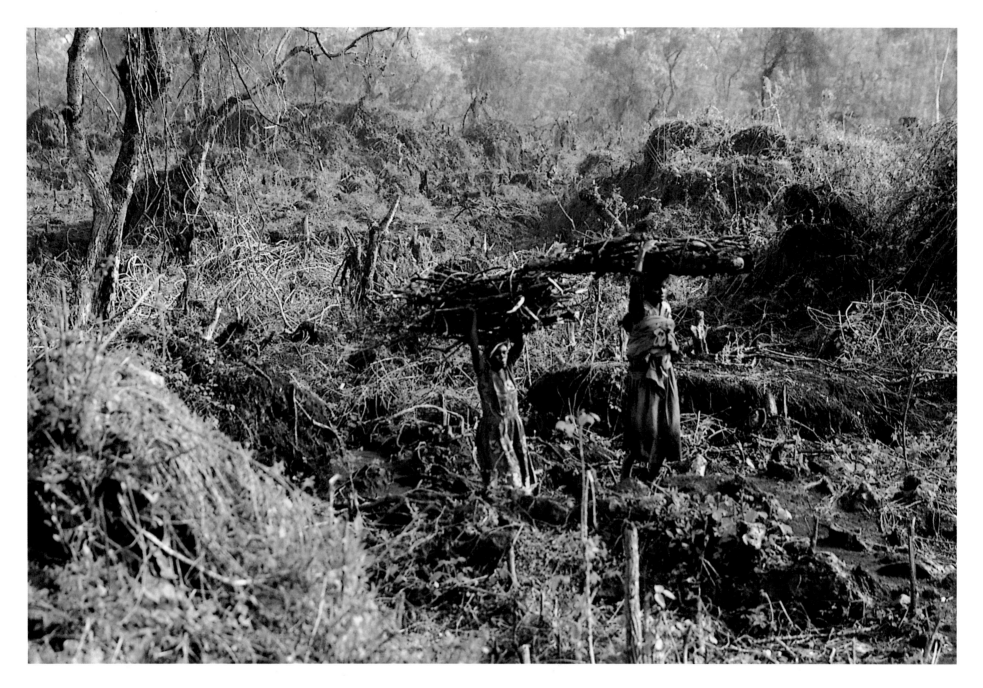

This jungle will soon be cleared to be used for campfires—KIBUMBA.

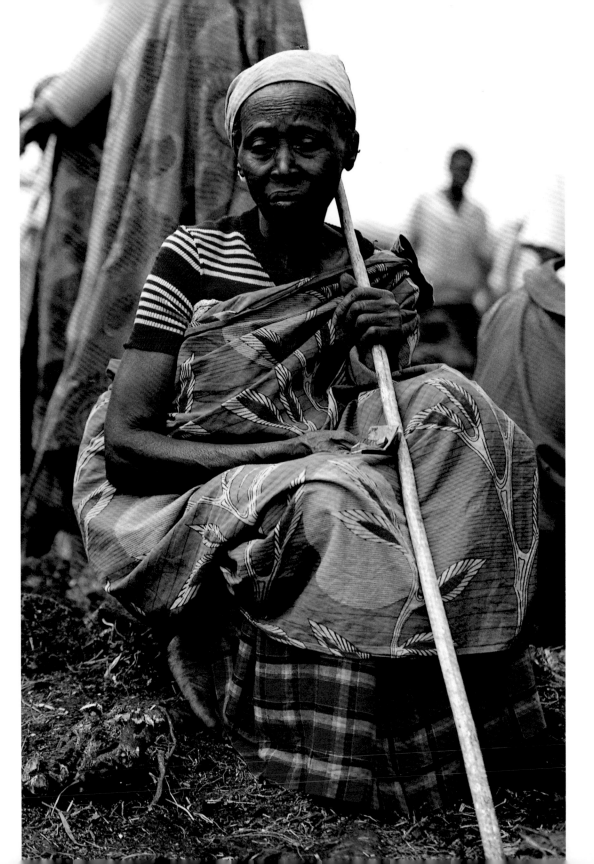

Old woman with
staff—MUGUNGA.

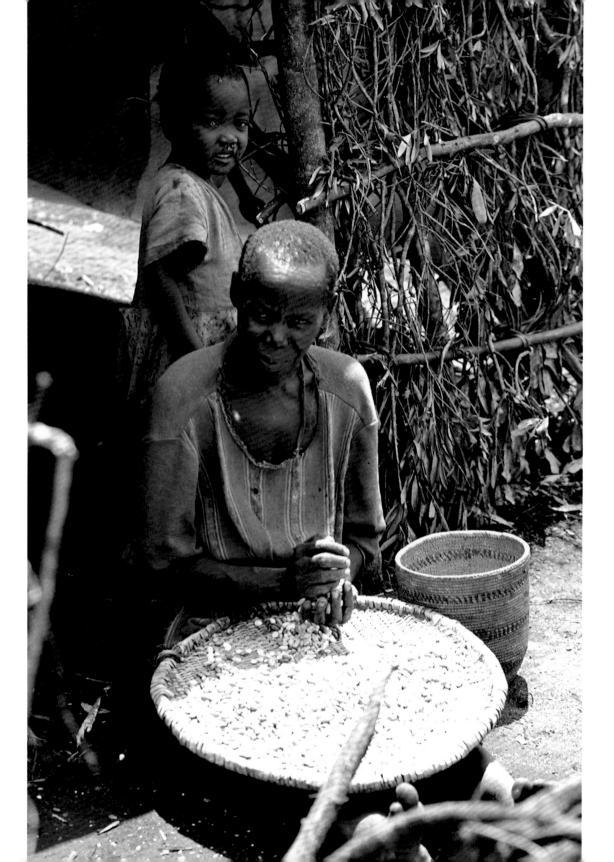

Preparing corn meal for
making gruel–KIBUMBA.

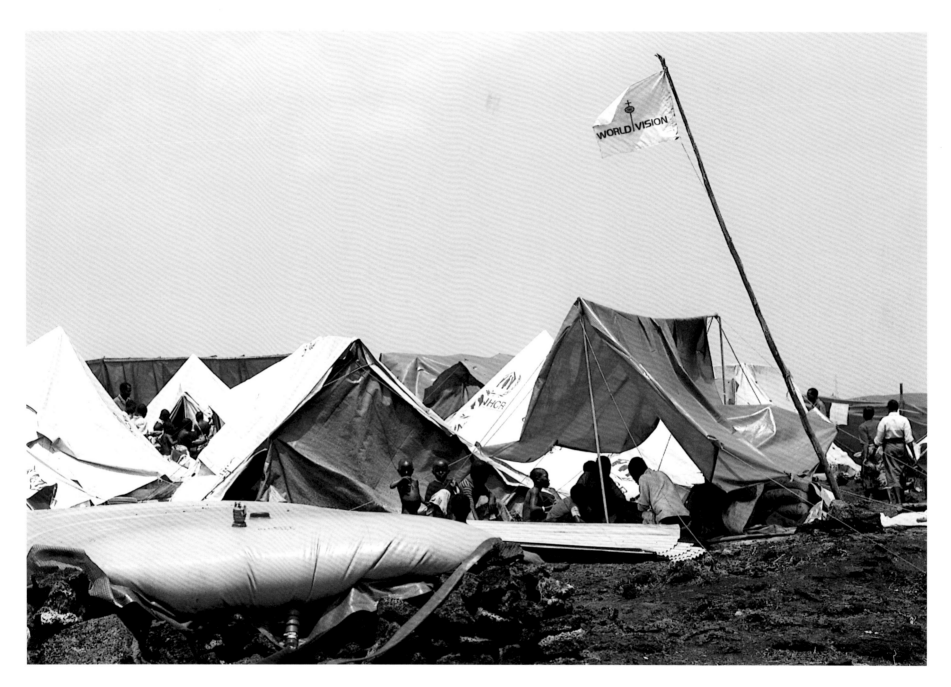

World Vision orphanage in the Mugunga camp of more than 200,000 refugees.

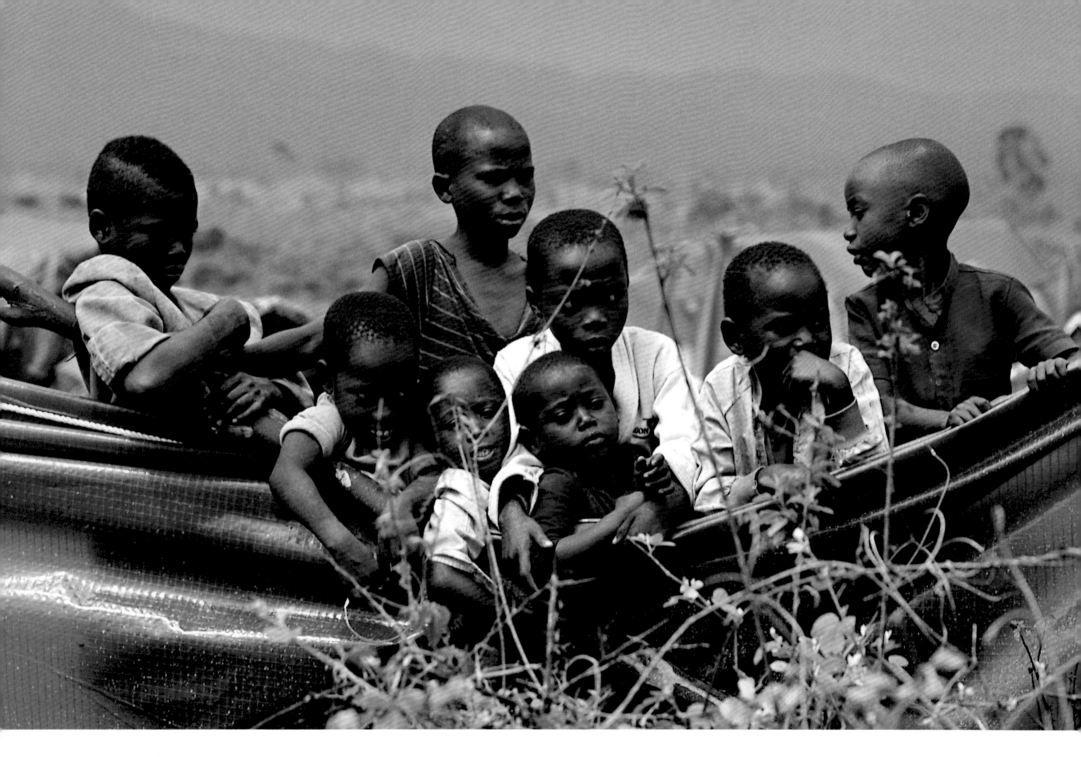

Outsiders looking in on the orphanage–MUGUNGA.

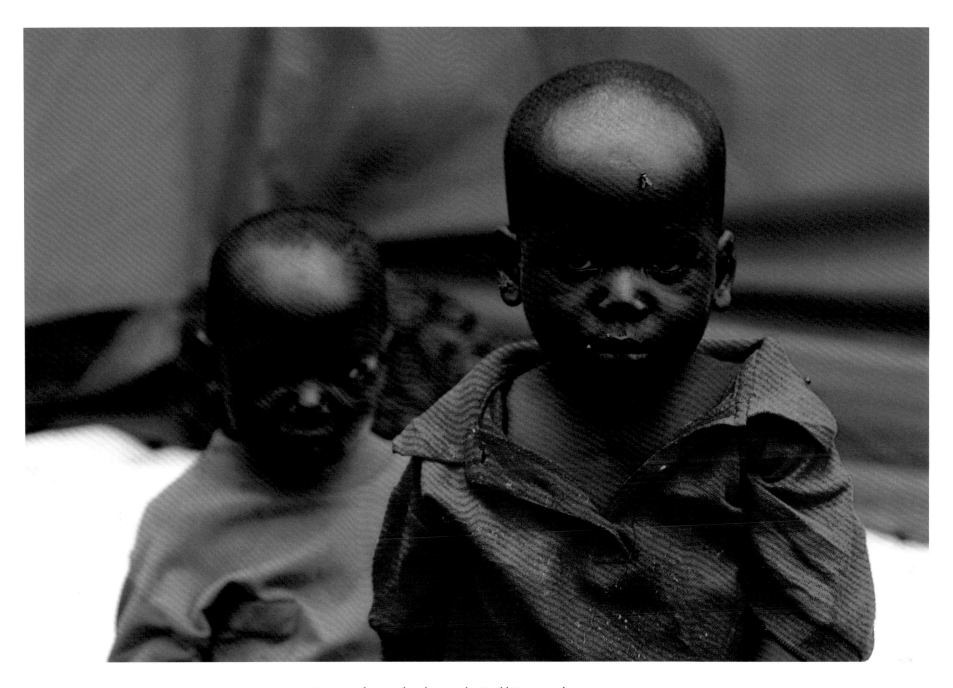

Two recently arrived orphans at the World Vision orphanage–MUGUNGA.

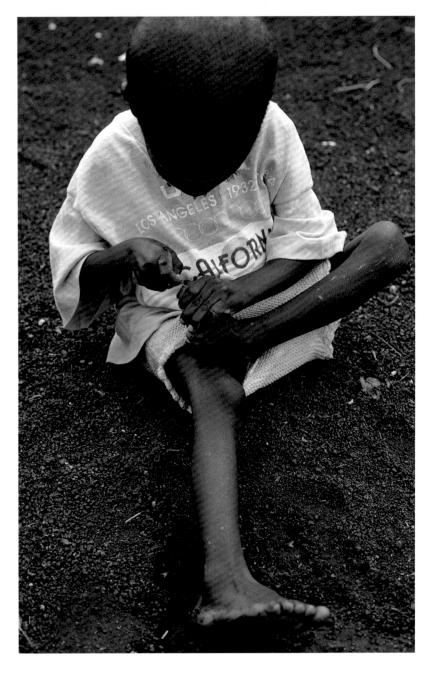

A young boy pulling out a cactus thorn from his foot in Mugunga camp.

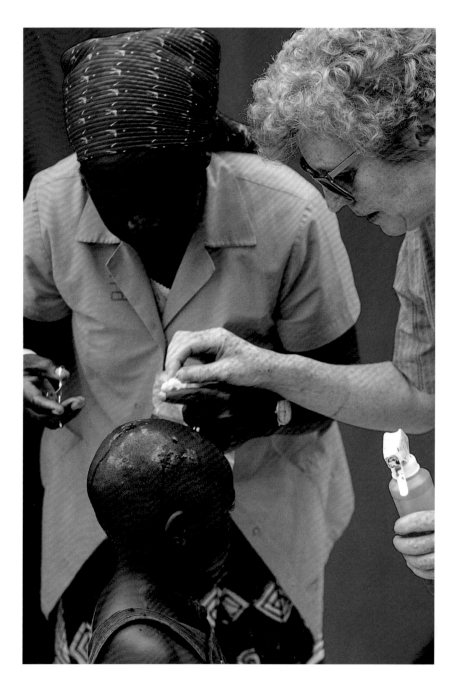

Irish nurse disinfecting a new orphan at Mugunga camp.

Orphan at the Mugunga
World Vision orphanage.

Two orphans at the World Vision orphanage–MUGUNGA, ZAÏRE.

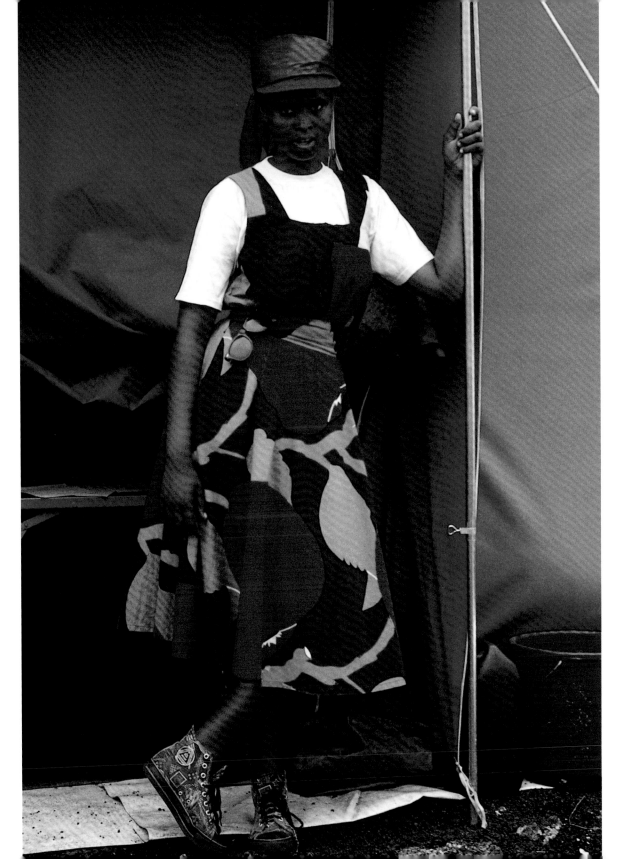

A Zaire schoolteacher
providing help at the World
Vision orphanage–MUGUNGA.

Zaire schoolteachers at the Mugunga orphanage.

Seven orphan children–MUGUNGA.

Orphan girl in the Mugunga orphanage.

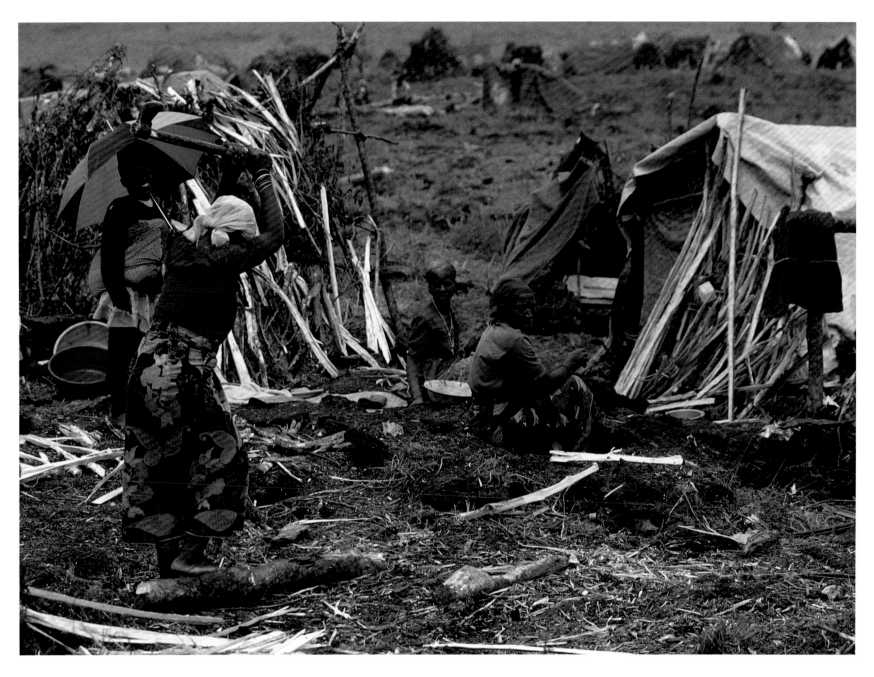

Close-up of Kibumba camp.

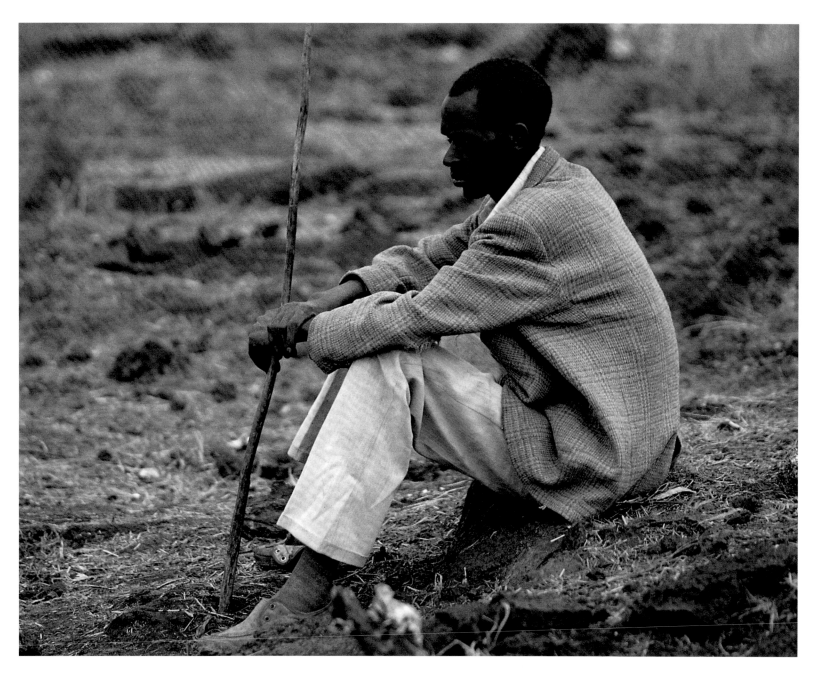

A professional man–MUGUNGA.

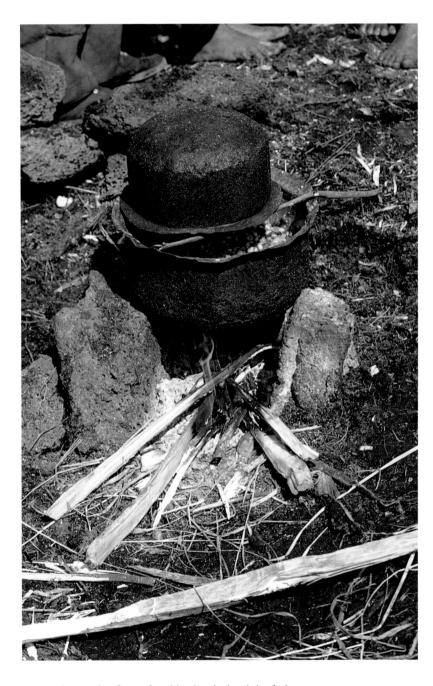

Thousands of campfires like this depleted the fuel near camp–KIBUMBA.

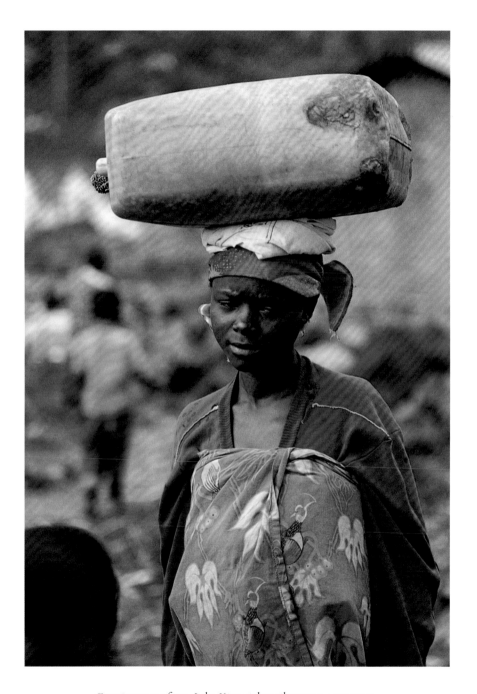

Carrying water from Lake Kivu eight miles away–MUGUNGA.

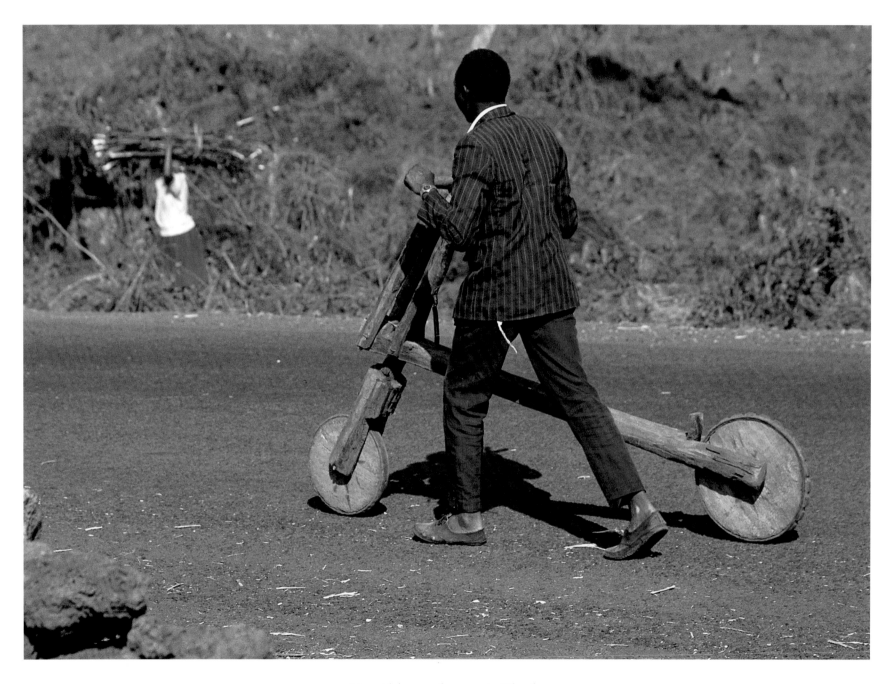

Man with homemade scooter in Kibumba.

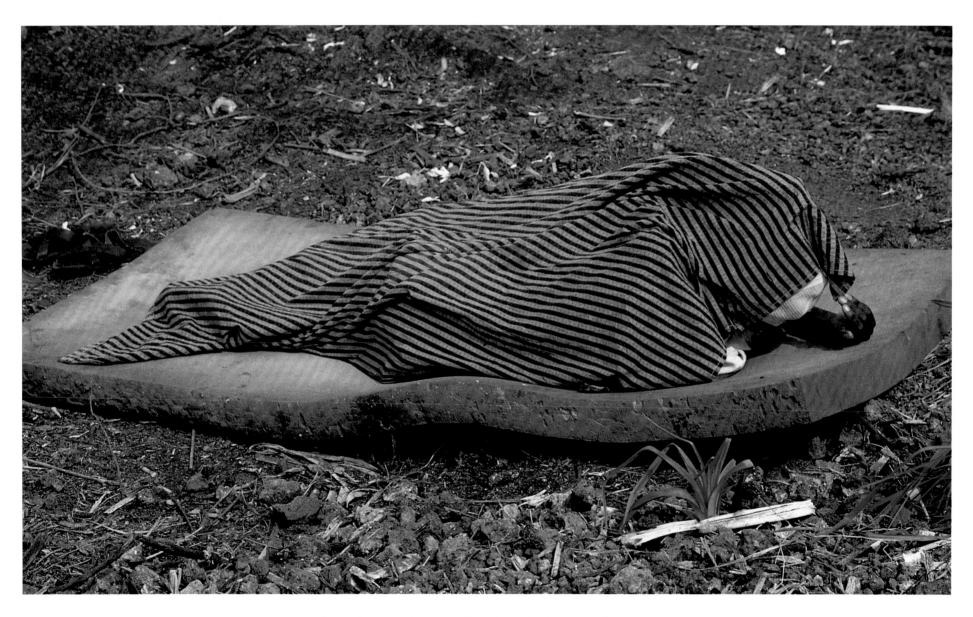

A dying refugee near the road will be picked up by the Gaol trucks–KIBUMBA.

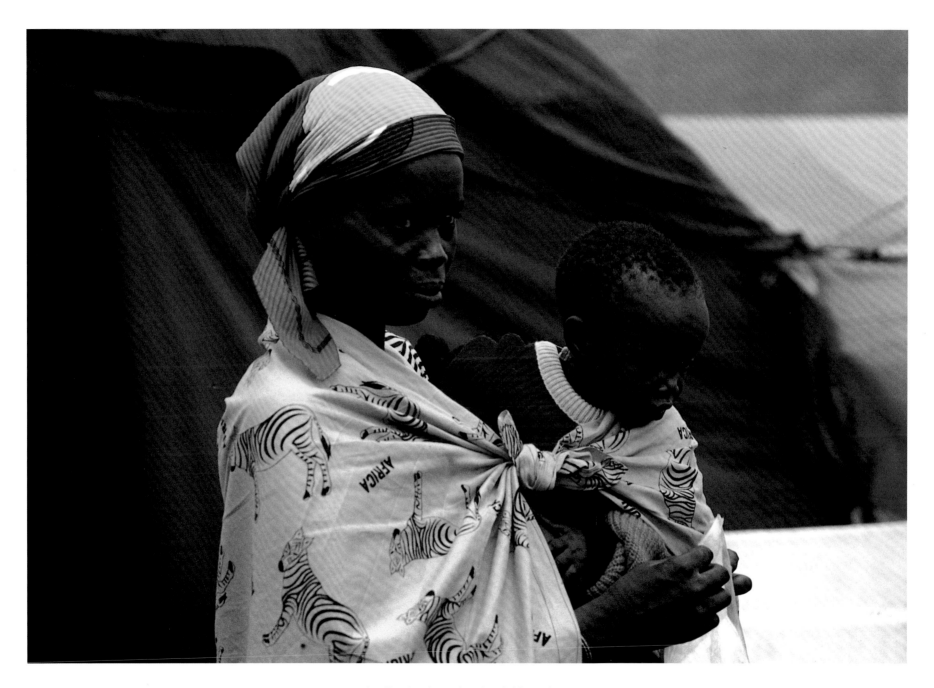

Woman with yellow bandana taking her child to a doctor–KIBUMBA.

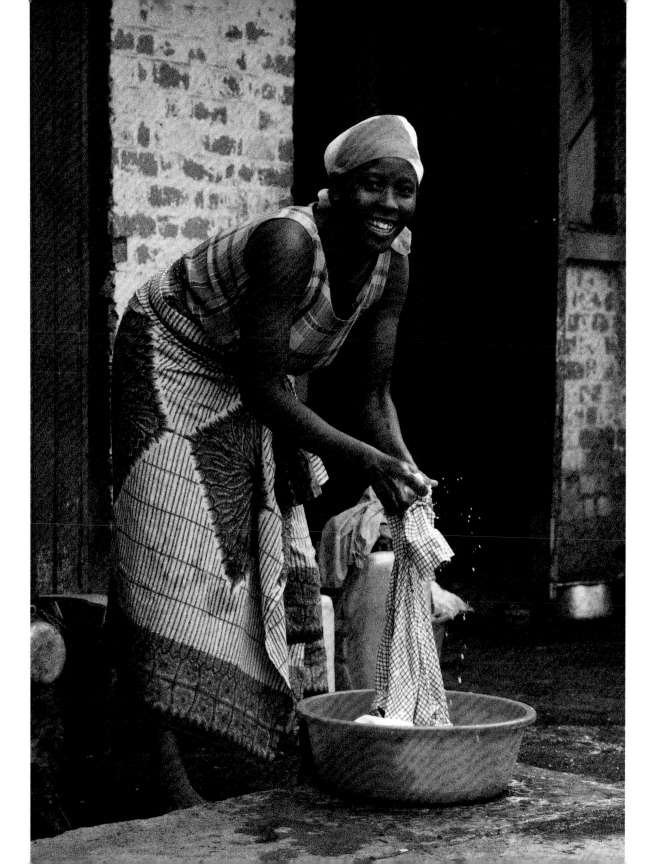

Woman washing
clothes in Goma.

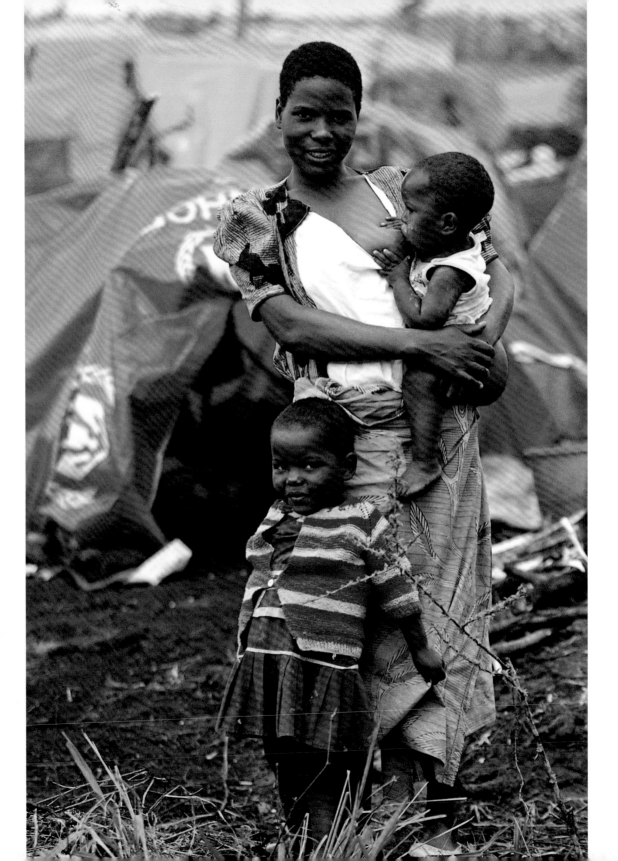

Woman nursing –KIBUMBA.

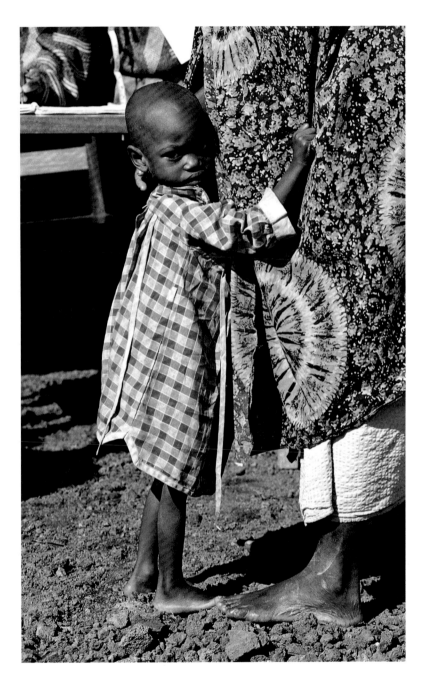

Child clinging to her mother–KIBUMBA.

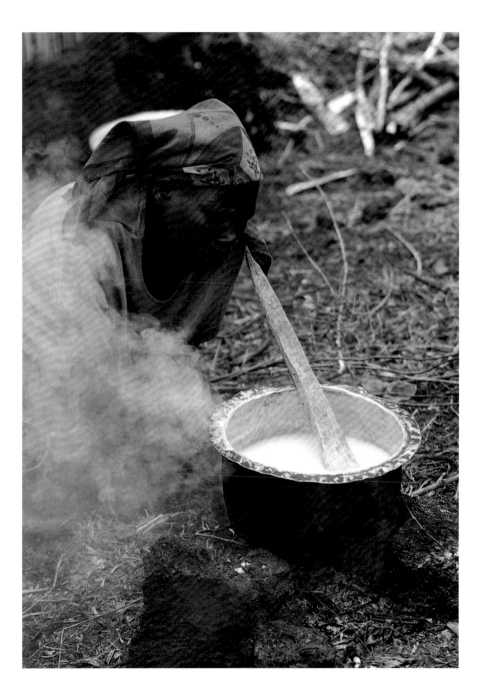

Woman cooking a corn gruel mash, supplemented with vitamins–KIBUMBA.

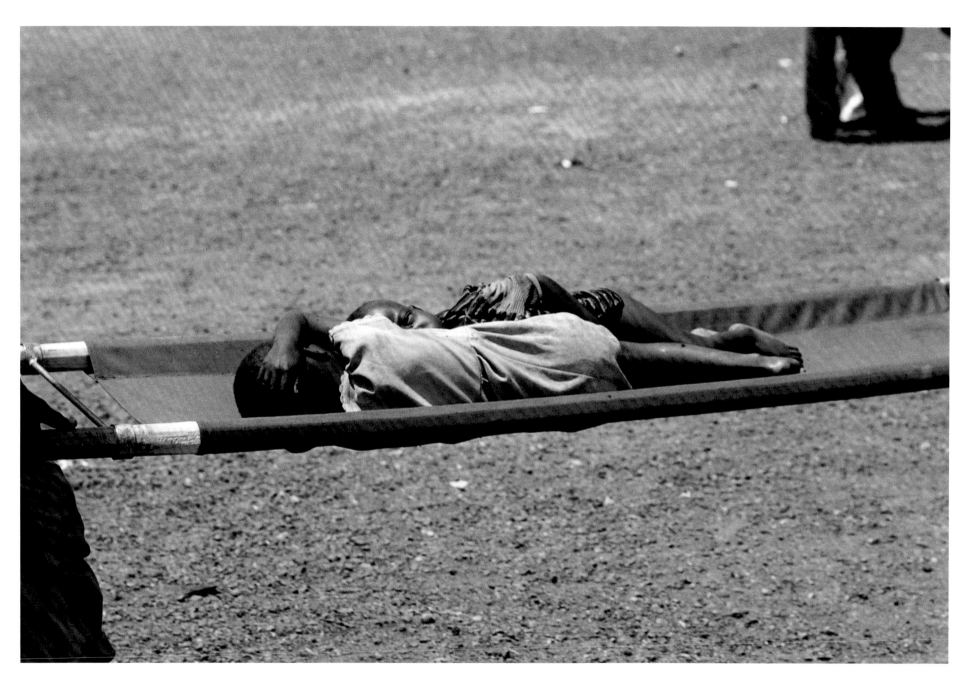

Dying children being carried to a mass grave–KITALI.

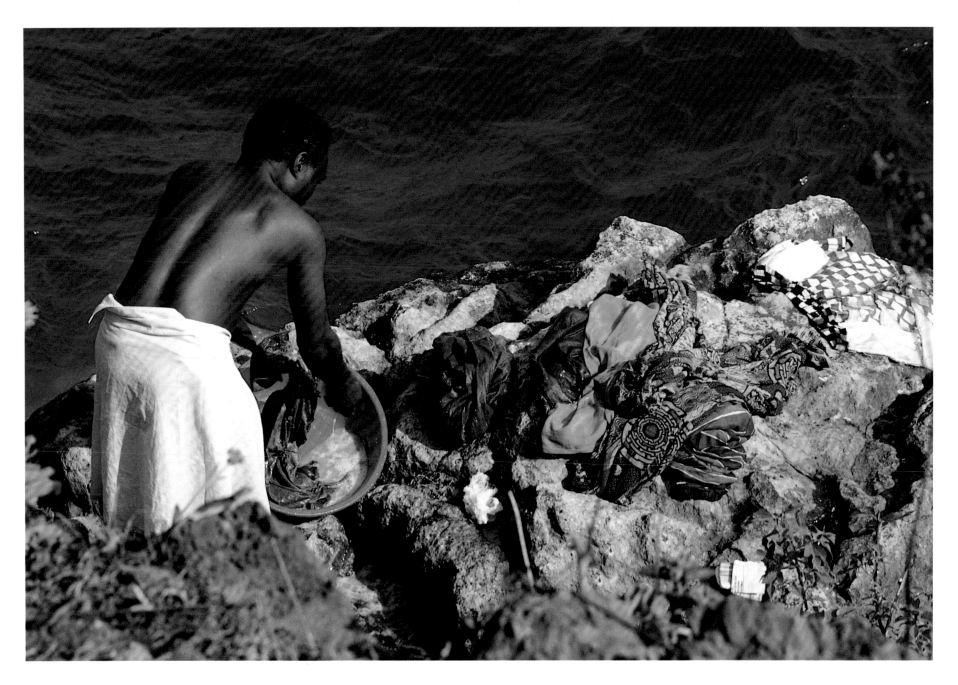

Washing clothes in Lake Kivu in Goma.

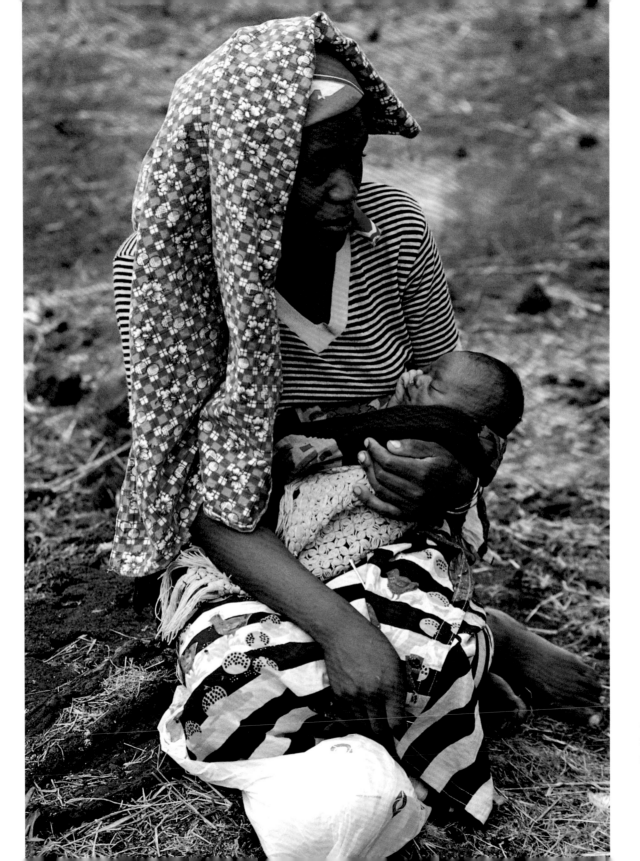

A woman with her
newborn baby who will
not survive—KIBUMBA.

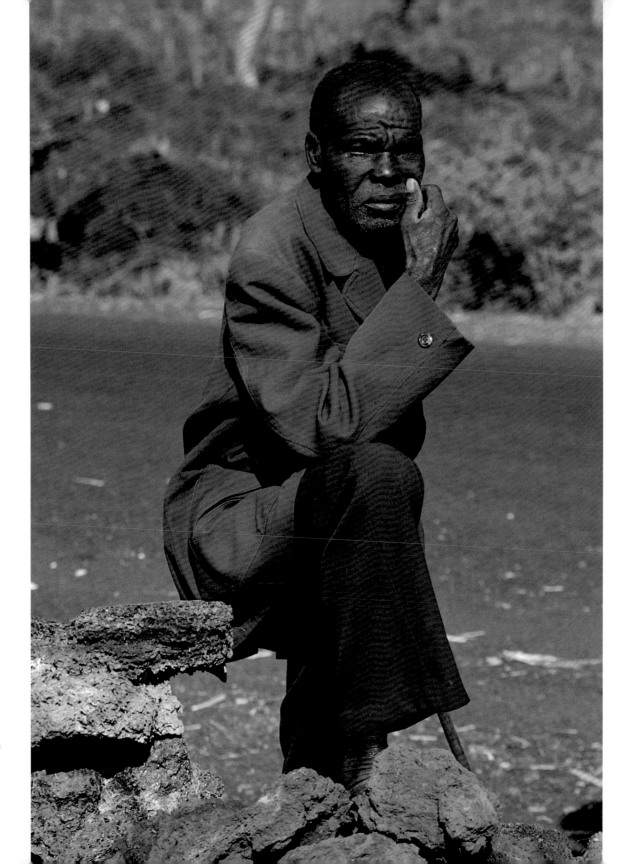

A professional man
waiting for work–KIBUMBA.

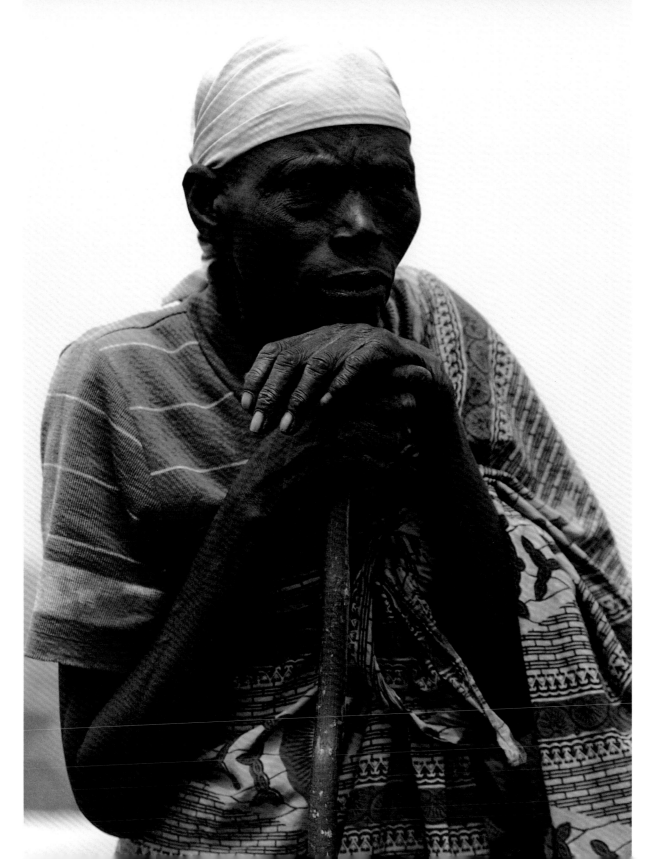

Old woman pondering
her fate—MUGUNGA.

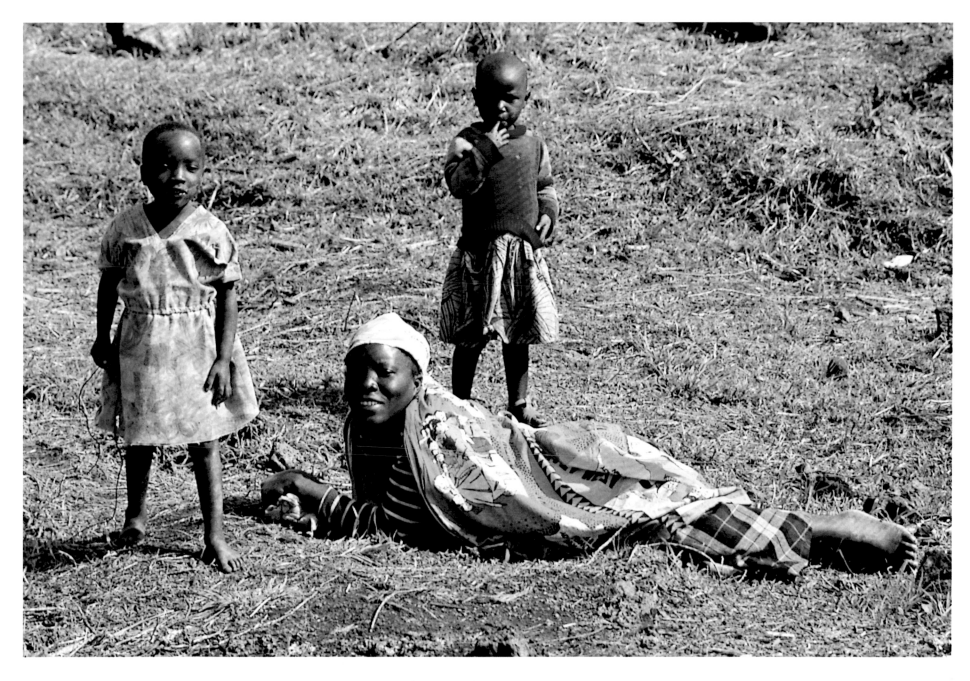

Woman dying of Blackwater fever tends to her children–KIBUMBA.

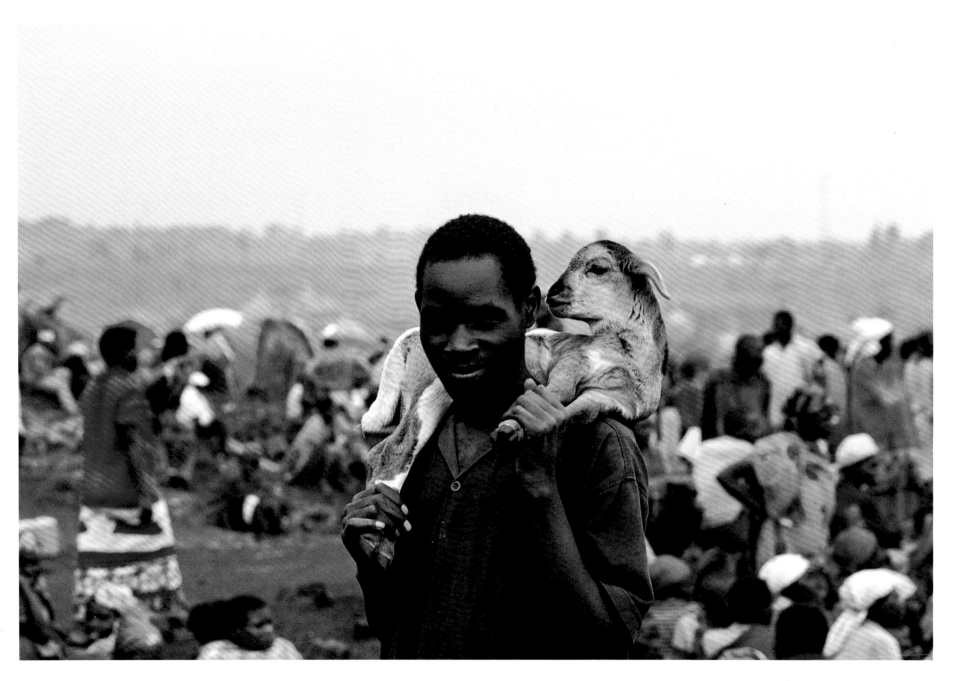

Man with a rare goat in Mugunga camp of more than 200,000.

A man with his dying
child with no place to
go for help–MUGUNGA.

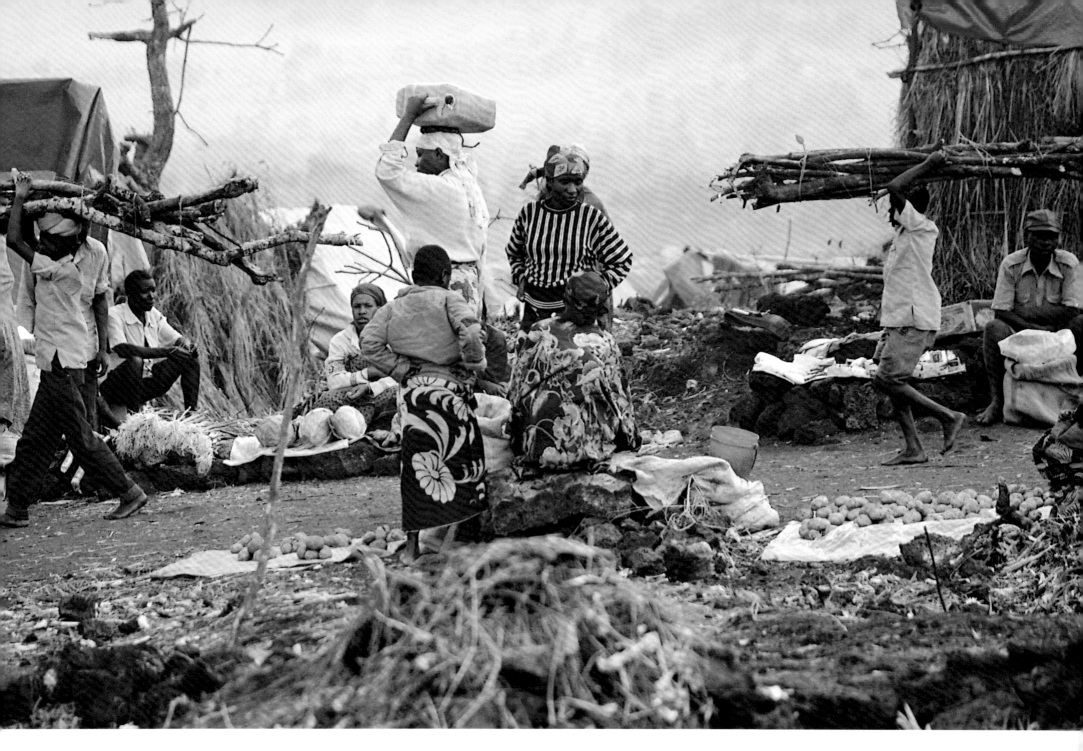

Kibumba refugee camp market for more than 200,000—ZAÏRE.

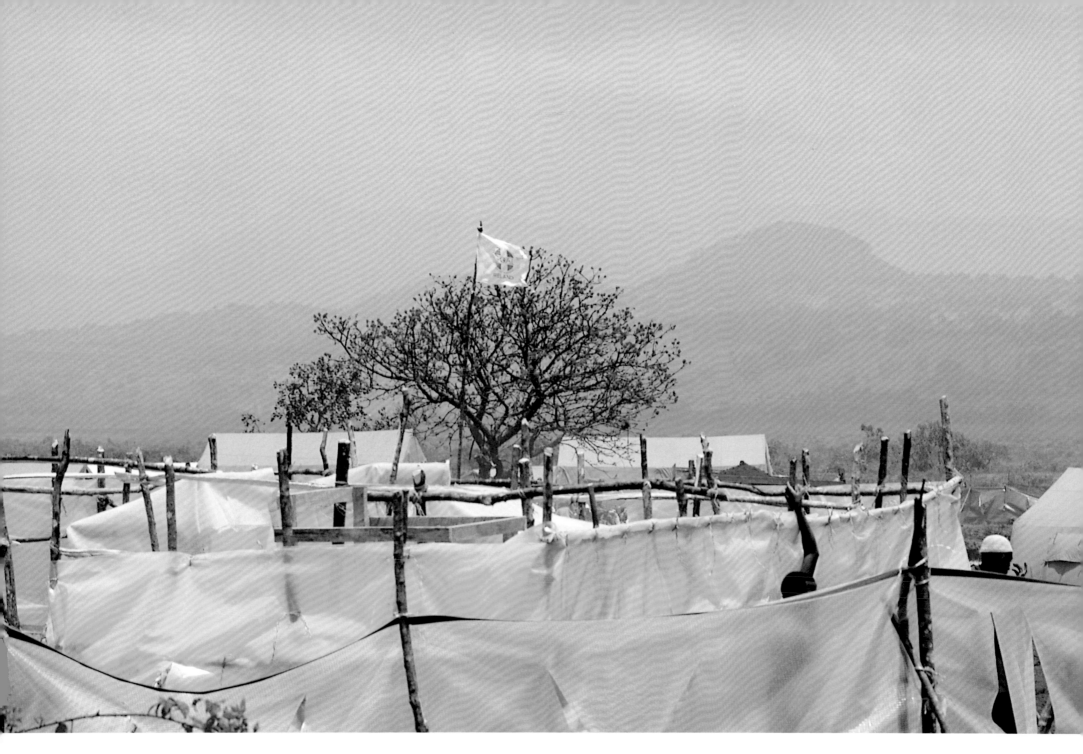

Latrine tarps are shoulder high because refugees fear being killed in covered enclosures–KIBUMBA.

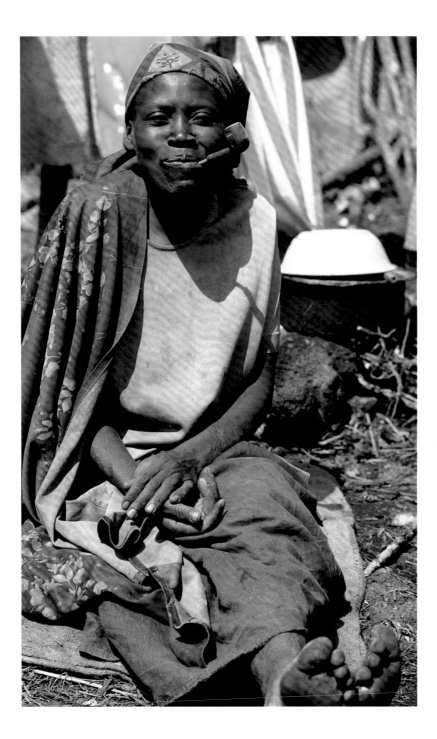

Indomitable woman with pipe in Kibumba.

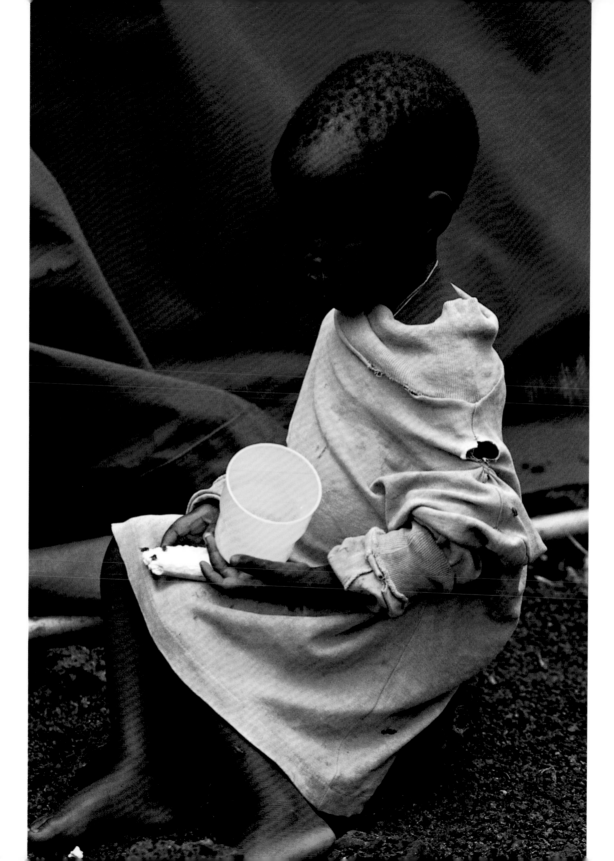

Girl with a yellow cup–
MUGUNGA, ZAÏRE.

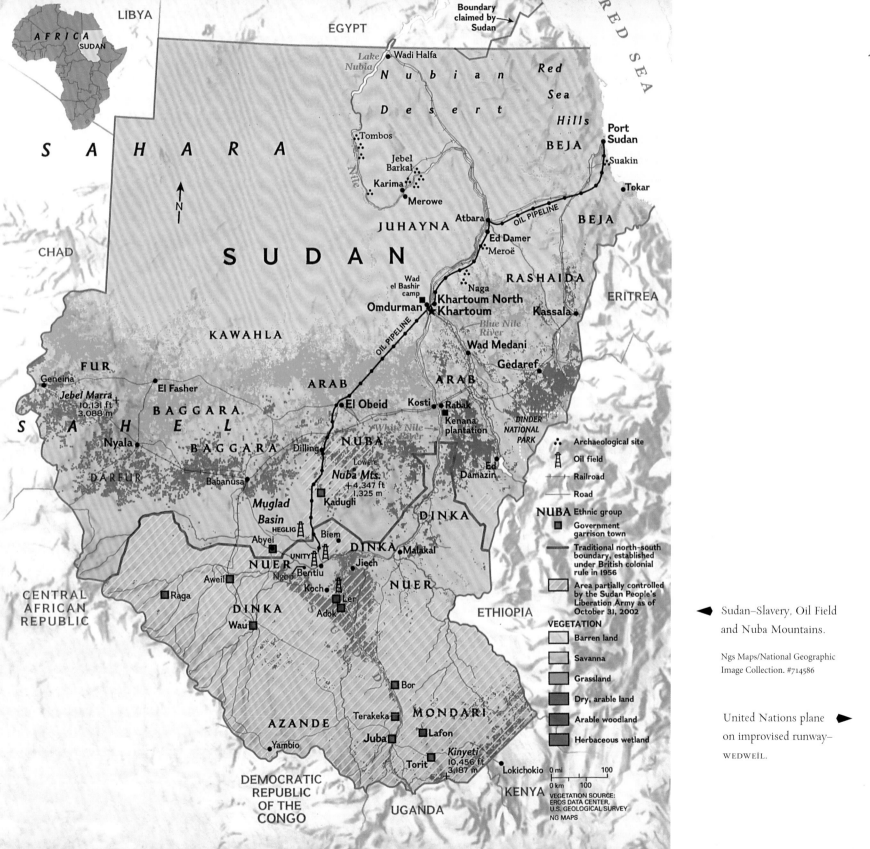

LIBYA

AFRICA
SUDAN

EGYPT

Boundary
claimed by
Sudan

RED
SEA

Lake Nubia • Wadi Halfa

N u b i a n

Red

D e s e r t

Sea

Hills

Port
Sudan

BEJA

Suakin

S A H A R A

Tombos

Jebel
Barkal

Karima

• Merowe

Nile

Tokar

CHAD

S U D A N

JUHAYNA

Atbara

OIL PIPELINE

BEJA

Ed Damer

Meroë

BEJA

ERITREA

KAWAHLA

Wad
el Bashir
camp

Naga

RASHAIDA

Omdurman
Khartoum North
Khartoum

Kassala

Blue Nile River

Wad Medani

FUR

Geneina

Jebel Marra
10,131 ft
3,088 m

El Fasher

ARAB

ARAB

Gedaref

S A H E L

BAGGARA

El Obeid

Kosti

Rabak

White Nile River

DINDER
NATIONAL
PARK

Nyala

BAGGARA

Dilling

NUBA

Kenana
plantation

Archaeological site

Oil field

DARFUR

Babanusa

Muglad Basin

HEGLIG

Lowere

Nuba Mts.
+4,347 ft
1,325 m

Kadugli

Ed
Damazin

DINKA

Railroad

Road

NUBA Ethnic group

Government
garrison town

Abyei

Biem

UNITY

DINKA

Malakal

Traditional north-south
boundary, established
under British colonial
rule in 1956

CENTRAL
AFRICAN
REPUBLIC

NUER

Ngop

Bentiu

Koch

Ler

Jiech

NUER

Area partially controlled
by the Sudan People's
Liberation Army as of
October 31, 2002

Aweil

Raga

DINKA

Adok

ETHIOPIA

VEGETATION

Wau

Barren land

Savanna

Grassland

Bor

Dry, arable land

Arable woodland

AZANDE

Terakeka

MONDARI

Lafon

Herbaceous wetland

Yambio

Juba

Kinyeti
10,456 ft
3,187 m

Torit

Lokichokio

0 mi 100

DEMOCRATIC
REPUBLIC
OF THE
CONGO

UGANDA

KENYA

0 km 100

VEGETATION SOURCE:
EROS DATA CENTER,
U.S. GEOLOGICAL SURVEY
NG MAPS

► Sudan—Slavery, Oil Field
and Nuba Mountains.

Ngs Maps/National Geographic
Image Collection. #714586

United Nations plane ►
on improvised runway—
WEDWEIL.

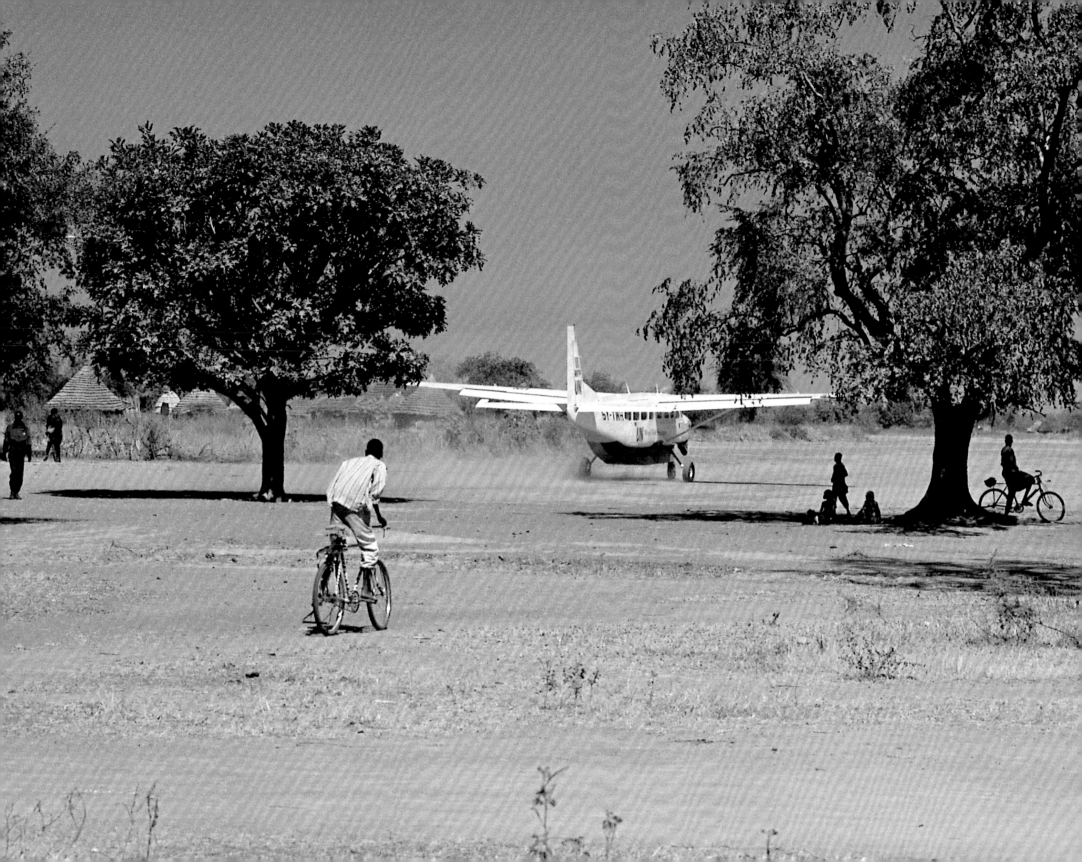

THE SUDAN
SLAVE STORY

In December of 2000 Christian Solidarity International (CSI) invited me to accompany them to the Sudan to document the purchasing of slaves in order to free them. (CSI is a human rights organization based in Switzerland that has specialized in helping the Dinka people in southern Sudan by providing medicine and redeeming tribal members from slavery since 1995.) One of the world's most tragic stories is set against the backdrop of a continuing eighteen-year war and genocide, predominantly by the Arab Muslim north on the African Christian south. The north, in its efforts to force a national religion, is conducting an unrelenting religious war. It is despotism at its worst. Two million people, mostly civilians, have died in the conflict. Amidst this carnage, a huge slave trade is going on. Civilians, mostly women whose husbands are slain and children, have little ability to resist and are being sold into slavery to northern Sudan Muslims and Eastern emirates. Most civilized nations have turned a deaf ear to this great holocaust now going on. It is one of the shames of the world that considers itself civilized.

SUDAN: A SAGA OF GENOCIDE AND ENSLAVEMENT

In a land in the northeastern horn of Africa, the oldest known history of man has been revealed, dating back over two million years. Here man has found the roots of civilization in the ancient accounts of Egypt, the White and Blue Nile, Khartoum, Lawrence of Arabia, the Mahdi, Nubia, and Gordon Pasha. In the Christmas season of 2000, under a blanket of a brilliant black velvety night and brightly twinkling stars that cover the whole earth, a deadly drama of genocide and slavery is being enacted in this land in a manner that should revolt all civilized people. For in southern Sudan the native Christian Dinka and Nuer people are being killed and enslaved in large numbers by members of the Islamic faith, abetted by the government of Sudan (GOS). While the Israeli and Palestinian confrontation is the more visible and well-known religious conflict in the world, southern Sudan is the frontier. For here genocide is practiced with a malice that knows no human boundaries. *In this oldest of human backdrops, the human condition has not advanced far.*

The war between the Islamic north and Christian south in Sudan has old roots, stemming back to the 1950s when the country, separated at the time as South Sudan and North Sudan, was made one by Great Britain after World War II, with the administration centered in Khartoum, the northern capitol. In 1956 the country of Sudan achieved independence from England. A war between the two religious factions broke out in 1983, with the Islamic north invading the Christian south. This is considered the time by which the current struggle is measured. Since 1983, it is estimated that at least two million people have been killed in this genocide, mostly civilians. Early on in this conflict, two professors at the University of Khartoum, Ushari Ahmad Mahmud and Suleyman Ali Baldo, learned about the genocide and enslavement of the Dinka people and investigated it. They found that raiders from the north had been killing men and taking women and children into slavery for more than two years. They wrote their report in 1987, and it was widely circulated but denied by the Sudanese government. The United Nations analyzed the report and then discounted it as hearsay. These two humane professors were incarcerated by their government and then discredited throughout the world. *The civilized world would not and could not hear.*

The rumors persisted. The Catholic, Presbyterian, and Anglican churches have had a strong presence in southern Sudan, as have nongovernmental organizations (NGOs), which have given food, medicine, and agricultural assistance to the affected people in this sub-Saharan land. We all have heard about the starvation of the Dinka people in this area with the southward movement of desert conditions combined with the uncertain and devastating conditions of war. A normalized situation would be difficult enough for these people, but with war conditions, it is intolerable. The United Nations, the European Common Market countries, and the United States have all

played significant roles in the area. All have received reports about genocide and slavery in Sudan. All have turned a deaf ear with chilling results.

In President Clinton's address about Africa to the world, he said mistakes were made by the United States and the world in the Rwandan genocide. He vowed that future U.S. policy would not allow genocide to happen again in Africa and apologized for the U.S. role. At the time this speech was given, the State Department had sent an Assistant Secretary of State for African Affairs, Susan Rice, to Sudan to investigate the depth of the genocide and slavery. Her report gave a horrific account of slavery being practiced in the southern Sudan region and included interviews with former slaves. The U.S. government was in possession of an earlier report on the slavery issue, issued in 1994, as were the United Nations, the European community, and the three active churches, which explained in some detail the episodes of raids, the genocide, and the wide scope of slavery. By this time several organizations had attempted to buy back slaves from their Islamic masters and had limited success. In 1995 CSI was asked by local communities to expand their life-giving operations to include the purchasing of slaves, and it has been quite successful. But overall, the extent of the human disaster has been only succeeded by the hypocrisy of the world community, both moral and political, and *I am so ashamed.*

Is the moral and political evaluation of the progress of our human struggle to be measured by the acceptance of genocide and slavery in Sudan by the world community?

Some years ago, the United Nations took the firm position that genocide and slavery were world crimes that should be eradicated and that those engaged in them should be put on trial by the world court in The Hague, (Resolution 260 [111 A], U.N. General Assembly). This resolution has been the modus operandi in the case of Kosovo. Yet the world has not addressed the crimes being committed in southern Sudan. Indeed, it has not even acknowledged that crimes are being committed. It is now the correct politic direction by the churches, United Nations, United States, and the European community to encourage the Sudan government (GOS) to join the world community through negotiation and not to create tension via confrontation among those Islamic movements that are destabilizing large societies of the world. The term for slavery used by the GOS in answer to questions from the world community is "*abductions.*" Certainly the *spin* fits the requirements of the world community. Meanwhile help from Europe and the United Nations has all but stopped in southern Sudan, based on the notion that the world community should work *with* the government to solve the problem.

The GOS has put into place a fact-finding commission to investigate the crimes and assuage the world community that slavery does not exist in Sudan. As recently as several months ago the president of Sudan stated in New York that *there is no slavery in Sudan.* While it is true that recently Sudan was denied membership in the U.N. Security Council, a firm resolve by the civilized powers of the world to end the genocide and slavery has not been stated or mandated. Meanwhile,

the atrocities continue unabated. Only a few NGOs and food given by the United States fill the vacuum of need, while the greatest problems are still to come. The drought and the coming offensive by the GOS during the dry season will create chaos in southern Sudan again. When this terrible catastrophe is unleashed in the next few months, the few, brave NGOs will be the only respite for the innocent people. The rest of the world community will wring their hands and say, *how terrible*.

Sudan–Christmas 2000

It is the dry season in the White Nile region. The GOS is massing for an offensive into southern Sudan. The Russian-built Antonov planes fly overhead each day, bombing and supplying garrisons from which new offensives will take place. On one day, seven planes passed overhead, resupplying garrisons or bombing strategic locations south of us. When this attack commences, men will be killed and new women and children slaves will be taken along with cows and goats. The cycle of genocide and enslavement will be continually repeated, while much of the world looks on, enjoying the peacefulness of Christmas, Hanukkah, and Ramadan in safe places. The durable Dinka and Nuer people will face their continuing struggle for survival from a belligerent Islamic government and an Islamic jihad combined with starvation.

In early December I received the call that invited me to travel with CSI. This invitation came because of my connection with another human rights organization, Jubilee Campaign, which had invited me to travel with it in the spring of 2000 to document the persecution of Christians in Indonesia by the radical Islamic community. As I had also done work documenting the aftermath of the Rwandan genocide resulting in articles and a traveling exhibition called "Rwandan Refugees: A Story of Life," I was naturally interested in genocide in other parts of the world, and especially Africa. As I was to meet CSI only four days later, I had little time to get tickets and prepare for the trip. Yet I arrived in Zurich to meet with the CSI executives and traveled with them to Nairobi. We boarded a small charter aircraft owned by Trackmark, a relief service airline to southern Sudan. We were eight persons: five CSI staff, a human rights worker on a U.S. senator's staff, a human rights activist, and myself. I knew from past briefings and research that southern Sudan was a war zone. I also understood that we were going into the heart of it. In fact, I had to sign a document for CSI, releasing it from any liability while I was in their care since the GOS bombed the tribes of southern Sudan daily. I also knew that there would be no protection for me by the U.S. government and that the GOS sought to destroy CSI (not to mention the plane that provided the logistics), which had embarrassed them by redeeming slaves.

Let me describe the area in which I was to work. Sudan is a large country, the size of the eastern United States from the Mississippi River to Maine. Through it runs the great river Nile and its tributaries; otherwise it would be almost a desert but for a few coastal regions. Historically there have always been a northern Sudan and a southern Sudan. Southern Sudan is a large arid country, undeveloped by U.S. standards with only one railroad running from north to south and a few unpaved roads. (In the rainy season the roads are often impassable, while in the dry season they are meager at best.) These roads provide the arterial connection between towns and trading centers. This trade is almost always conducted on foot. The main distinguishing geographical features are the Nile and its tributaries, the White Nile, the Blue Nile, and the Lol River, and the Nuba Mountains. The southern Sudanese people mostly live in small, tribal villages served by a few regional markets. The people survive by tending to their flocks of goats and cows and by growing crops of corn and other staples. They live in small grass and mud *tukuls*, usually arranged in small villages near the floodplains of the tributaries of the Nile. The Dinka are a large tribe living in the Bahr-el-Ghazal region, which is the southwestern part of Sudan. Here, in the dry season, genocide and slave raids take place during regular GOS offensives. The boundary between northern and southern Sudan has another important attribute: it separates the Islamic north from the Christian south. Thus the religious divide and color and cultural differences create a very separate politic, which is a difficult breach to overcome. Yet in this region, Christian Dinka farmers quite often work closely with neighboring Arab Islamic traders, both groups trying to make a living in this very poor region. The weak and economically poor central government of Sudan plays a very small role in administrating the south.

The GOS has attempted for decades to force a national religion, Islam, upon all of its people. Despite many years of war and genocide, it has not succeeded in forcing its will on the south, resulting in the creation of a defense organization, the Sudan People's Liberation Movement (SPLM), and the Sudan People's Liberation Army (SPLA) (sometimes referred to collectively as SPLM/A), which provide the overall defense for the south. The GOS forces have occupied some regional trading centers, Wau, Aweil, and Juba, garrisoning them with troops, but have affected the people little. The government troops remain in isolated compounds whose soldiers cannot foray into the countryside without danger. They are logistically supported from the air and the railroad, which is usually controlled by the government but only runs sporadically. Thus the vast, open spaces populated by small Christian villages are particularly difficult for the GOS to control. The people are for the most part self-subsistent. This sets the stage for the genocide and slavery that the GOS has forced upon its southern people in its attempt to subject them and assimilate them into the Islamic religion of northern Sudan.

Over the years the GOS has conducted major forays into the south, destroying villages, killing men, taking women and children into slavery, and stealing their animals. Raids conducted two, three, four, six, eight, and ten years ago are documented. (These coincide with the years some slaves told me they have

been in servitude. The average is between four to six years of servitude, though one woman told me that she had been in slavery over twelve years.) Some of the local Arabs who worked and traded with the Dinkas were opposed to the continual warfare and raids, which eliminated total villages and enslaved tens of thousands of their friends. When the Dinka chiefs attempted to find their stolen relatives, some friendly Islamic Arabs would seek out the slaves and inform the chiefs of their whereabouts. Then the chiefs would raise the ransom that the northern Arabs asked for, plus a fee for the intermediaries for the costs they incurred. Over time, a monetary standard was established that amounted to the equivalent of $35 per slave for redemption. A new trade was created. Usually the Arab masters would sell the weaker, older, and less able slaves for currency. As this network became more established, it became a source of hard currency for the Arabs and the redemption of slaves grew sizably. Masters now had the ability to raise scarce cash. The friendly Arabs would be the go-betweens, providing the logistics and risking the wrath of the government. Soon the local chiefs could not raise the cash needed to redeem the slaves. So approximately six years ago, local chiefs asked CSI to take over the program to purchase slaves from their masters. When CSI took over the trade, fifteen to twenty slaves were being redeemed at a time. As the network has improved, the number of slaves redeemed in a single five-day period has risen to an average of four thousand. On one single trip CSI actually bought back more than five thousand slaves. CSI conducts secret trips to new locations every two to three months. They have now redeemed more than 42,000 slaves, but the flow of the trade shows no sign of abatement. The trip that I went on brought home 4,119 slaves plus one, when you add the boy who was born on the redemption day. I witnessed the birth.

On the first day we flew six hundred miles into Sudan to a small town, Wonrok, right on the border lying on the north-south road and on the front line. We landed in the evening on a small, dirt airstrip that appeared out of nowhere within a half-mile of putting down. The rough, dirt strip was just long enough to handle the small plane, which was a handful to bring to a stop on the very short runway even though it was piloted by an experienced bush pilot. Upon arrival, the local SPLM commissioner, SPLA commander, and the tribal chiefs greeted us warmly. They had been informed in advance that we were coming and that CSI would redeem slaves on this trip. Our luggage was taken to a *baay,* or an enclosure of matted reeds, which contained several tukuls around an open area. Armed guards with Russian AK-47 automatic weapons taken from the enemy surrounded the area. We pitched our tents and then walked to the center of the village, where there was a ceremonial fire. Unique Dinka chairs, which defy all normal furniture standards for stability and longevity, were brought and greetings and introductions began. Around the meeting place, the massed townspeople stood and watched with avid interest.

The political structure that has arisen from this continued war includes local tribal chiefs, a commander for an area selected by the SPLA, and the regional commissioner selected

by the SPLM, who reports to the rebel civil government and is usually an elder chosen for leadership ability. All three were at this meeting. After the introductions and discussion, music and dancing by villagers commenced. Later a feast of chicken, bread, and fish was brought out to welcome the CSI personnel. The human rights worker, senate staffer Sharon Payt, and I, as outsiders but as guests of CSI, were welcomed warmly too. It was a lovely evening, but in the center of the village stood a covered machine gun captured from the government troops. *It stands there forever reminding us that we are on the front lines, as do the armed guards that are all around us.*

As I had been asked to go on such short notice and was told to be in Zurich at a specific time with few other instructions, I did not realize that I should take a bed roll, mattress pad, food, and a tent. Fortunately, the human rights worker invited me to share a tent, but I had to sleep on the floor with only a thin cloth over me. The day was very hot, but in the evening the temperature dropped into the low forties. So I covered myself with my jacket and the thin cloth and used my photographer's vest for a pillow. The ground was as hard as concrete. I was very uncomfortable and it took some time to drop off into a fitful sleep.

We awakened early the next morning to take the plane to the first redemption site. We had to take off very early so the GOS planes would not spot our plane and bomb it. After a breakfast of tea, we were escorted to the plane and in a cloud of dust and with a highly revved engine, we took off for a forty-five-minute flight to a new dusty, rough airstrip. As before, we unloaded and then were taken to a compound where we pitched our tents and prepared ourselves for the first redemption of slaves.

We walked for a ways and soon saw a great number of somber women and children sitting under a huge tree. In all, there were 292 people. To the side, a number of Arabs were waiting, clothed in white robes with white face coverings to prevent being recognized in photographs, which would enable GOS leaders to identify them for retaliation. The slaves had been waiting, some for two months and some just arriving a few days before. They lived in the open, protected at night from the elements and the mosquitoes only by a cloth held up with sticks. Their only food was gruel made up of corn ground into a fine mush and water. Many slaves showed signs of malnutrition over an extended period.

I spoke to some of the women and children through an interpreter. Without exception, the younger women told the story of a raid destroying a whole village by fire, the killing of the men, and being captured along with the children. They told me about soldiers in fatigues coming in trucks and Arabs with white robes and horses conducting the raid, killing and burning. The people and animals were then herded into a march to the north. On the way the women were gang-raped. Then a master took them to a home. Here the story varied. Some women became concubines, some became servants in the house, some worked in the fields, but all were sexually abused on a regular basis. Young girls as young as six spoke of rape. In this group the average time of enslavement was four years. Some women had large, protruding scars that had been

inflicted by their captors, who used iron rods, knives, and fire, usually because of resistance to sex. Some women told us about genital mutilation, though I did not witness it. Many of the women had Arab children and/or were pregnant by their masters. Some of the women could not identify the father because they had suffered multiple rapes. Some gave the name of their masters. In this group eleven had died en route to the redemption site.

Young boys were used as herdsmen and for sex, and as they grew older, they were inducted into the army, while the younger ones were used for security purposes. Most of the boys were given instruction in the Koran and some wore the traditional caps worn by Islamic people. A fourteen-year-old boy told me about the raid and his capture six years before, which included his father's herd of thirty goats. His cousin was also captured with a herd of twenty goats, but he lost one and was killed on the spot. The cousin's herd was added to his own, and the boy was told that if he lost one, he would be killed too. He proudly told us that in six years, he did not lose one goat. Since his whole village had been obliterated (the ruins of the tukuls were covered with brush and trees that had taken over the area of the former village), when he was freed, he did not know anybody. When asked where he would go, he replied that he would go to the local chief for help.

At some point the CSI leader explained to the slaves that they were being purchased to be freed. After some documenting and assuring that the roster was accurate, they were fingerprinted, photographed, and released. Throughout the process of verifying the numbers and the roster, the murmur of the crowd became more and more animated. Smiles started to appear. Families who had lost wives and children waited in the brush as the process continued. As family members spotted each other, recognition and joy would come. It was lovely. Finally the process was over, and the CSI leader sat down with the intermediaries and counted out the piles of money, $35 multiplied by 1,500 (the value of local currency to the dollar) by the number of slaves redeemed. Right after the transaction, the leader stood up and told the crowd, "You are free to go." Immediately a roar went up, the freed people surrounding the CSI personnel, and then some rushing to their families, some going slowly, as if there were some question of their acceptance in the community. Others drifted quietly into the underbrush, returning to their villages. Some would walk for days and weeks to find their relatives. It was a heartrending time for my colleagues and me. Later, I learned that all would be received warmly into their communities and that the Arab children would be accepted as Dinka family members. Pregnant women would be received by their husbands. Many would ask that I take a picture of them. Most of them had never seen a white man.

The next group of slaves was nearby and consisted of 322 women and children. The stories were the same, as was the procedure. The intermediaries were different. This was *Schindler's List* revisited. It was easy to dislike the white-robed Arabs as they were conducting the transaction, but as they said later at a meeting, "Yes, we do it for money, but the money could not pay us for the danger we are incurring. These are our friends and we

do not agree with slavery and genocide." Without exception we were told of the Arab intermediaries' kindness in the redemption process, as the slaves were treated well, some even receiving medical care after being purchased from their masters. We also heard stories about some "kind" Islamic masters, those who, even though they expected sexual favors, otherwise treated the slaves well. Many of the women slaves were redeemed because of a jealous Islamic wife's intervention.

In this dusty, remote, and beautiful land, for a moment the redeemed slaves realize one moment of absolute freedom. Others are not so fortunate.

The return to the compound brings somber reflection about what we have witnessed. Is it real? Can it be like this? The thoughts race through our minds with stunning power. The Dinka people are simple people with old values. Here truth is a basic value between people. Too many historical facts would have to be arranged by these simple people to create stories that were not real.

With a dawning, it comes. This is real. Slavery and cruelty do exist just as they did in America 150 years ago. How can this happen in our modern society? How can the world powers accept slavery, declared a world crime by the United Nations? How do the churches rationalize the morality of the situation? Don't all of the world's organizations understand what they are being told? *If they know, then aren't they part of the crime?* Here, where the roots of American slavery started, the cruel attempt to assimilate the Dinka people into the Islamic religion is apparent for all the world to witness. Here genocide and slavery are revealed with all their horrific attributes and appendages. *Here human life is valued at $35.*

We eat a visitor's feast of goat stew with bread and water for dinner. The villagers eat a gruel with touches of green and meat. The star-studded sky is peaceful, and a little later, the brilliant moon lights up the compound as though it is day. Finally, the quiet of the evening lulls us to sleep on the hard earth. We are awakened by the sound of a donkey braying and roosters crowing before dawn. Dawn rises with the red sun appearing through the acacia trees. *For yesterday's redeemed slaves it is a new day.*

SLAVERY, AN ANGEL, AND THE CHURCH

Today we pack our tent and wait for Heather Stewart and her Trackmark Cessna to pick us up to take us to the next town. Her story is quite unique. A grandmother with five children, she owns Trackmark flying relief service and a rest camp in a nearby Kenyan border town. When the southern Sudanese people were starving some years ago, the United Nations and other NGOs

utilized her services to ferry goods and people into southern Sudan. At that time, Heather owned a fleet of fourteen planes and employed twenty-two pilots. Trackmark also ferried the CSI personnel in and out of southern Sudan to redeem slaves. As Sudan denied the slave trade and the United Nations accepted this story, CSI personnel were considered non grata by the United Nations, UNICEF, and European Common Market countries. They were considered alarmists and meddlers who did not meet different political criteria of various nations in addressing problems in the region. Though the reasons why are open to interpretation, Heather lost the United Nations contract for supporting CSI. Other NGOs pulled out of southern Sudan, and the United Nations contract was awarded to a South African company. The United Nations still calls on Heather when someone is seriously ill and needs hospital care or when a dangerous run over the border for an emergency relief effort is needed, but now her business has been reduced to one plane and herself as the pilot. The GOS continually bombs the southern Sudanese airstrips and has attempted to prevent this logistical pipeline from flowing, so her work is risky, but Heather is a legend to those chiefs and commissioners in southern Sudan whose tribes depend on her for logistical support and medicine. Her primary account now is CSI, and the mission is both secret and dangerous. Without her logistical capability, the redemption of slaves would not be as great.

With a whoosh and a cloud of dust, the Trackmark plane taxis to a halt near our compound and a beaming Heather greets us. *She is a flying angel.* Today we go to a more central village.

Upon our arrival, we are greeted and taken to a compound where we do the usual setting up. We then go by truck to a distant location where two new groups of slaves wait with new intermediaries. The same procedure takes place and two groups, amounting to 680 slaves, are redeemed. It is an extremely hot, dry day, but the experience with the slaves and their trials keeps our attention riveted. We visit a dusty market and the school, and the children sing a song for us. *It is the universal joy of man to see happy laughing children, and so it should always be. I think of those children still in slavery and it makes me weep.*

The following morning Heather returns with a plane full of medicine for the local hospital, diesel fuel for the few trucks, and miscellaneous supplies for the tribes. We then take off for another short and dusty runway and a new village with eight hundred slaves. After our return to the compound from the slave redemption, we sit and rest in the unique Dinka chairs. The Anglican/Episcopalian Bishop of Wau, Henry Chuir Riak, enters the compound with a priest. After greetings and some discussion, I ask why the church is not a more visible critic of the slave trade taking place in his diocese. I am met with the statement from the bishop that *there is some slavery in his diocese, but it is not the central church politic to broach the matter.* After some more discussion about his incarceration by the GOS, from which he was released only a year before, I repeat the question, informing him that I am an Episcopalian. Now he acknowledges that genocide and slavery are widespread in his diocese, perpetrated by the northern Islamic people on his flock. The bishop adds that the number of Christians is increasing due to the war. He thanks the

leaders of CSI profusely for redeeming his people, and he invites us to have breakfast with him the next day. The next morning we go to his compound where he greets us, and CSI staff ask to do a recorded interview, to which he agrees. The Bishop acknowledges the widespread slavery and renounces those people responsible for it. It is a powerful statement from an important local religious leader against slavery and genocide. He then asks us to go to his church where he will be confirming children and adults in his congregation. The church is packed with seven to eight hundred singing and joyful people. It moves me greatly.

MORE REDEMPTIONS AND HORROR

The next morning we fly to an airstrip that Heather had never flown to before. Our GPS radio tells us that the airstrip is very close, within a mile. We look down and see a very narrow dog-leg to the right. It is inconceivable that we will land on that strip, especially since Heather does not know the quality of the surface. Yet down we go, making a pass over the runway and then making a rough and scary landing. At the last moment the landing strip straightens out and we come to a sharp-braked stop just at the end of the dusty strip. As usual friends are there to meet us, as well as the chiefs, and they take us to a nearby compound near a river. It is extremely hot, and we sit under a beautiful tree near the water. Here it is hard to remember the horror of the mission that we are all on. It is so tranquil, with colorful birds noisily welcoming our presence. After some tea and snacks, we walk two miles to the redemption site. After walking through the tent village, we see the large group waiting for us under a large tree. The Arab intermediaries are nearby.

Two stories slaves told me stick out sharply in my memory. One came from a beautiful young woman who had a remarkable scar around three-quarters of her neck, two to three inches high, protruding about three-quarters of an inch. We asked her how she received the scar, and she quietly told us that her throat was cut. She was twenty-two and was captured six years before. While resisting her captor's advances, her throat was cut and the cut extended down to her breast. We asked how she survived the wound, but she could not answer how. The answer was simple: many did not. Each additional question elicited more answers, one more horrific then the other. She did not offer answers but quietly answered each question that was asked of her evenly, without emotion. She was taken as a concubine when she recovered from her wound, and in her master's house she slept on the veranda. Many times the master would come in the middle of the night to visit her. Because she had been seriously wounded for resisting sexual advances, she dared not reject him. Her master called her by a generic name like "she," ignoring that she had a

given name for the duration of her captivity. Finally the wife of the master had her ejected and she was sold to the redeemers.

Another memorable story came from a boy who was captured in a raid when he was eight. While walking to the masters' homes, his sister could not walk further and collapsed. The Arabs cut her head off. They told the young boy to carry the head, and he carried it for five days. At this point the head was decomposing and was so putrid that the captors told him to burn it. In Dinka tradition, burning any human body part is taboo. An older woman nearby raised her hands and voice in protest, and she was severely beaten. Then the captors put a gun to the head of the boy, and he burned the head. That was six years before, and the memory was evidently as fresh as if it had happened just that day.

I heard so many stories like this one. A girl resisting rape had her hand placed into a bed of hot coals, burning off her fingers. Then five captors each had his way with her. Another very pretty girl had her captors get into a fight over her. Each wanted her for his wife. After a severe fight they stopped, determining that she was the cause. They placed hot knifepoints to her chest and burnt it severely. It was one episode after another. The cruelty of the northern Muslims on the Christian Dinkas, whom they consider *unclean and inferior,* is uniquely sadistic. On this day 707 slaves were redeemed.

As we walked the two miles back on the dusty and hot path, we passed two more groups of slaves waiting to be freed. Some of the already freed slaves walked with us, telling the remaining groups that they would be freed. There was

pandemonium. The retrievers had difficulty maintaining order so that a correct accounting could be made on the morrow. When we got back to the compound, I used the extra time to visit the market, a hospital, and the river. After a meal of goat stew and bread, we lay down for a fitful sleep. Africa is so beautiful, yet it can be so cruel.

On the last day of the redemptions for this trip, an early foray into the countryside revealed wonderful villages of friendly people, all wanting to be photographed, striking serious, severe poses. I loved it. The emotions of the last few days were the most extreme that I have ever had. They have etched and seared me forever.

Today two large groups amounting to 1,318 Dinkas were redeemed. One difference in the day was that when we arrived, the groups knew that they were to be freed and the sullenness encountered in earlier groups was absent. They were more interested in the process and us as white people. The boys were mischievous and the girls smiled more. The huge pile of money that was used to redeem this large group was spread over a large cloth and was six inches high. I noticed in this wetter region, malaria was a common sickness. This group had traveled for up to four weeks to get to this camp, and there was more serious illness here than in previous camps.

At the end of the day, I added up the number of slaves that had been purchased on our trip, and it amounted to 4,119 people of the Dinka tribe, with one newborn boy. In all, CSI has redeemed 42,537 slaves. The Sudanese government and the

United Nations, United States, and European Union personnel and leaders, along with the church leadership, think that the slave trade is random, small, and a local problem. They do not understand the scope of the genocide and slavery in the Sudan. They do not wish to confront these terrible world crimes. *They have become part of the problem.*

Genocide and Slavery—Epilogue

Christmas 2000

As I sit here on the eve of Christmas, writing this account of my experiences earlier this month, I cannot help but reflect on the condition of this earth we live on and my own little role in it. The beauty of where we live wafts about me like a lovely breeze. The smells and sounds of Christmas make me think of the deep and satisfying traditions that my parents gave to me. I am looking forward to this evening when my daughter and her husband will come to share Christmas with us. The same traditions and warm thoughts are found in the Dinka people in the heart of Africa. There is little difference between us except distance and economic circumstances. Yet today they are facing decimation because of extreme religious and political zeal and a continuing global warming, which is creating a desert where they live. *What can be their future? What is mine? How are they intertwined?*

The morning after the last redemption, we had to leave early to escape detection by the GOS planes. We flew to Lokichoggio, the Kenyan border town where we were to refuel and proceed to Nairobi for departure to Zurich, and then home to Santa Fe. When we arrived at the border town in the afternoon, there was an urgent radio message from a doctor in Sudan regarding a patient who was having a problem giving birth and needed to be hospitalized. Heather turned to us: either we go to Nairobi as planned or she flies the other way to save a life. The patient won and we stayed over in Lokichoggio an extra night, rising early to catch our plane. This epitomizes the kind of help people give because it is the humane thing to do.

Yet in this remote land, a horror exists that is exceptional in this world. The religious differences between Islam and Christianity have magnified a genocide that history will regard as one of the worst ever recorded. The holocausts of Russia and Germany, followed by Uganda, Angola, Rwanda, Cambodia, and so many more, need to be reexamined so that we can place them into our value structure of what is acceptable and unacceptable in the world. We need to set minimum standards of behavior in our societies and then enforce them evenly. While genocide and slavery have been declared world crimes by the

United Nations, the world's leaders have selectively chosen *which* genocides to address. Politics have played a role in these decisions, clouding what is really happening. Since World War II, addressing this problem has been neither just nor correct. As a world community we have let the people of southern Sudan down, specifically the Dinka and the Nuer people, as we did the Tutsis in the 1994 Rwandan genocide. The world community needs to address this global oversight. The religious denominations of the world should also address the atrocities as they *should* be the moral guide for our human condition. This has gone on too long. The Sudanese cry out for help, and people of goodwill throughout the world must respond.

About two weeks after I was there, Marial Bai, a village where we redeemed slaves and met with the Anglican Bishop of Wau, was attacked and destroyed. After some killing, more than one hundred women and children were taken. The bishop was evacuated by the United Nations on January 3rd. Five Dinka men followed the northward-bound column, attempting to recover their wives and children. They were discovered, their arms were cut off at the shoulders, and they were left to die. Three men did die from the loss of blood, but two survived. They were airlifted by CSI to Nairobi, where to the best of my knowledge they are recovering. *Maybe it was in retribution for our visit.* The cruelty and the genocide do not stop.

▲ Young slave boy waiting to be redeemed in Aweng.

Aerial of the River Lol and adjacent village–SUDAN. ►

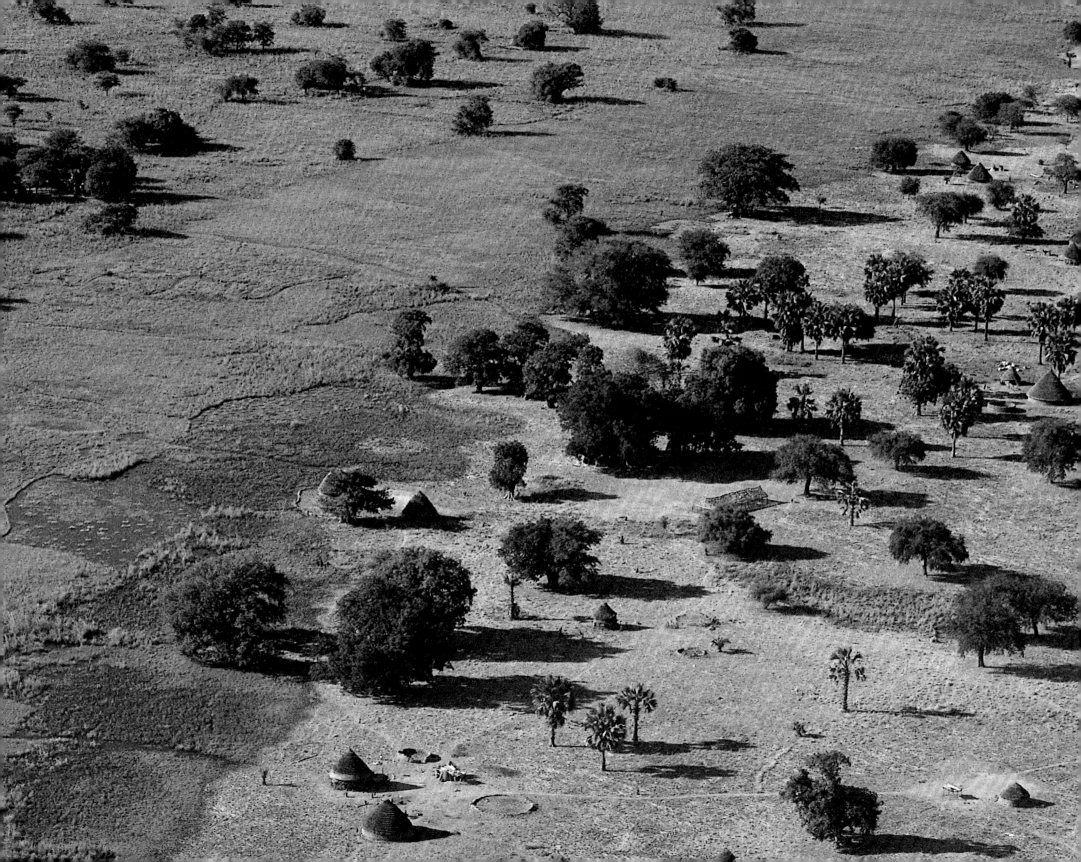

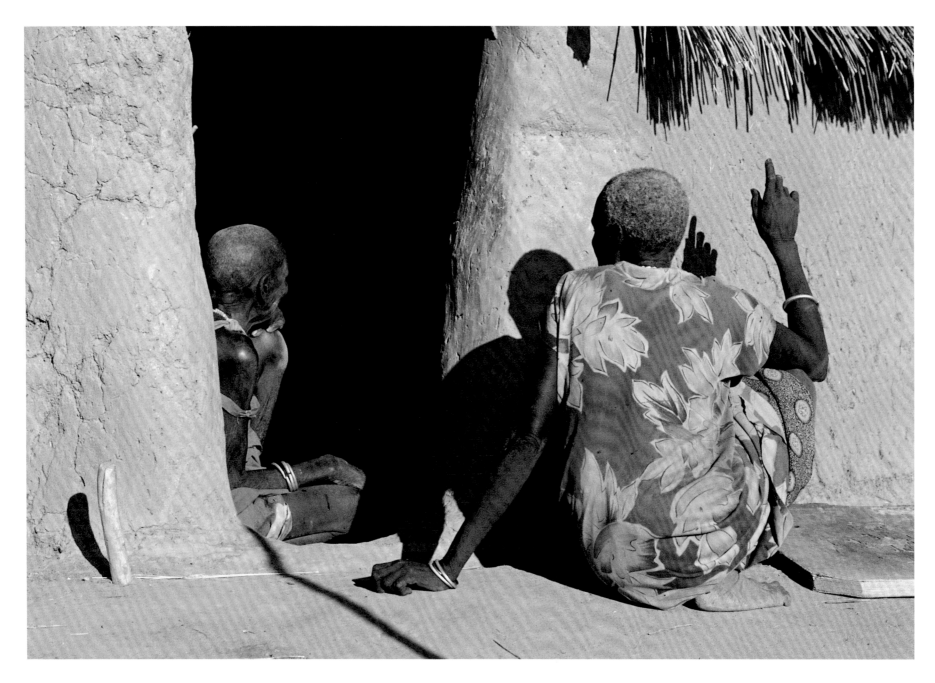

Elderly women visiting in the evening–WONROK.

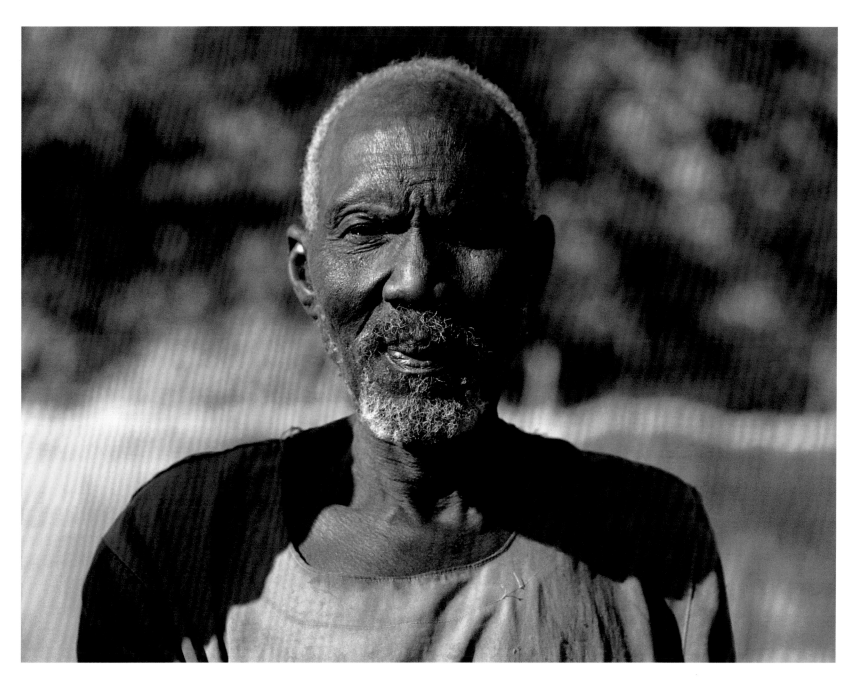

Village elder in Wedweil, SUDAN.

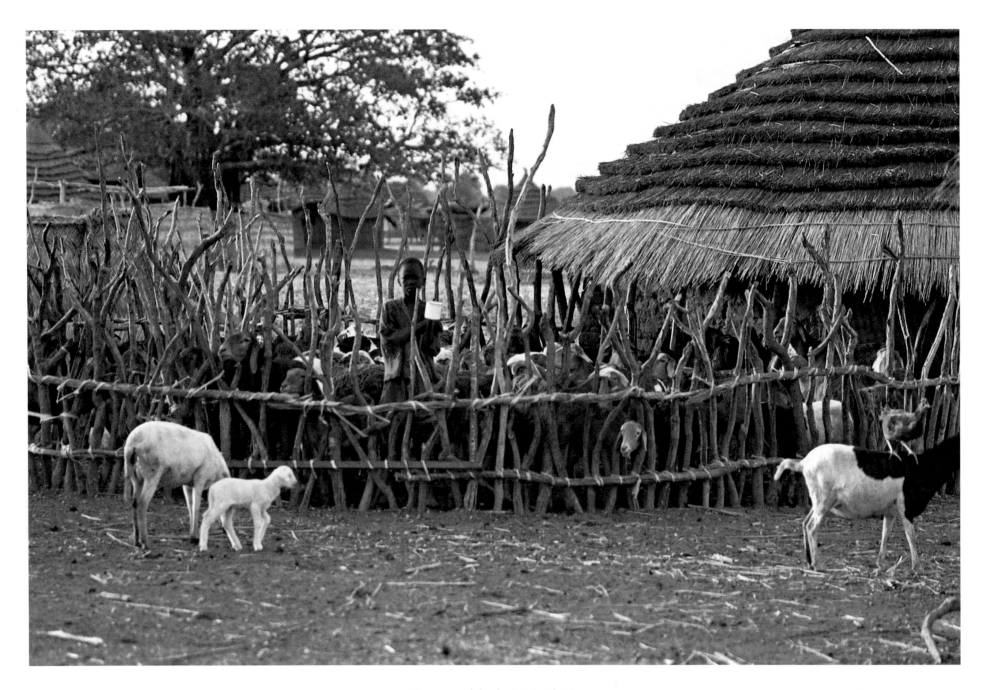

Goat pen with herder in Marial Bai.

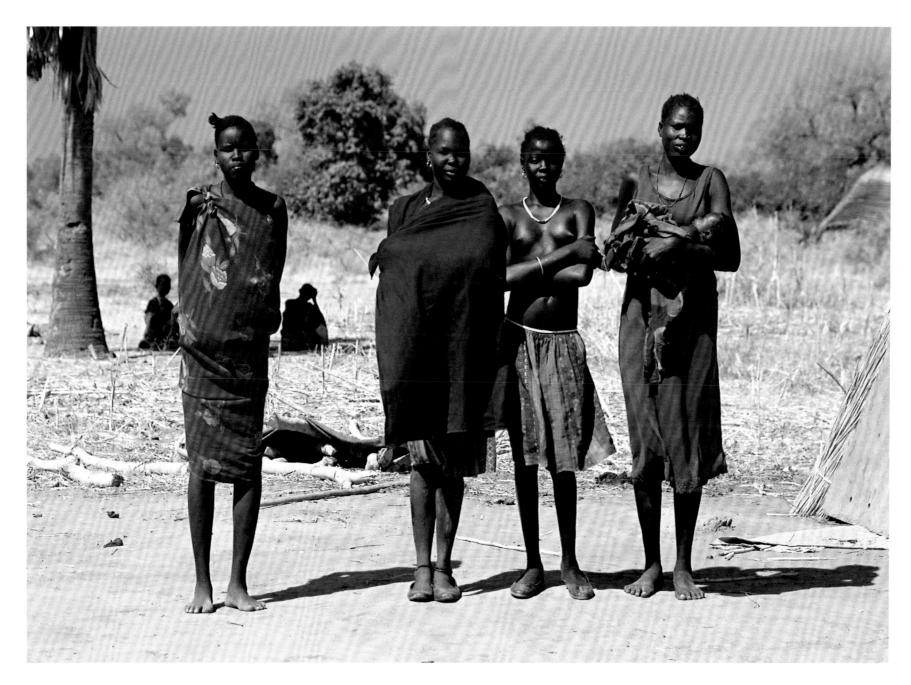

Four Dinka women in Marial Bai–SUDAN.

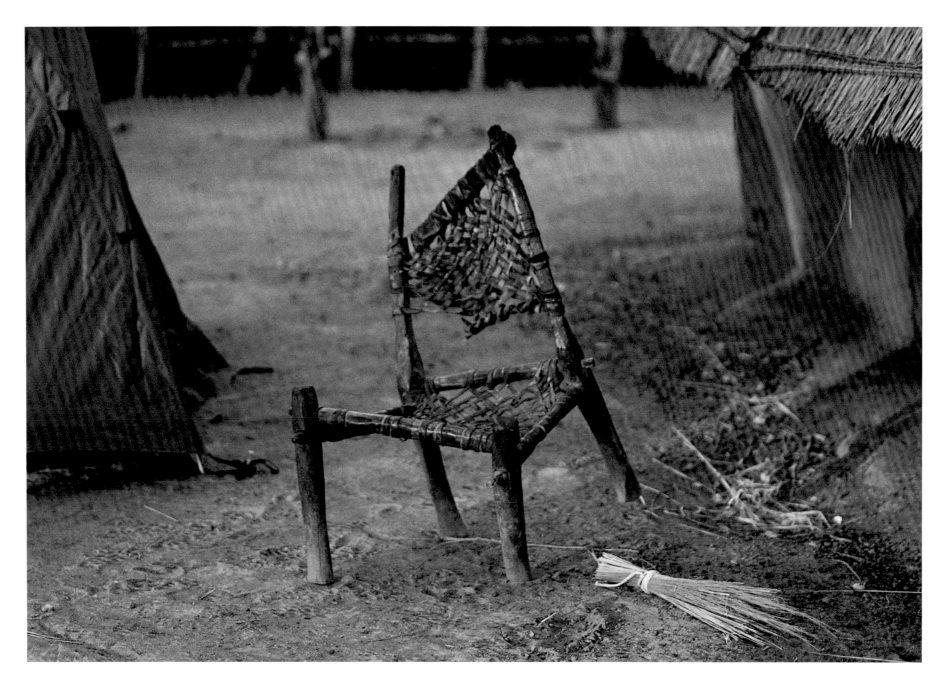

A famous Dinka chair. It works!—WONROK.

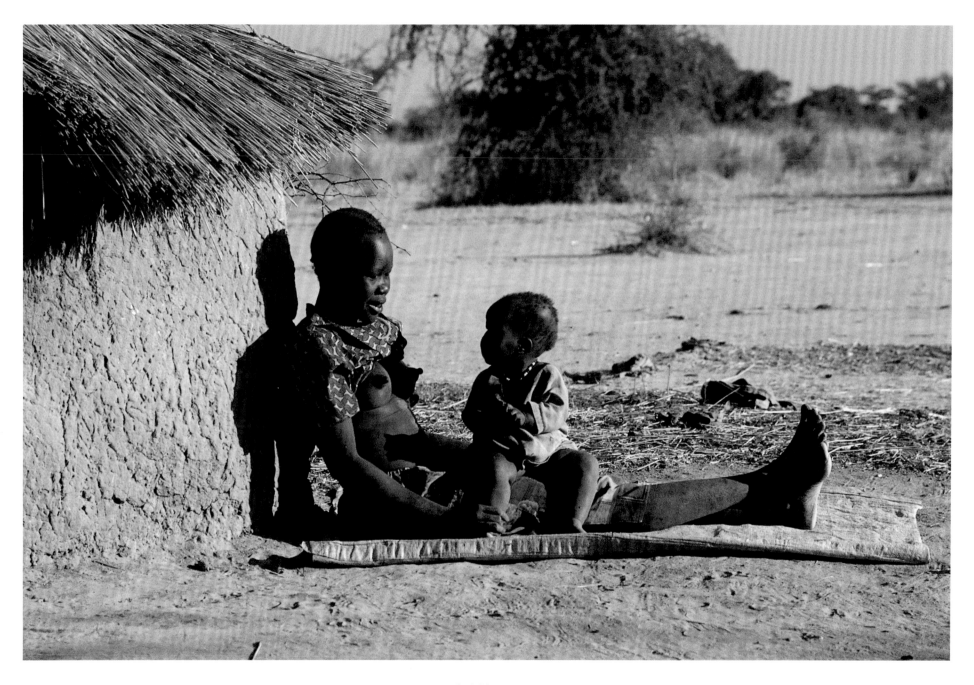

Woman with child–WONROK, SUDAN.

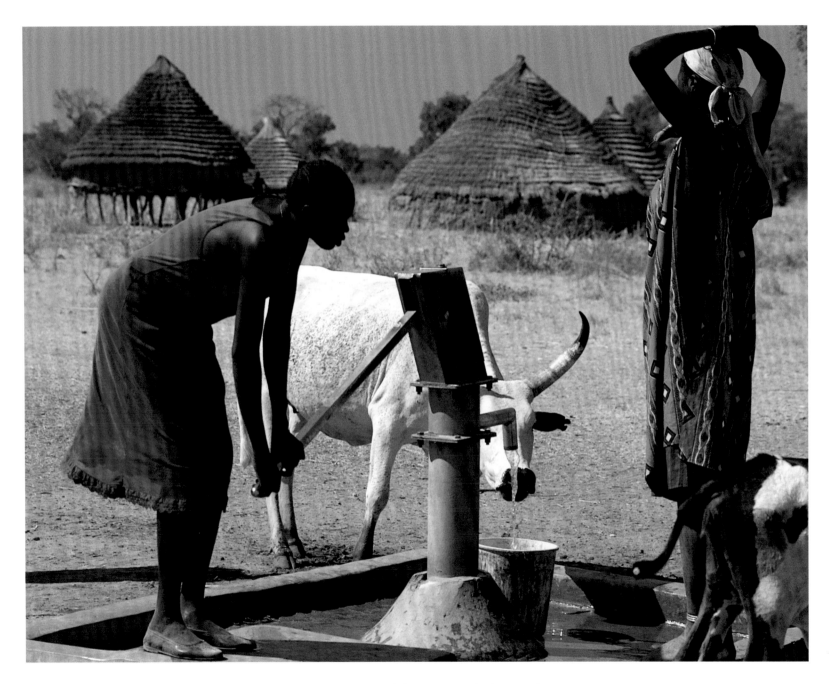

Women pumping water while a cow gets a drink in Maiol–SUDAN.

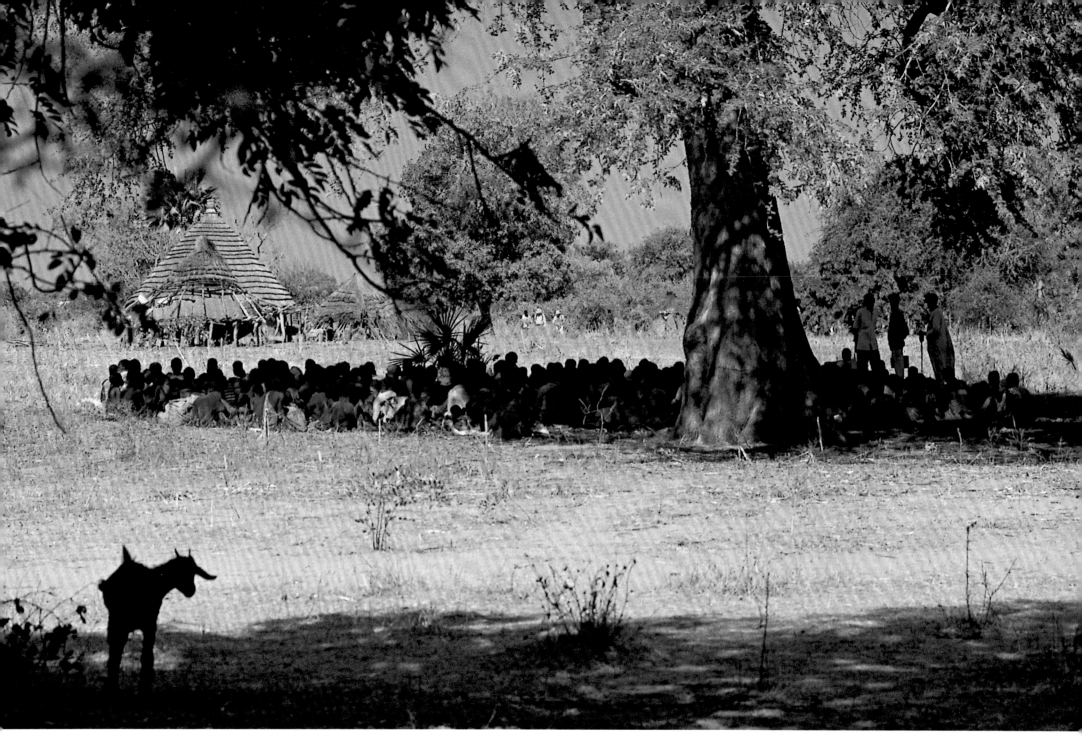

A gathering of slaves waiting to be redeemed for $35 each–SUDAN.

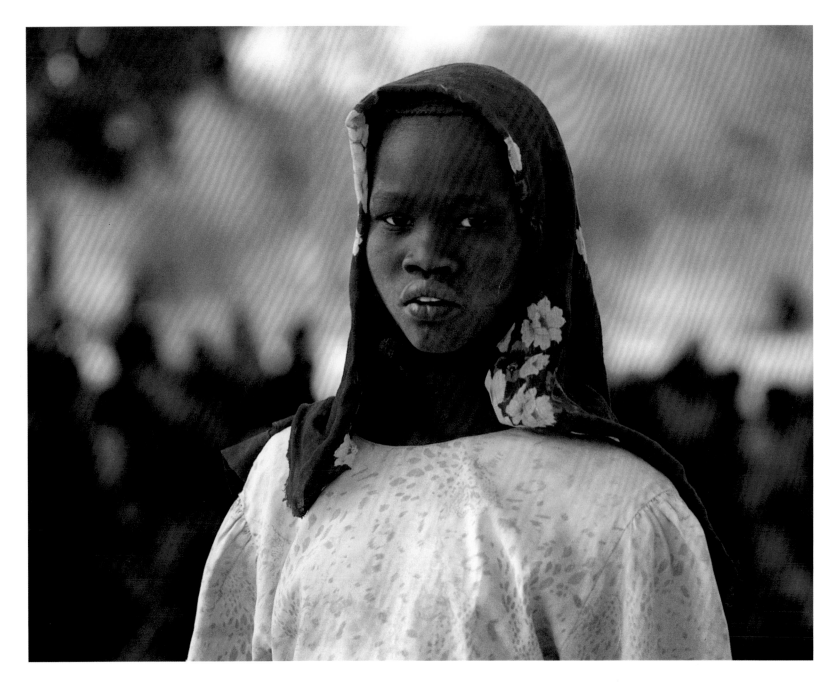

Young slave girl with shawl waiting to be redeemed—AWENG.

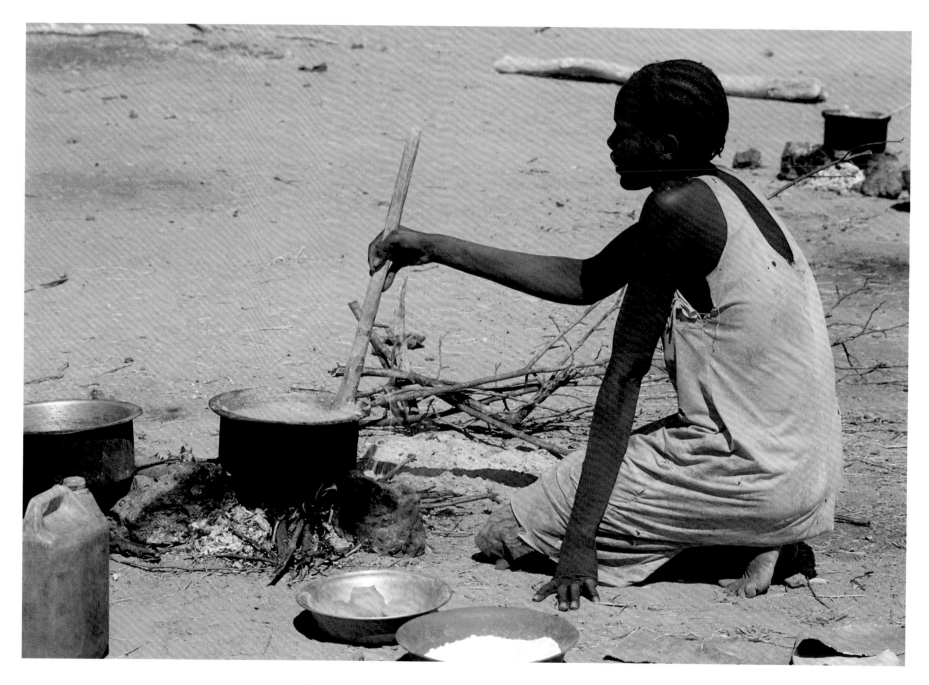

Slave woman waiting to be redeemed cooking for the camp–MARIAL BAÏ.

A tent in the slave camp where mosquitoes and malaria were a major factor–SUDAN.

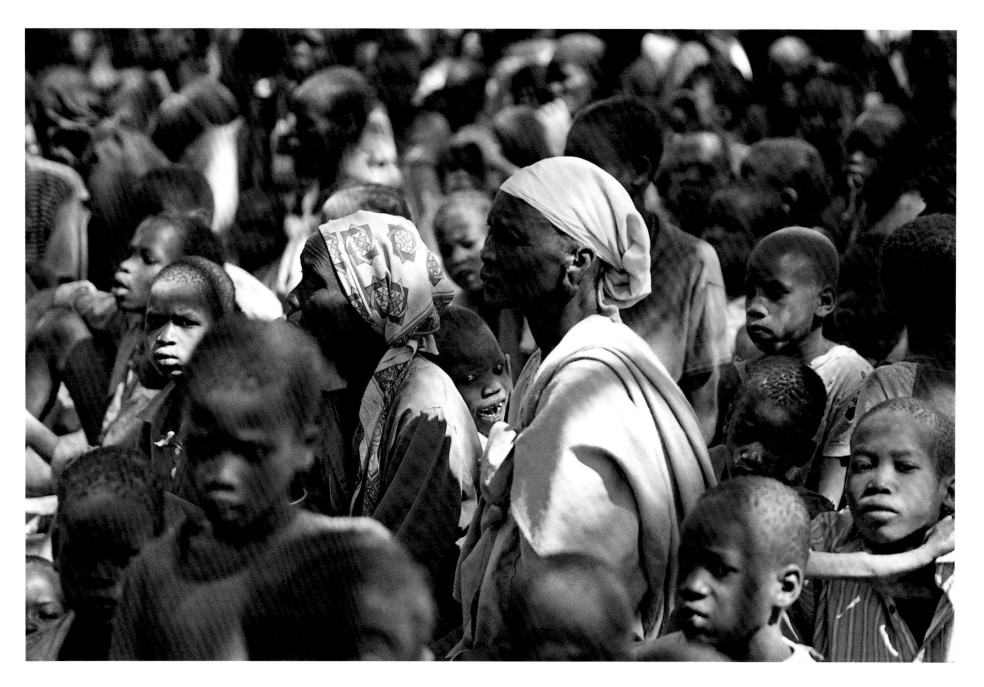

Woman in crowd waiting for redemption–AWENG.

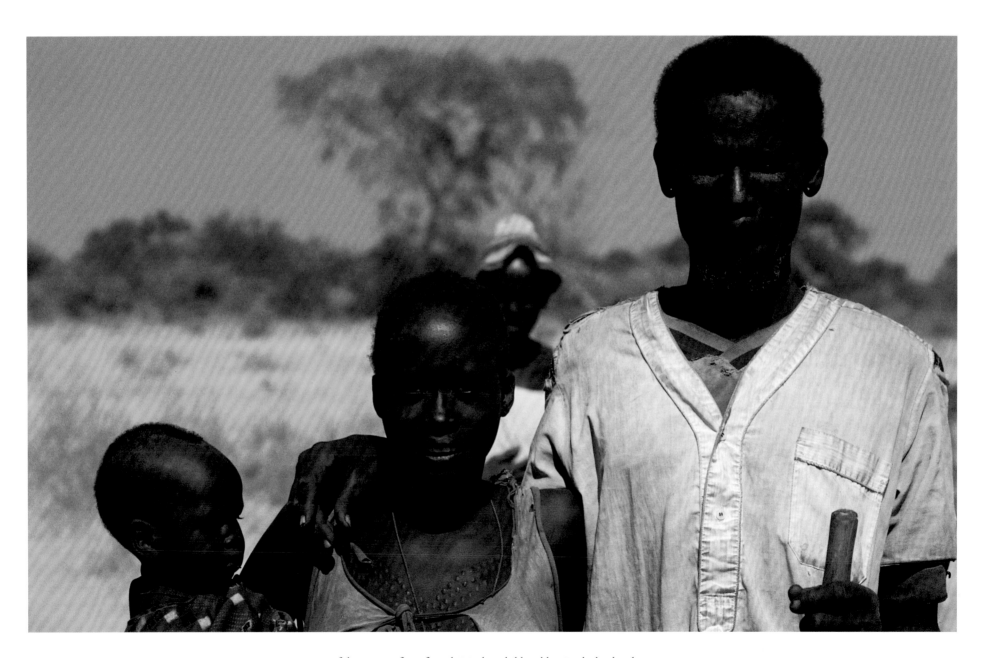

A tearful reunion of a wife with Muslim child and her Dinka husband–SUDAN.

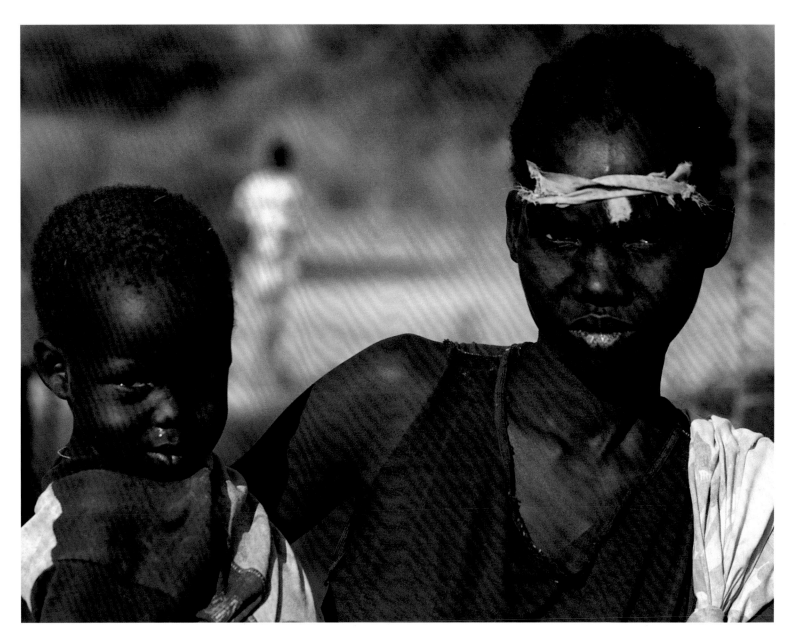

Slave mother and child waiting to be redeemed for $35 each, also the price of a goat–SUDAN.

Muslim husband waiting for his Dinka wife—AWENG, SUDAN.

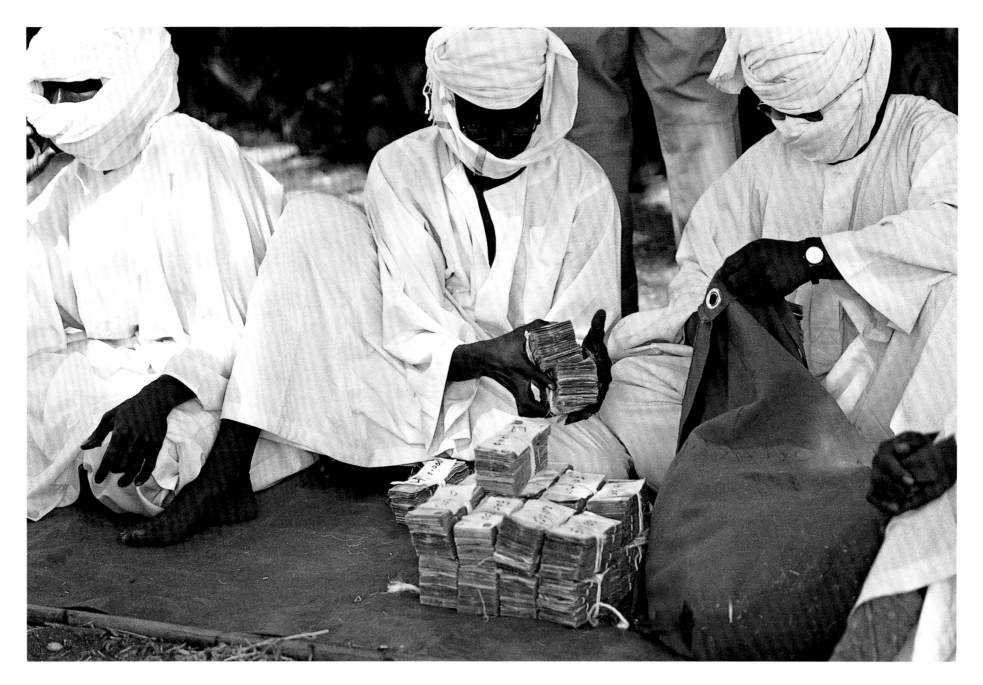

Muslim intermediaries counting money for slave exchange–SUDAN.

A Dinka slave woman in Aweng.

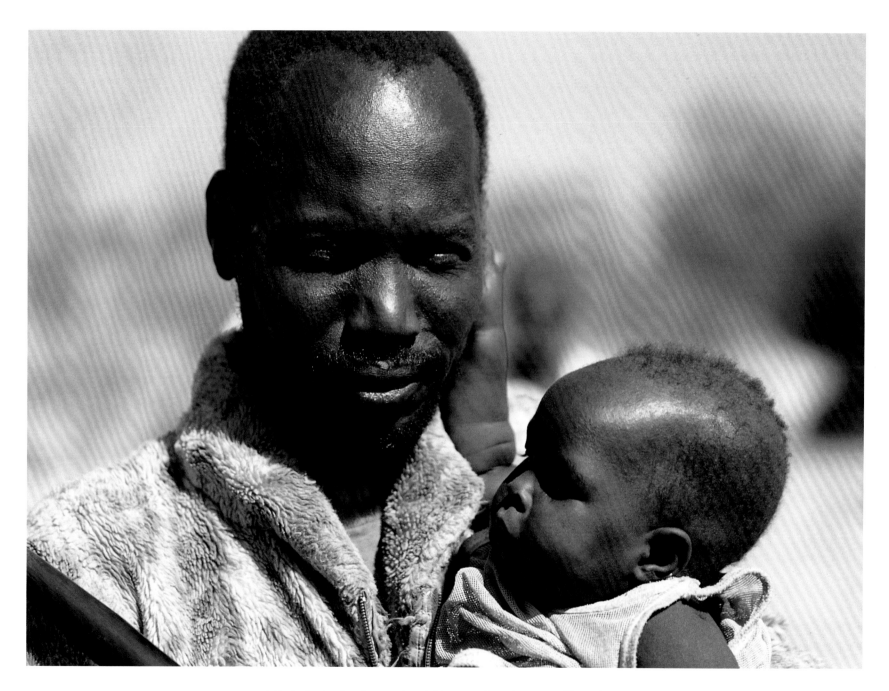

A Dinka husband with a Muslim child waiting for redemption of his wife–SUDAN.

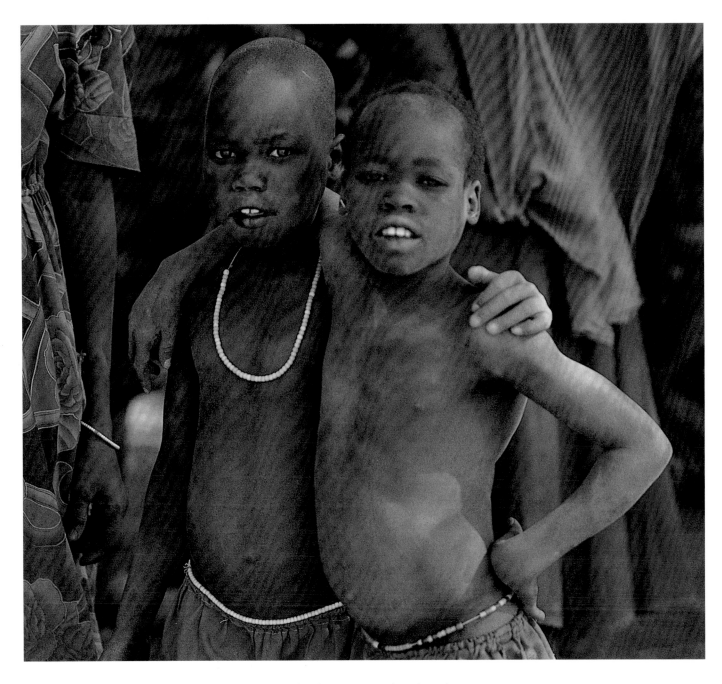

Two young slave boys waiting to be redeemed–SUDAN.

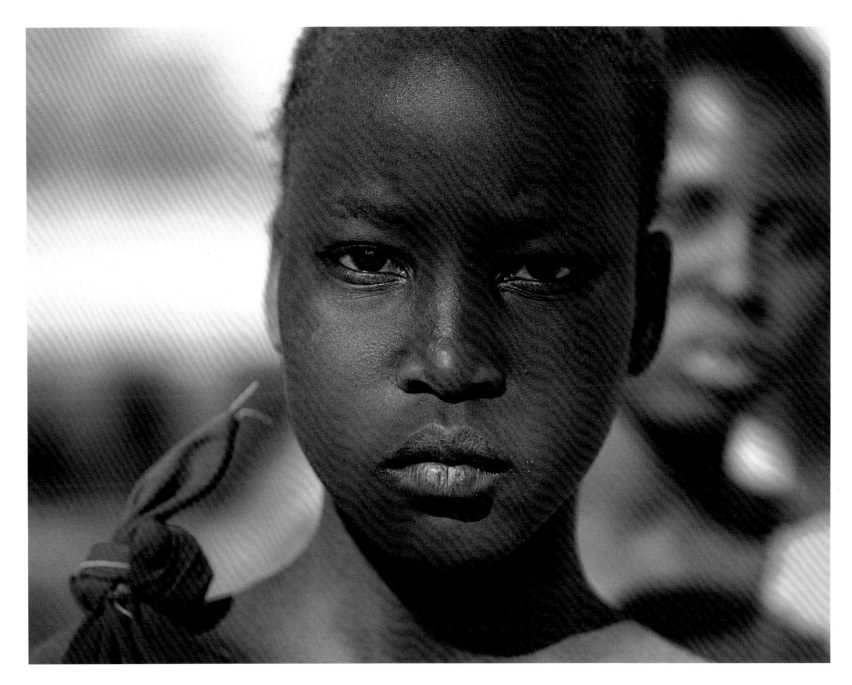

A close-up of a young slave girl waiting to be redeemed—WEDWEIL.

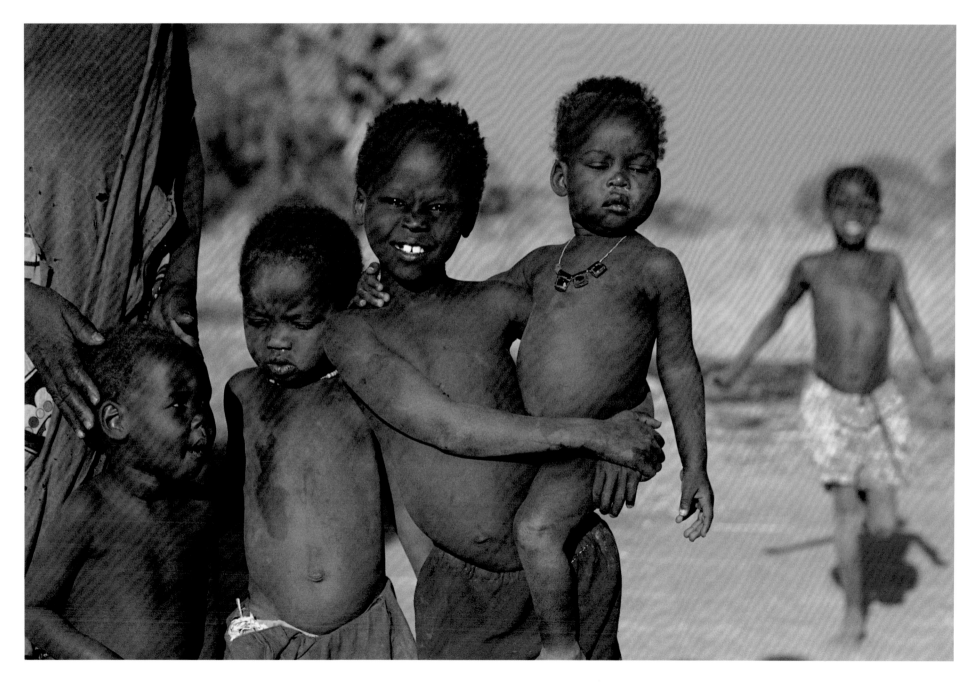

Five slave children waiting for redemption in Marial Bai.

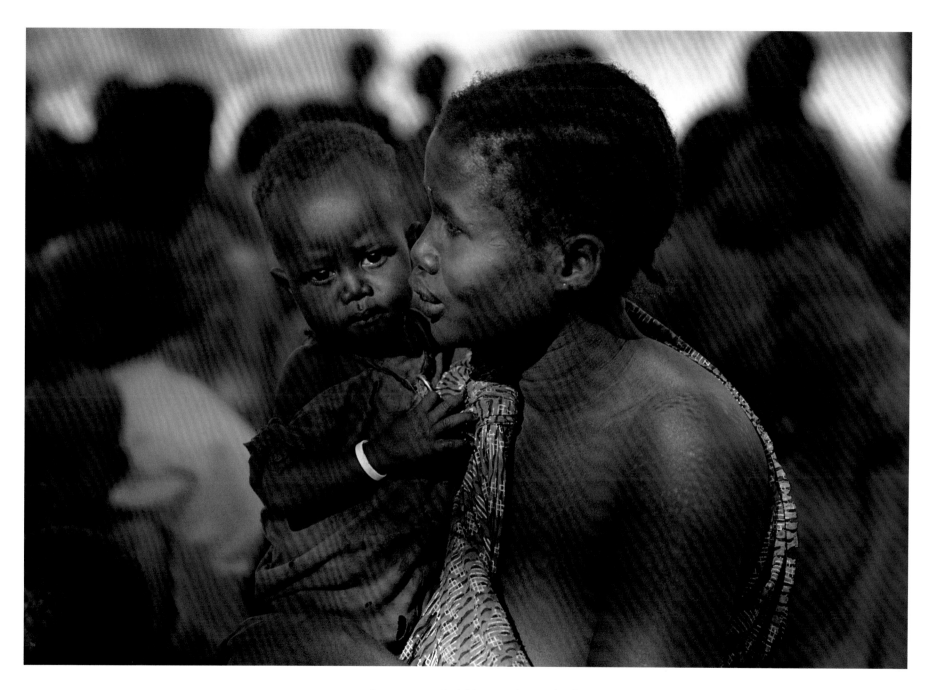

Slave woman with child in crowd in Wedweil.

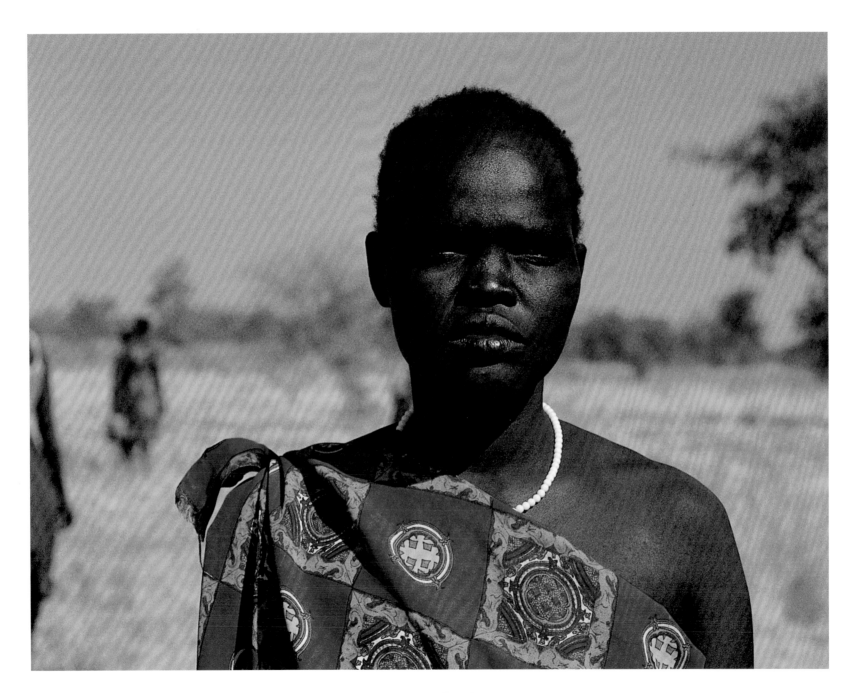

Young slave woman waiting for redemption–AWENG.

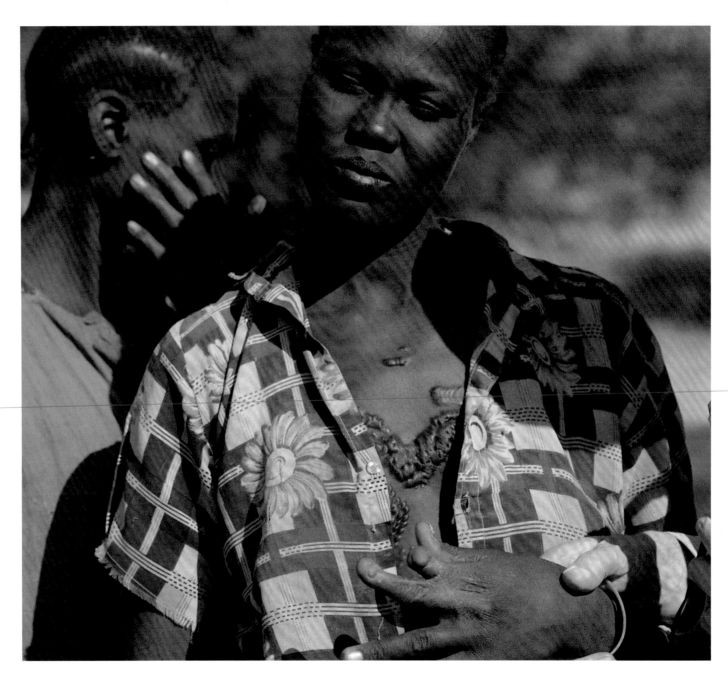

Woman with scars and burnt fingers acquired while resisting rape–SUDAN.

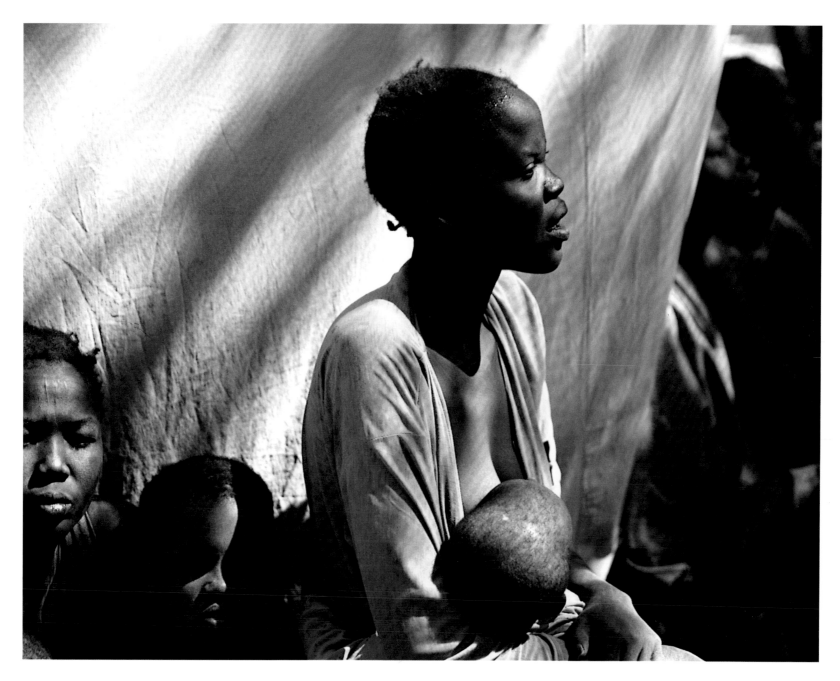

Woman feeding child before redemption–AWENG.

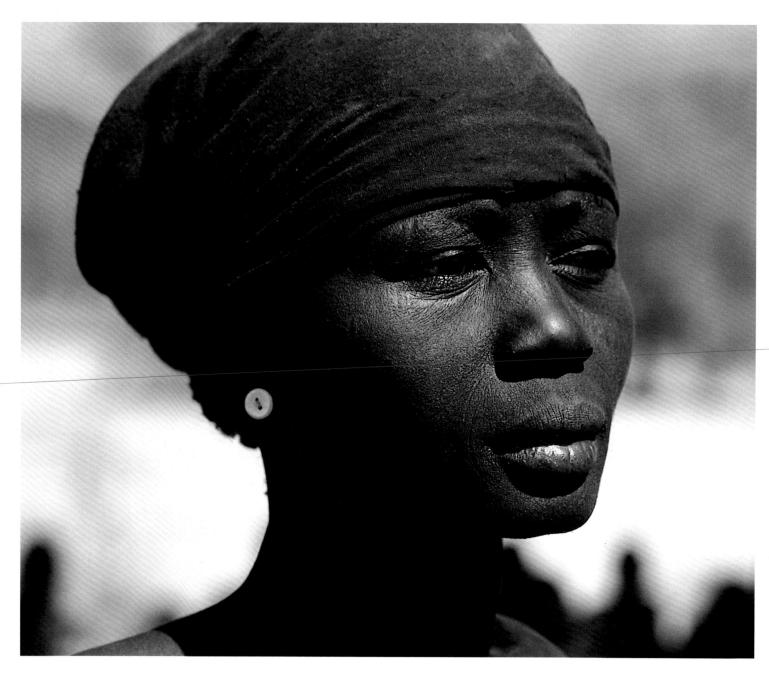

Woman who has been a slave for six years shows the impact of the Muslim strictures–SUDAN.

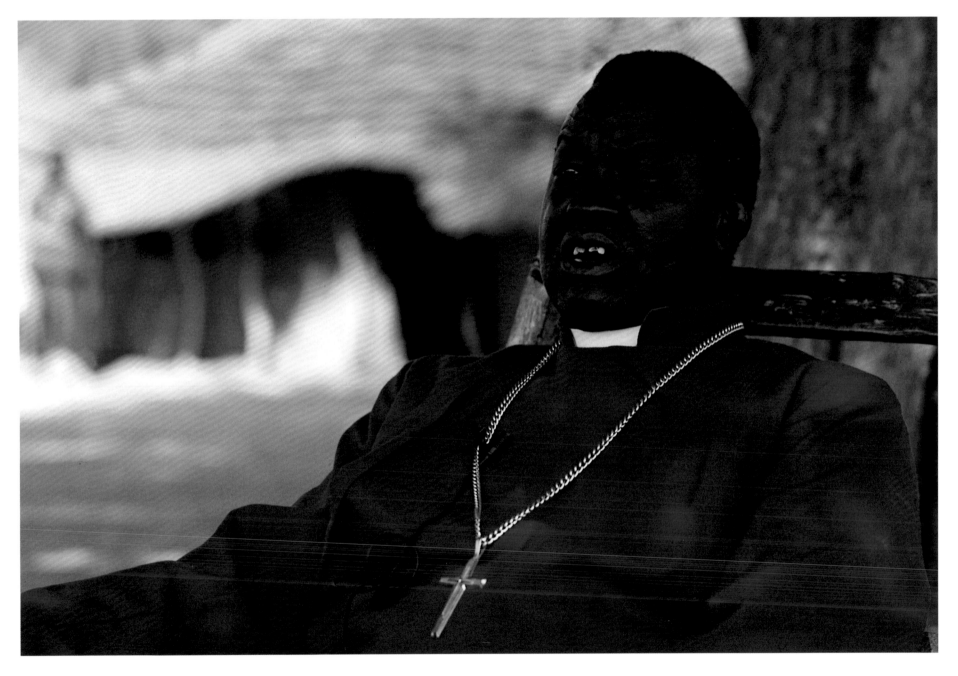

Bishop of Wau, Henry Chuir Ruik, in Marial Bai.

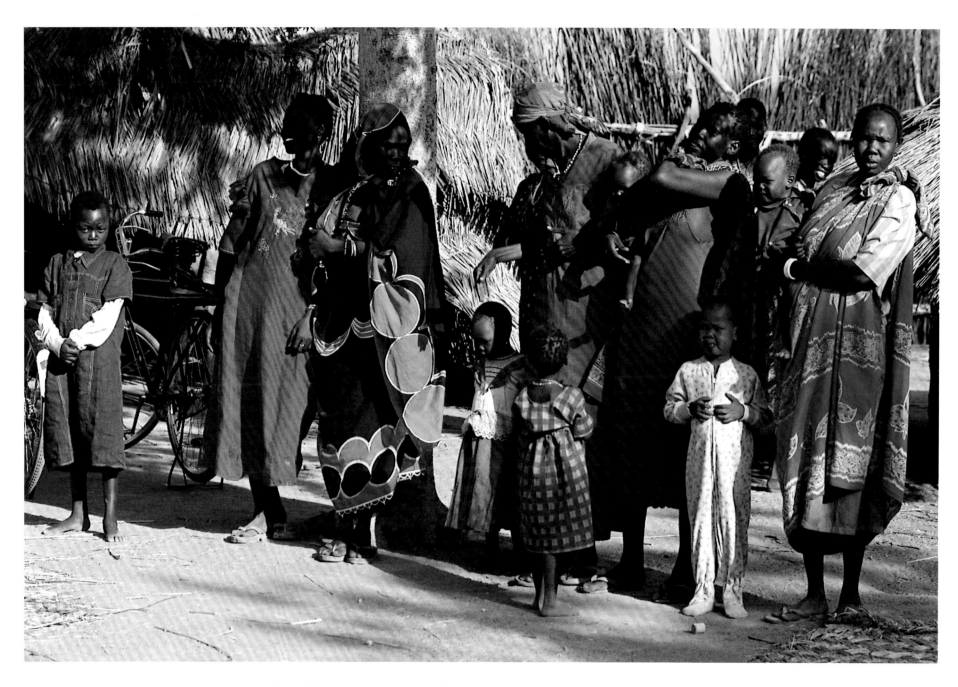

Redeemed slaves who were interviewed by Susan Rice, Assistant Secretary of State—MARIAL BAI.

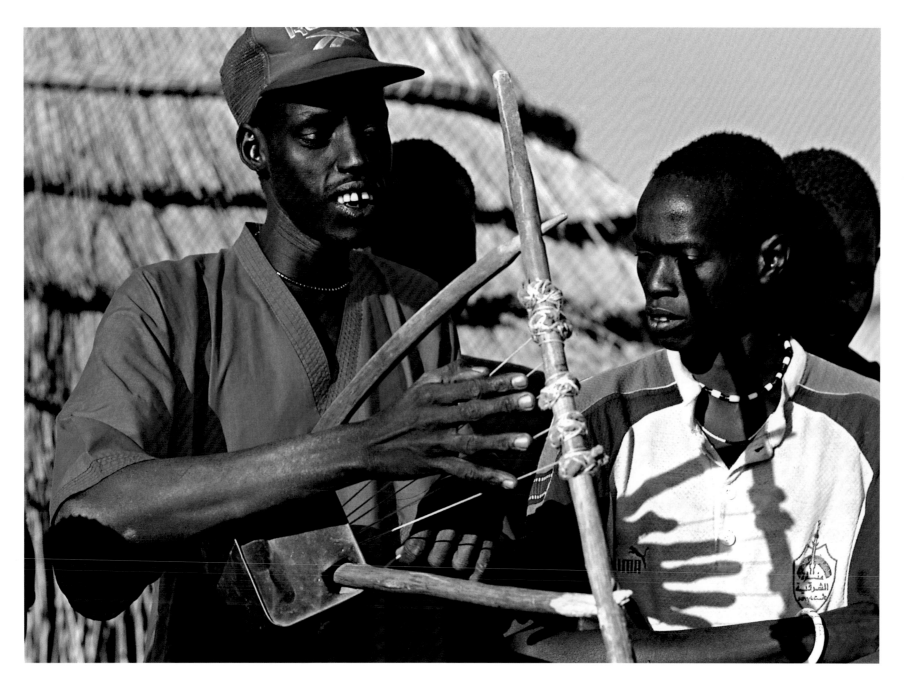

Dinka playing homemade lyre in Wonrok.

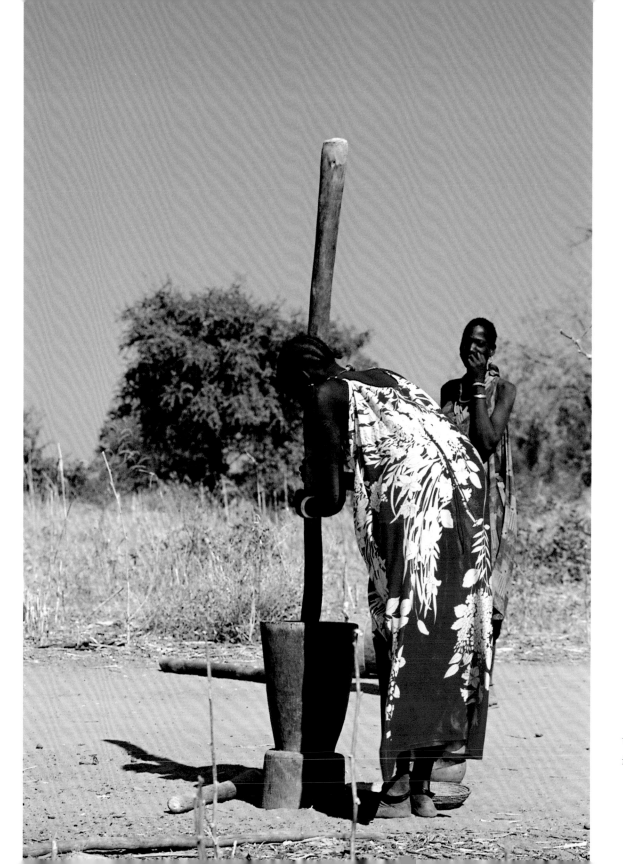

Woman grinding corn
for bread in Aweng.

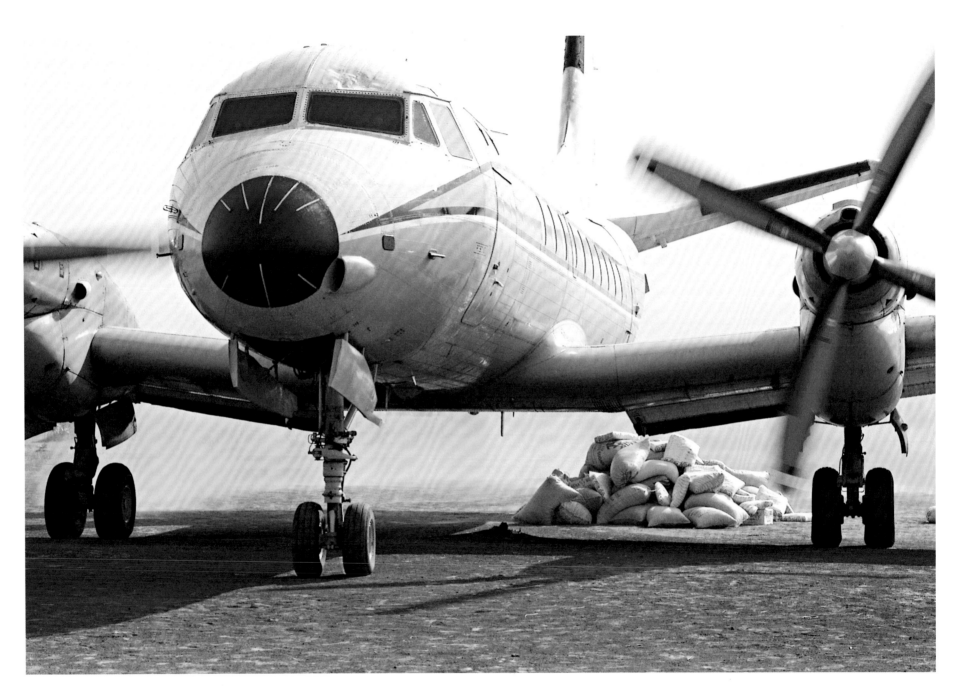

Bringing in supplies to the front lines in Ngop–SUDAN.

SUDAN OIL FIELD GENOCIDE

There is a killing place in Africa called the oil fields of the Sudan. Here the Sudanese government (GOS) practices systematic genocide on its own people with a vengeance. A more able world has ignored the cries of cruelly persecuted natives who have lived here for many generations. In this place a terrible holocaust is taking place each day. Here a repressive government kills its own with impunity, challenging the United Nations resolution to enforce the protocol of 1948 outlawing genocide.

The history of man can be found here. It is an old land where the first humans lived. Old empires flourished in this region, now forgotten except for their extensive ruins. In the Bentiu/Malakal area of El Ouahda, Sudan, along the upper White Nile and the Bahr-el-Ghazal River, tributaries of the Nile, a new history is being written. This is an arid land broken up by the rich floodplains of the Nile, creating some of the most fertile farming land in the world. The Nuer and the Dinka tribes have lived in this southern region for centuries, cultivating the land and tending their flocks. Slightly to the north are the Nuba people, who live in the mountains in small tribes. There are few roads here and little or no infrastructure. Years ago, fresh water wells were dug in the small villages, but they don't have electricity or telephones. Very little medical

care is available, and schools and churches are rudimentary. Regional trading centers can be reached by paths and rough tracts, but these are passable only in the dry season. In this place only the strongest survive. These villages have survived for centuries within the infrastructure of tribal territories. Some villages communicate with the outside world via radio, and in these communities each person knows about the events of September 11th. Each person says, "We are with the United States and would like to help you. Now you know what we have been going through for fifty years."

In the early 1950s, the British government, which had colonized Sudan, melded North Sudan and South Sudan into one country to facilitate administration from Khartoum in the north. Sudan has twenty million inhabitants spread throughout an area similar to the United States east of the Mississippi River. The northern area is dominated by Arab Muslims, while the southern region is dominated by Christian and animist blacks. When the British left Sudan, fighting between the two regions broke out. (The current struggle dates back to 1983.) Four years ago the statistics given for the holocaust were two million dead and five hundred thousand people displaced. These figures are still being used today, even though continued killing and displacement have produced greater numbers in this genocide. The south has no administrative center. Juba, the former center, was garrisoned by the government, and subsequently, a defense organization called the SPLM/A was created. At first this loose confederation of tribal leaders of the Dinka, Nuer, and Nuba fought with each other about how to defend the south

against the declared war from the Sudan government based in Khartoum (GOS). In 1992 the GOS declared a holy jihad against the Christian south and vowed that all of Sudan would be a Muslim nation. Over the years the government has developed into a fundamentally radical state similar to the theocracy of Afghanistan's former Taliban government. Osama Bin Laden had developed his al-Qaeda organization in Sudan before being asked to leave by GOS leaders, who were encouraged by the United States to expel him for terrorist activities.

The racial and cultural divisions between the people of the north and south are enormous, Arab/brown/Muslim against African/black/Christian. Combine that with a political divide that the holy jihad justification by the northern government provides and the gulf becomes as immense as any on earth. The Sharia, the Islamic code of conduct, claims that any non-Muslim people are unclean; thus they look down upon the Christian blacks as an inferior people.

It is here that Chevron, a U.S. company, explored for oil and discovered large fields of it in the 1970s. After Chevron found oil in the south, criticism from the U.S. government of the newfound ability of the GOS to finance the war on the south, along with several deaths of its employees, caused Chevron to sell its interests in 1984 to a consortium from Canada (Talisman 25 percent), China (China National Petroleum 40 percent), Malaysia (Petronas 30 percent), and Sudan (Sudapet Ltd. 5 percent), which developed the fields. Later, Sweden (Lundin Oil) and France (Total Fina Elf) also invested in the oil fields, purchasing concessions from the GOS. In 1999 the oil started to flow

through the nine-hundred-mile long pipeline to Port Sudan in the north on the Red Sea, and then to the world.

As soon as the oil began to flow, the weapons technology used by the GOS became superior. Hind helicopter gunships, tanks, artillery, and bombers supplanted rifles and mortars, giving the GOS the ability to dominate southern Sudan. Therefore, the economics that allows the north to commit genocide against the south is to be found in the oil fields, which are located in the south. The GOS has created these killing fields so that the oil flow is not interrupted. The SPLM/A, realizing that the money earned from the oil is fueling the holocaust, is trying to halt the flow, while the GOS is creating a scorched earth policy around the fields, killing and pushing age-old tribes from the region. The tribulations of displacement and direct genocide have created enormous killing fields. Food, always scarce, is no more. New water sources spread disease. The physical trials kill elders and infants. The holocaust continues unabated.

In the past, the GOS has not allowed human rights observers to enter the Nuba/oil field region, but a recent two-week cease-fire arranged by U.S. Envoy for Peace in Sudan, Senator John Danforth, allowed some U.N. observers to enter the region to make observations in the Nuba Mountains and the oil fields. While they were in the region, the cease-fire was violated by the GOS after only three days. Our trip into the oil region was scheduled to begin the day after the cease-fire was to end and just after the return of the U.N. mission.

The Trip

The Persecution Project Foundation, located in Warrenton, Virginia, invited my wife Joan and me to join them in delivering medicine, beans, salt, and soap to the displaced Nuer people in the oil region near Bentiu, a traditional regional trading center. Also on the trip was the board chairman of the foundation, a Christian missionary from Virginia, and a videographer from Nairobi. In the bright Advent season of 2001, when the Christian, Jewish, and Muslim faiths have great celebrations, it seemed congruent to take this difficult journey. We flew to Kenya and then to the northern border town of Lokichoggio for our departure into Sudan. We carried five tons of relief supplies in a small transport approximately six hundred miles to the upper Nile region to Ngop, where refugees had just built a nondescript dirt airstrip. Our pilots had difficulty finding it. Government forces occupied the closest established town of Bentiu. It was from Bentiu that one current offensive was taking place. The SPLA created a line of defense some four kilometers from the town, where it faced three different fronts on which the GOS was attacking. It was west of this point that our loaded cargo plane landed in a cloud of dust. The waiting crowd

surrounded the plane and quickly unloaded the welcome provisions. The plane took off, returning to Lokichoggio, leaving us and our equipment. The plan was that the plane would return the next day with another load of supplies and to pick us up about 2:00 p.m. That would allow us time to meet with local leaders and to document what we found. It seems that the provisions arrived in the nick of time, as the people's meager rations of corn were being supplemented by grasses found in the area after the rains just a month prior. The new stores were stacked in a community compound for distribution.

They welcomed us with smiling, shy faces and open arms. Joan disappeared into a sea of women and barefoot children, all anxious to touch her hair and clothes. She loved the attention and their welcome. Soon she had a contingent of twenty youngsters in tow, holding hands and repeating the refrain from "Old McDonald Had a Farm." After introductions with the commissioner, commander, and local chiefs, we were led to a straw-walled compound where we pitched our tents. On each side of our compound we could see new tukuls (the traditional straw and thatch homes in this part of Africa) being erected. The chiefs apologized for not providing a suitable tukul for us, it being such a new camp, but the commissioner told us a young bull was being slaughtered in respect for our visit, which was a great honor for us.

Just after we had put up our tents, we heard chanting from a large group of men. We went back to the airstrip and saw several thousand troops running in a formation of fours and chanting in unison, being led by a Christian flag and the SPLA colors. It was a stirring sight in the evening light. Tomorrow, the commander

told us, these newly trained recruits would go the front lines. It was moving to see the long line of troops, those in front carrying automatic weapons, machine guns, and rocket-propelled grenade launchers, then the lesser armed troops with AK-47 Kalashnikov automatic rifles, and finally there were the new recruits, boys, women, and girls, barefoot and carrying sticks. This was the front defensive line, and they were defending their families and homeland against annihilation. Maybe tomorrow they would be pushed out of this hastily laid out camp. Maybe tomorrow . . .

The commander, Peter Gatdet, is a legendary leader among the Nuer and SPLA forces. Trained in guerrilla tactics and wounded twenty-eight times, his discipline and training have kept the north from overrunning the south in this area. Deeply Christian and Nuer, he is committed to saving his people. Each day is a new challenge. Each day a new attack by the north tests his and his troops' mettle. At this time he is facing attacks from three different directions. In this command location he is training and conditioning his troops to be able to meet the onslaught. His brigade is known far and wide for its ability to fight, so it is with a touch of sadness that he tells me that he cannot fight tanks, artillery, and Hind gunships with rifles, grenade launchers, and mortars. The fourteen area chiefs who are with him for protection know full well that they will eventually have to retreat to a new location, taking their remaining tribes with them. There will be more death and less future.

The young bull was killed and we ate quietly, thankful for these hospitable people. The commander and the commissioner sat with us, giving us a report on the situation. Their assessment

agreed with what we had heard from experts in Lokichoggio. Singing from the soldiers' camp went well into the night. Afterward the quiet stillness of a starry night and a crescent moon provided a measure of peace for us.

Dawn broke early. The troops were training and running on the landing strip. The commander would conduct a review before the troops left for the front. A Nuer Presbyterian minister and his staff led the parade, and it included a bass drum, banged in cadence with vigor by a young man. Shortly after the parade and a review by the commanders, we heard loud artillery fire in the distance. The commander told us a major battle was taking place five kilometers from our camp. For five hours the battle raged. At noon we were told to be prepared to retreat immediately with the troops if the battle went poorly. At the same time we received a radio message that our plane could not return until the next day. The commander and his staff were preoccupied with the battle and its results. At 2:00 p.m. the artillery stopped. The tension was quite great. Then we heard that the commander had won an important victory, with the GOS forces in full retreat to Bentiu. We understood that tomorrow there would be yet another battle from a different direction with a more able GOS general leading the attack.

We wanted to walk a few miles to the river, so we went in that direction, arriving first at the commander's camp and barracks. Around the camp, there were foxholes every twenty-five feet with guards in them night and day. The barracks were simple straw huts. They had a medical dispensary with little medicine, other than the shipment we brought that only included the basics. This

was an army on the move, retreating slowly, giving up their age-old land grudgingly and at a tremendous cost in civilian lives caused by the displacement. At the camp the commander stopped us from going to the river, telling us it was too dangerous to continue because GOS gunships were patrolling the area, picking off water gatherers. We did not mind too much as the heat was somewhere over 115° in the sun. My thermometer read 100° in the shade. In the tremendous heat we could not take in enough fluids to compensate for our dehydration.

We visited with soldiers at the camp and then walked back to the airstrip and compound where we had our tents. As the soldiers practiced deployment and tactics in this heat, I was amazed that with their meager calorie intake and lack of fat they could sustain such rigorous training for so many hours. But they had a cause and were banded together to fight for the survival of their families, tribes, and homeland, and it was a desperate and demanding struggle. Their chanting and singing as they ran in formation in the oppressive heat were a powerful display of the human spirit.

We knew the outcome of the battle by the late afternoon. One hundred of the SPLA forces were wounded and fifty were dead. Five hundred of the GOS troops were dead and wounded, with many prisoners having been taken by the SPLA forces.

That afternoon we took a long walk through a small village where the meager corn stores were kept in bins, and women prepared the corn for the daily ration for 10,000 people. On our return we had a meeting with the fourteen tribal chiefs. The oldest chief, whose tribe was north in the Nuba Mountains, told us that his tribe had 10,000 families three years ago, and now there

were two hundred. I asked him where the rest were. Starvation, disease caused by dislocation, river crossing drowning, war. This explained why there were so few children under four and fewer elders in the crowds. They had vanished as the result of the genocide and dislocation efforts of the north. Other chiefs told of similar, though not quite as great, losses in their tribes. All families in their tribes were affected. When we asked what the chiefs wanted, it was peace. Then they prayed. Their pride and faith in their people's strength and endurance was amazing; they just needed some peace from the killing fields to rebuild their families and tribes. There was such sadness in their pleas, a sadness based on a difficult past with little future for each person, young or old.

In the twilight the wounded were brought to the camp in a long line by women carrying straw mats on their heads. Even though the cost of the battle had been great, there was joy in the camp that evening. But the commander knew there would be a tomorrow. He knew that the artillery, rockets, tanks, and gunships would be too much for his rifles, grenade launchers, and mortars. He also knew that he would replace sticks with rifles and replenish his ammunition with the weapons seized from this battle. Finally, he knew that in the mind of the enemy, the continuing struggle would have no end until the north had killed the Christians of the south and the nation was Muslim. That is what the holy jihad tells us.

The next morning we awoke to a donkey braying as usual. Shortly after stowing our gear into bags and having a meager breakfast, we heard our plane arrive and had a final meeting with the commissioner, commander, and chiefs. The commander went to his wounded, who were crowded around the plane. He decided that after the plane unloaded its relief supplies, only the most critically wounded would be airlifted out with us. The pilots asked me if we had seen any gunships because on the previous day, an NGO plane that was to take out the wounded from the battle was harassed by two GOS helicopter gunships, so much so that the relief plane dove to the ground in its effort to escape and picked up leaves and twigs from trees on its undercarriage. This was a ratcheting-up of the aggression that the north was pursuing against the south with its newly found armaments. After our return to Lokichoggio, we were told that the pilots could not return to deliver the rest of the goods due to the gunships controlling the skies and the GOS's determination to stop relief efforts.

In Lokichoggio we visited a new school for homeless and disabled orphans established by the wife of the SPLA leader. It is a wonderful camp in southern Sudan built for 850 students. Initially it will have 240 students, equally divided between boys and girls. Persecution Project asked how they could help, and school officials said they needed $10,800 ($100 per month per teacher for nine teachers) for the next year. Persecution Project agreed and paid them so that they could open in January. It is a start.

The story of concerned and caring NGOs, with their unique and heroic dedication to give aid to the victims of this terrible tyranny, describes an exceptional human endeavor. I had heard that Persecution Project was one of very few relief organizations prepared to risk taking supplies to the front lines of this holocaust. They found only a few daring pilots who would assist them in their work. Each day these people of compassion,

dedication, and perseverance must adjust to new rules in order to assist oppressed people in the oil region and the Nuba Mountains. The United Nations does not . . . the United States does not . . . the European Common Market does not . . . the Presbyterian Church and Anglican Church do not . . . the Red Cross goes in if it is safe, now it is not . . .

The Overview

Apologists would say this is a long-standing civil war. They would also say that among the SPLA/M there are Marxist-leaning warriors. They would say that in the case of the Nuer, two tribes actually fight with the north. (The GOS has hired two Nuer tribes to help lead the battle against the south; they are placed on the front line and are the first to be killed and captured.) They would also point out that the Chinese have brought in troops to protect the oil interests, but that these troops are being used to search for, destroy, and remove Nuer from their tribal lands, killing them if they don't move. There is some truth in all of these statements, but the germane facts in the current situation are these. The SPLA/M is a defense organization, originally structured along tribal lines, that over fifteen years has had to take on a quasi-governmental role. In order to arm itself, it captures its armaments and ammunition from the GOS forces during battles. *The SPLA is Christian based and defensively oriented.* The south, understandably, is trying to take back its trading centers, which the GOS occupies, and to stop the flow of oil that provides the GOS with improved armaments.

Those who would say that this is "just" a civil war would also apologize for Hitler prior to World War II or say that the Holocaust did not take place. What is happening in Sudan is genocide and slavery in their clearest forms. The three churches (Catholic, Anglican, and Presbyterian) that have the largest presence are slowly responding. Archbishop Carey and Bishop Griswold, Presiding Bishop of the U.S. Episcopal Church, have called on President Bush to incorporate southern Sudan's plight into U.S. foreign policy. The Pope is starting to respond on the basis of Bishop Gassis's work in the oil region and the Nuba Mountains. The United Nations has been silent, as has the European Common Market, fearful of a political, Muslim, or terrorist backlash. The United States is acknowledging the problem but as of yet has done nothing, even regarding food relief, which has stopped. We are witnessing one of the world's largest and most cruel genocides. It dwarfs all but the Russian Gulag and the German Holocaust in its scope and tyranny. Yet the world is painfully silent. As knowledge of this situation spreads, the cruelty and scope of the genocide and slavery in southern Sudan will shock the world, which will inquire about how this could happen in the knowing world of 2001 well into the next century. Then there will be a wringing of hands and wailing and gnashing of teeth over the facts and the guilt for this holocaust in southern Sudan.

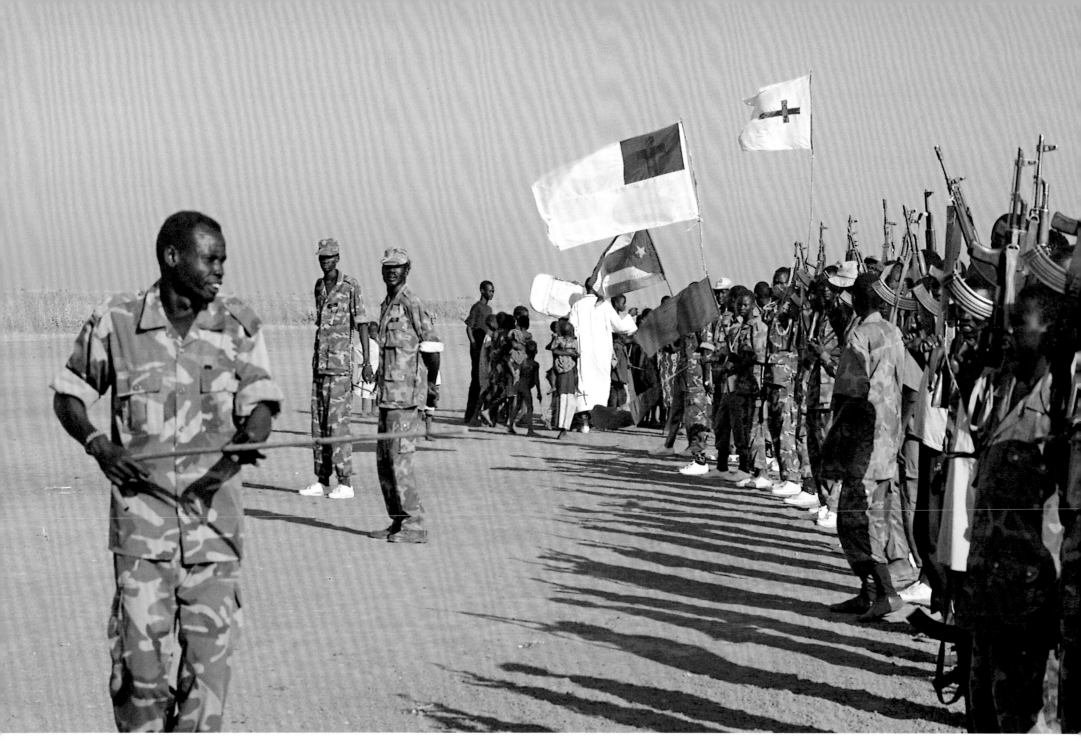

Parade of soldiers going into battle the next day, led by two Christian and SPLA flags—NGOP, SUDAN.

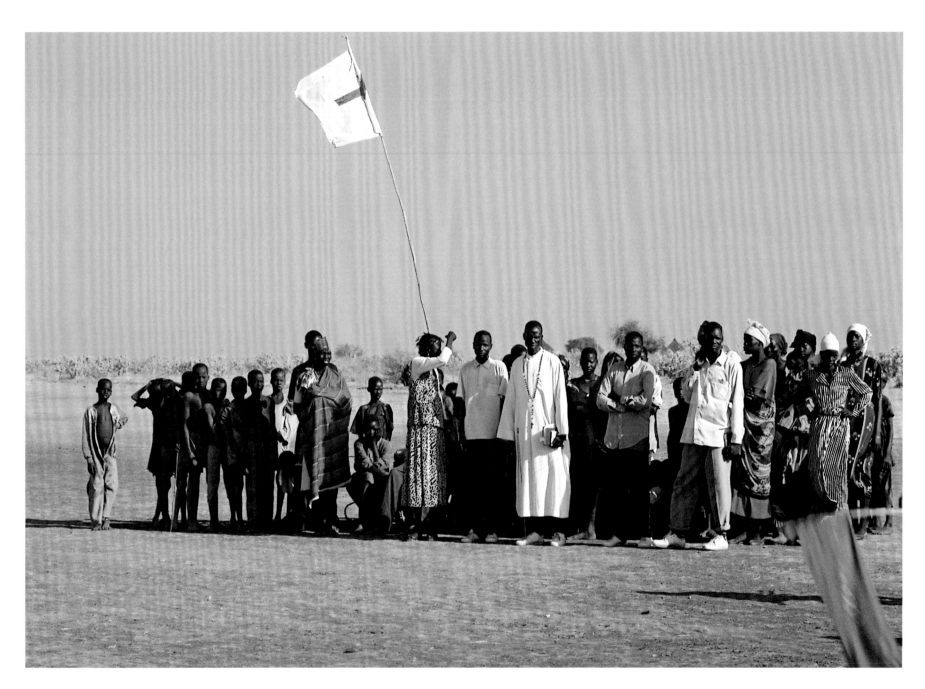

The Presbyterian minister leading the troops to battle–SUDAN.

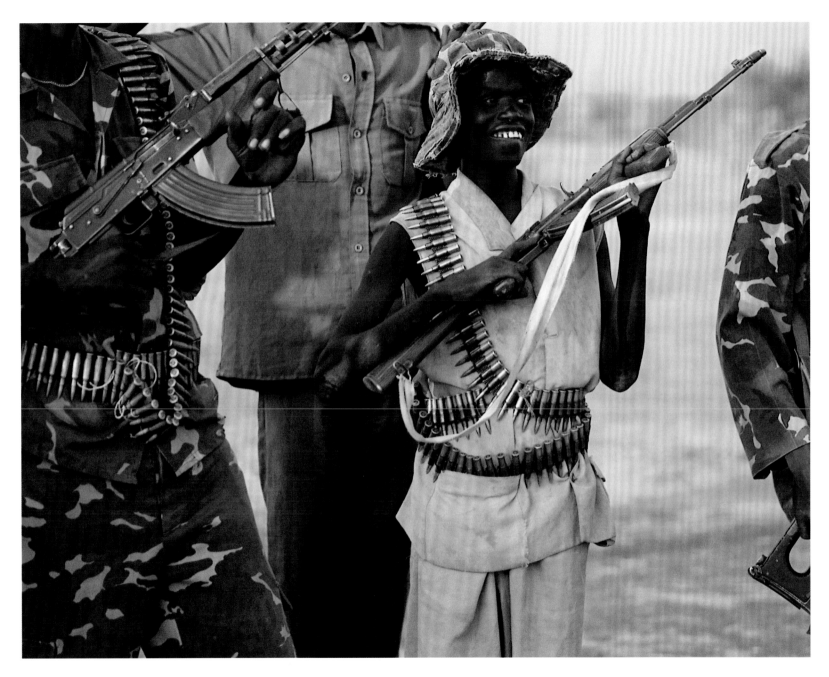

A young, well armed soldier–SUDAN.

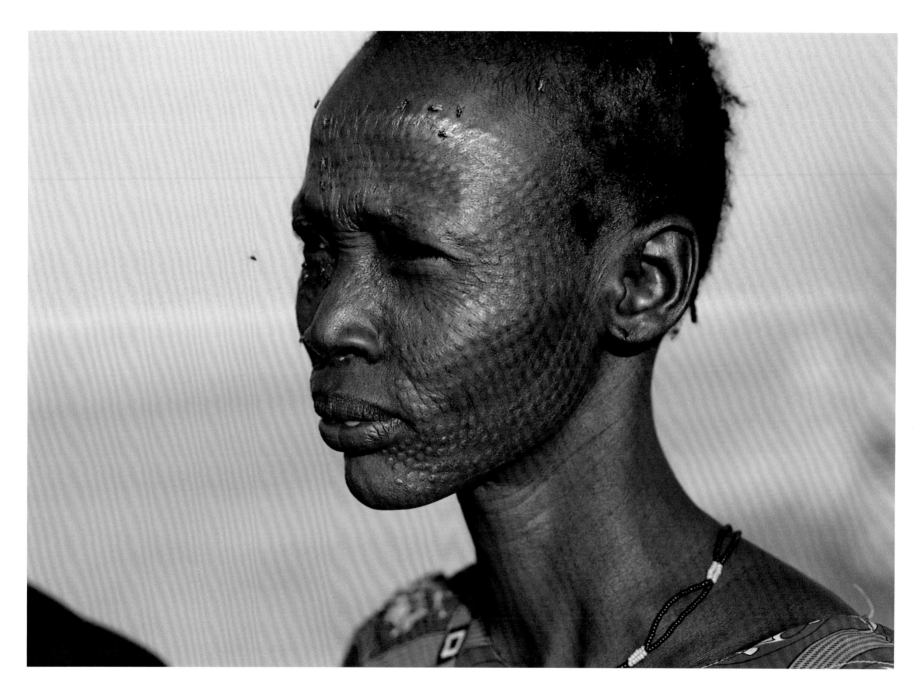

A Nuer woman—NGOP.

SPLM commissioner in the Bentui area of Sudan.

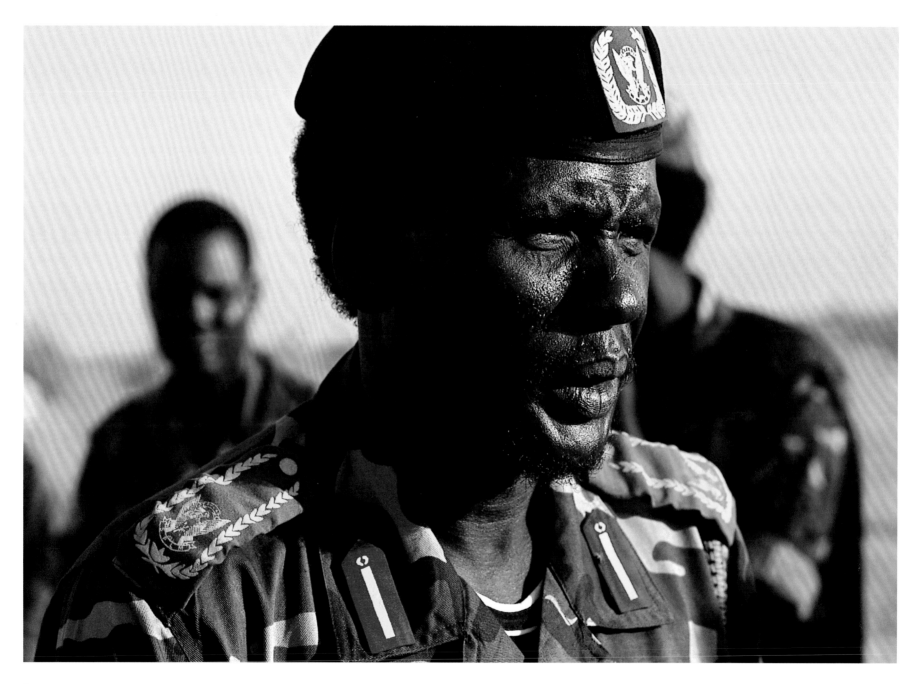

Peter Gatdet, legendary commander of the SPLA–NGOP, SUDAN.

The four thousand troops that were going into battle at Ngop near Bentiu.

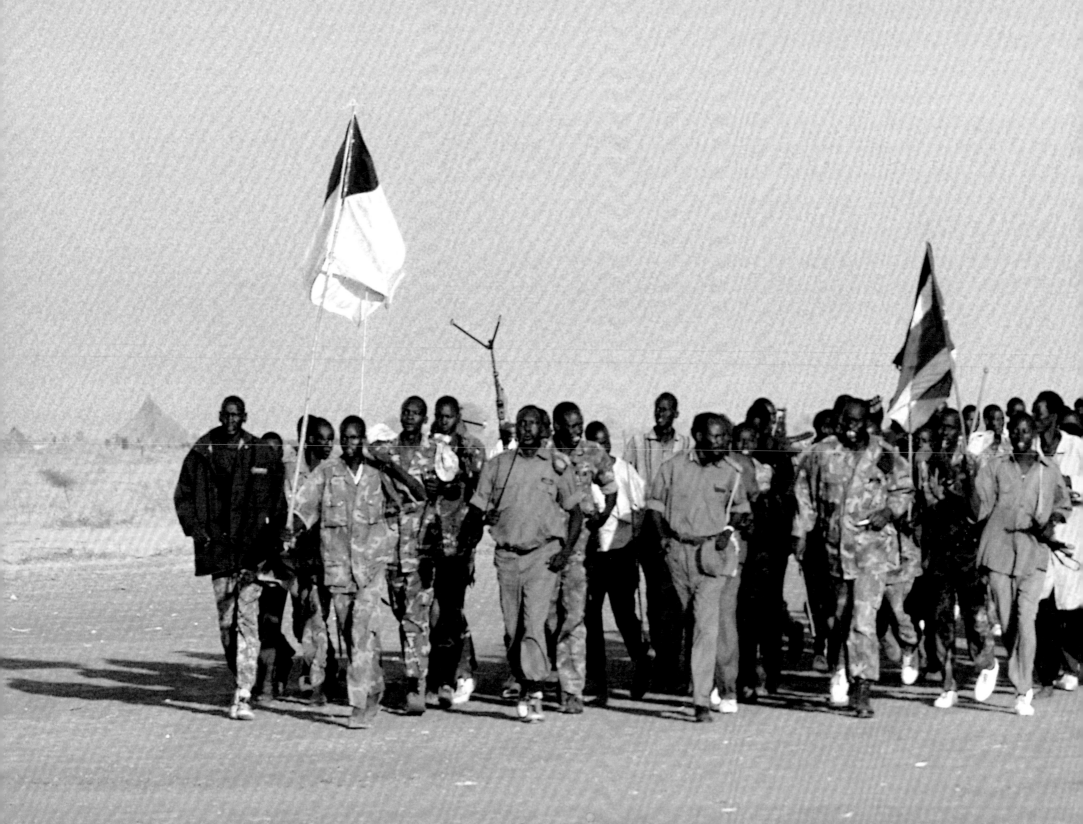

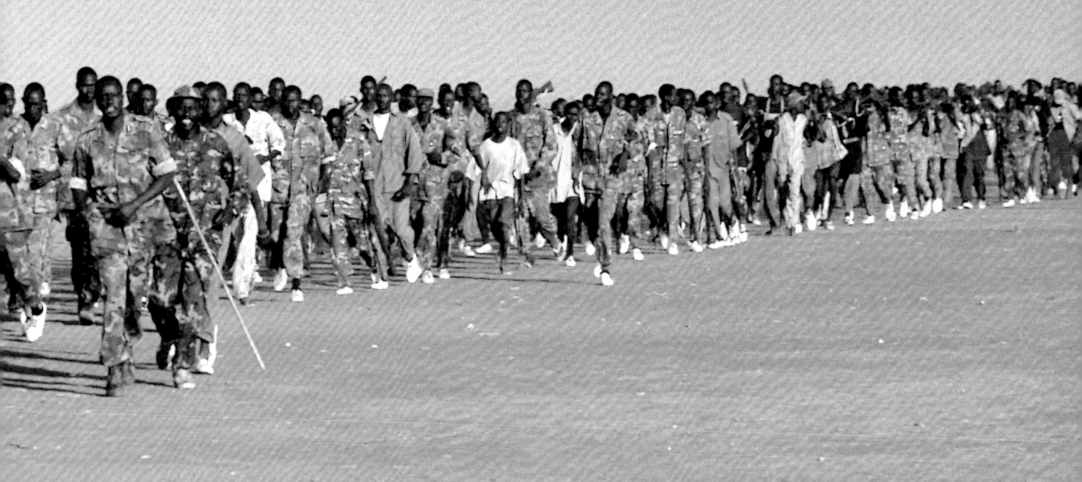

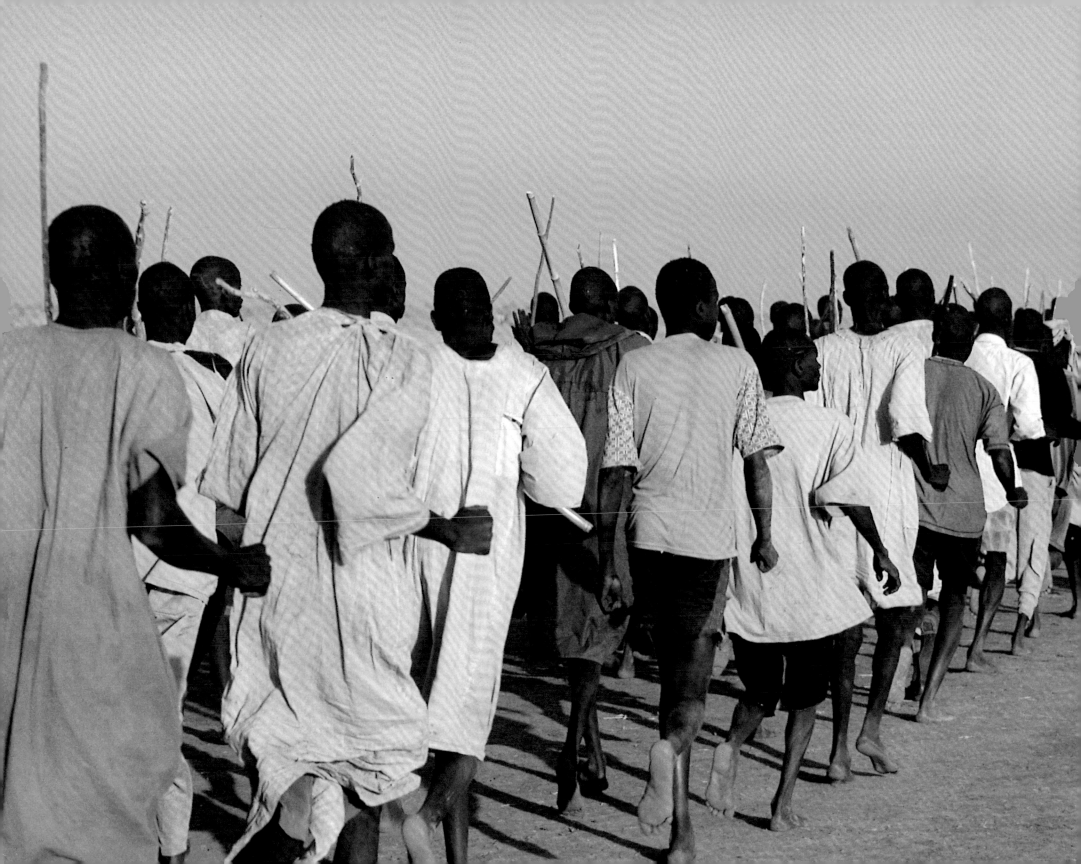

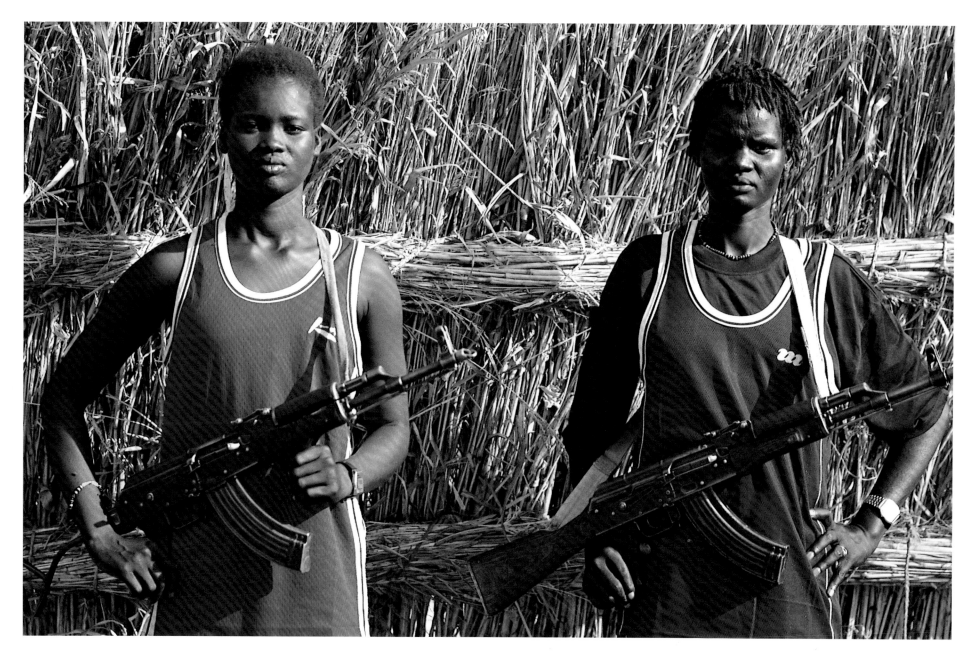

◄ The last third of the troops going into battle barefoot with sticks, ready to retrieve weapons from the fallen enemy–NGOP.

Two SPLA girl soldiers–NGOP. ▲

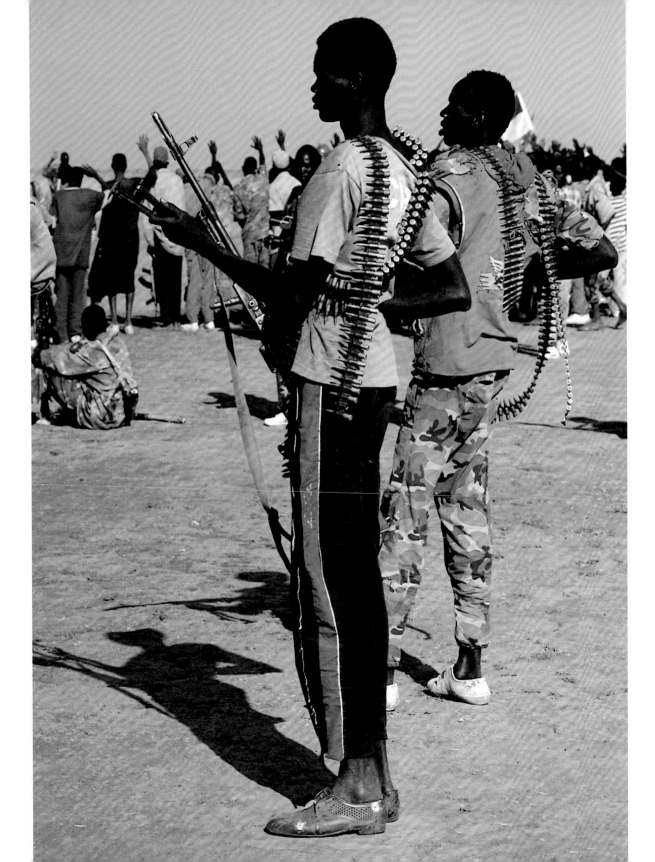

Well armed soldiers
going into battle–SUDAN.

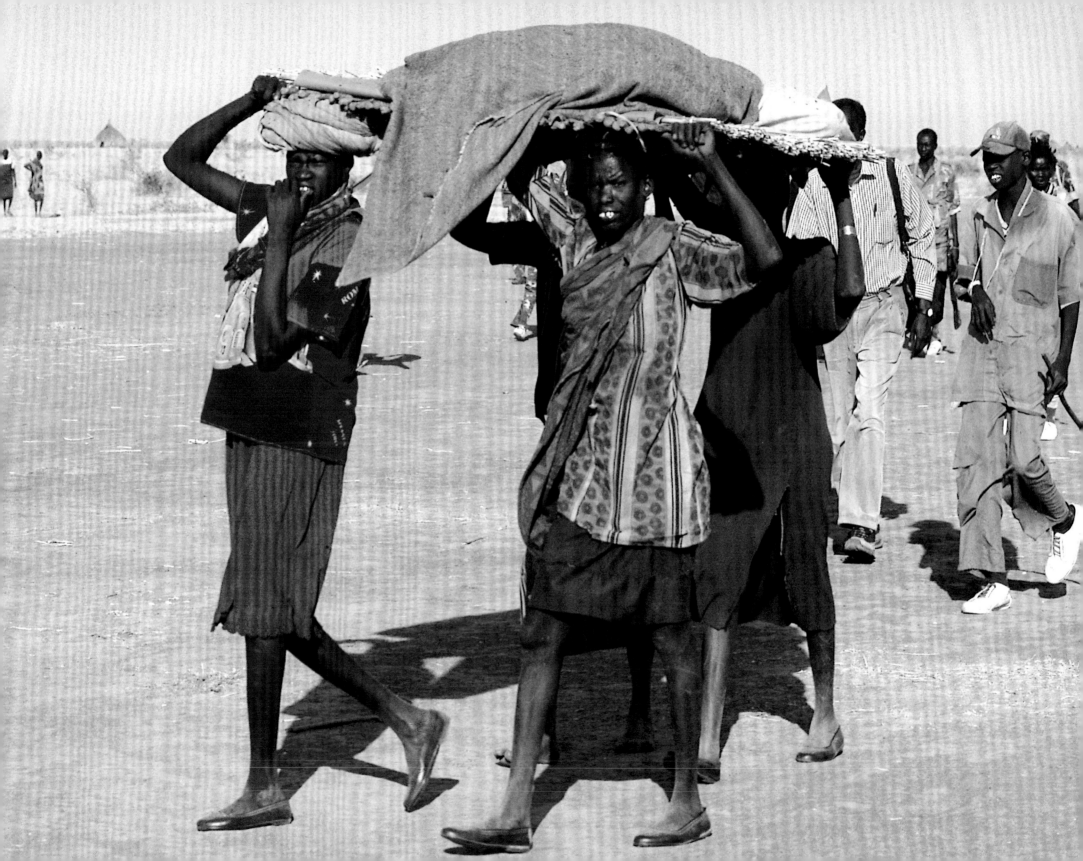

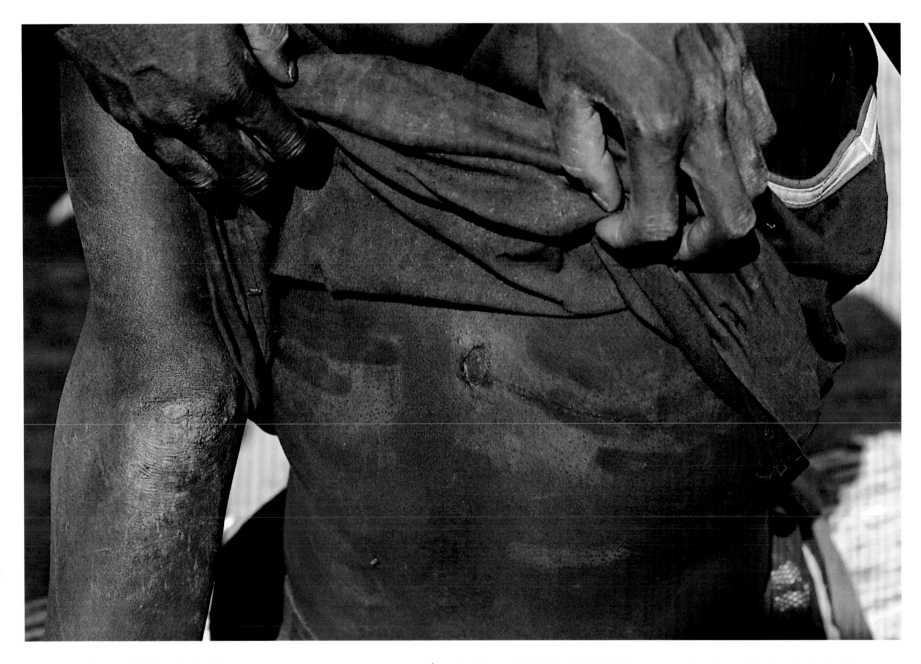

◀ Carrying the wounded from the battle site–SUDAN.

▲ A badly wounded soldier who had to be transported to a hospital six hundred miles away–SUDAN.

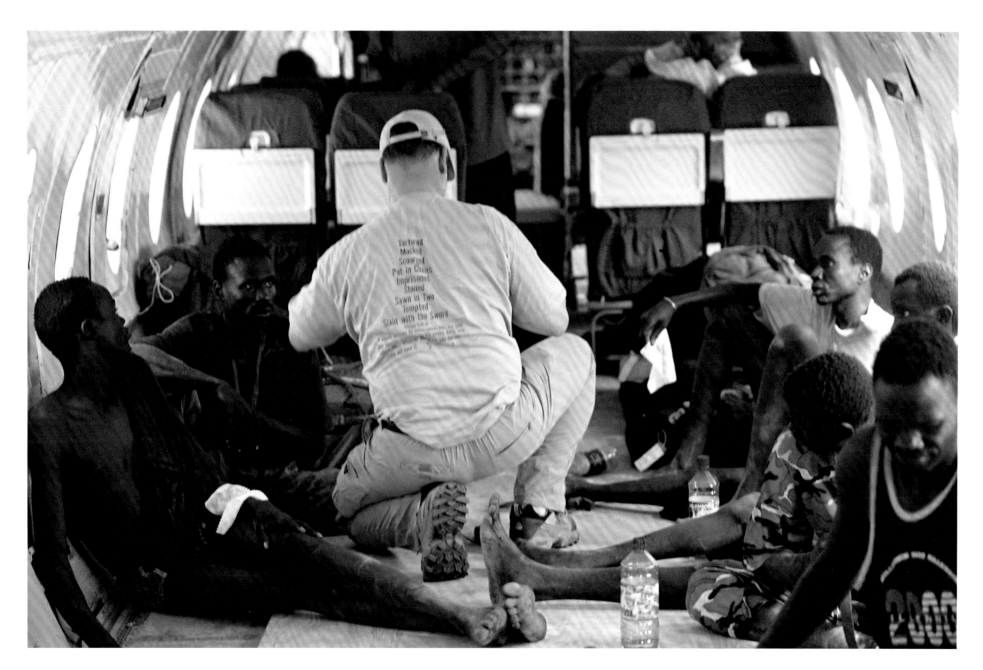

Transporting the badly wounded from the battlefield in Ngop to a hospital in Kenya.

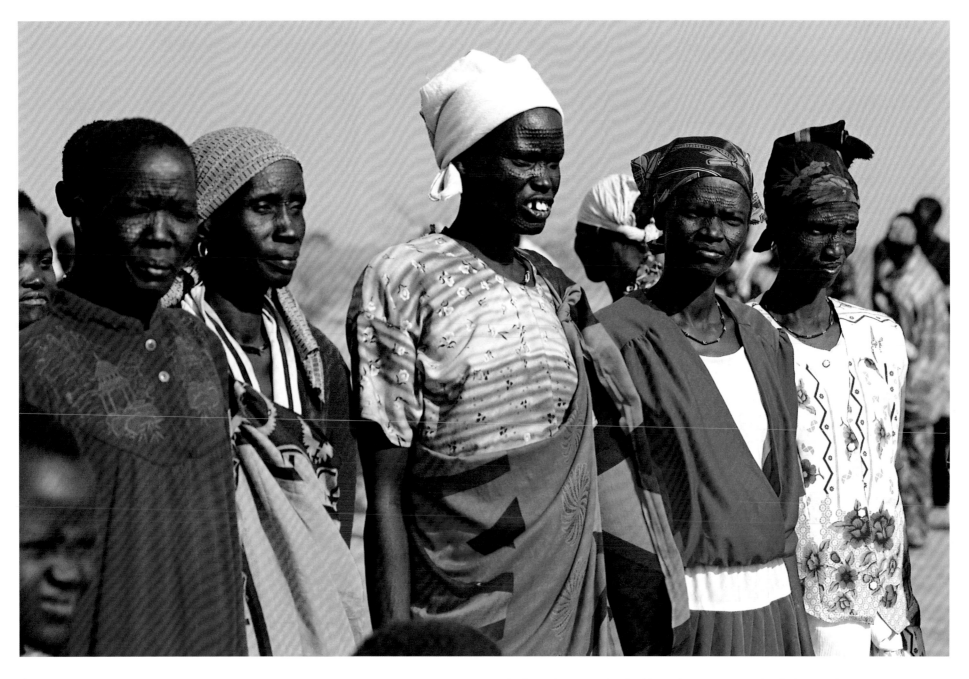

▲ Nuer women welcoming us at Ngop.

Nuer chiefs watching a parade of soldiers who are going into battle the next day—NGOP, SUDAN. ►

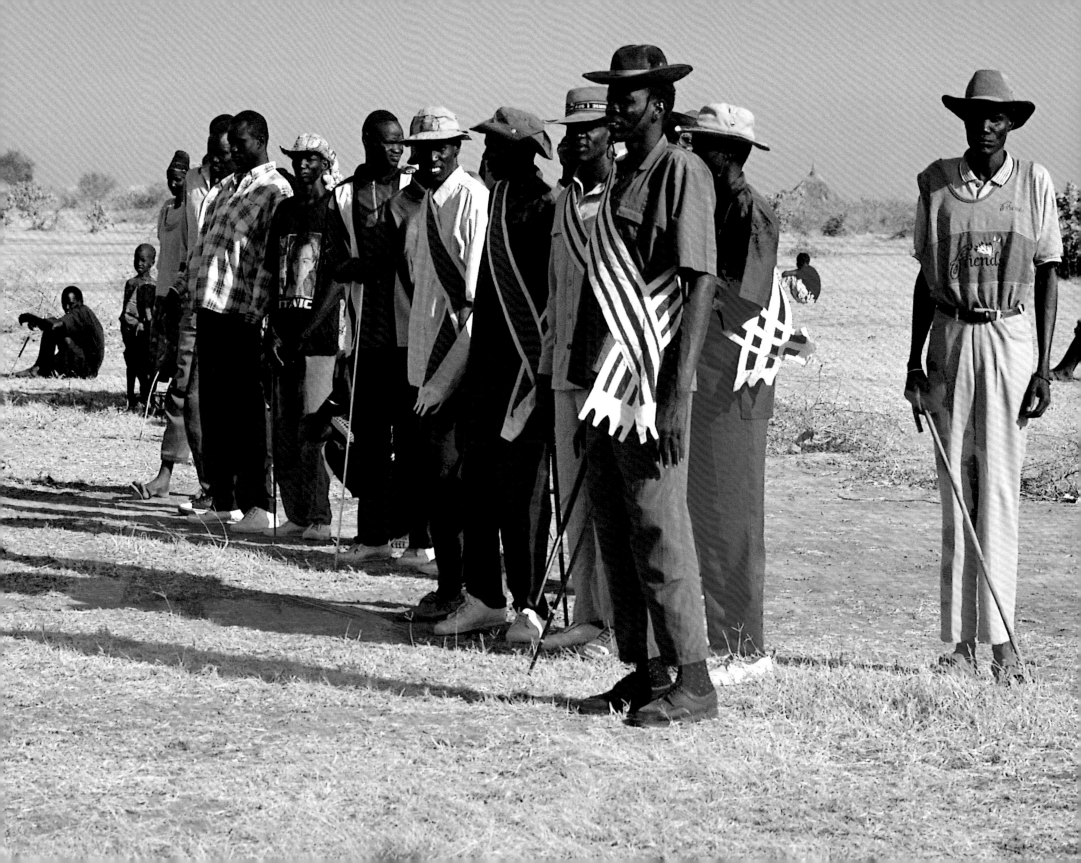

Tanning the hide of a young bull slaughtered for our visit—NGOP.

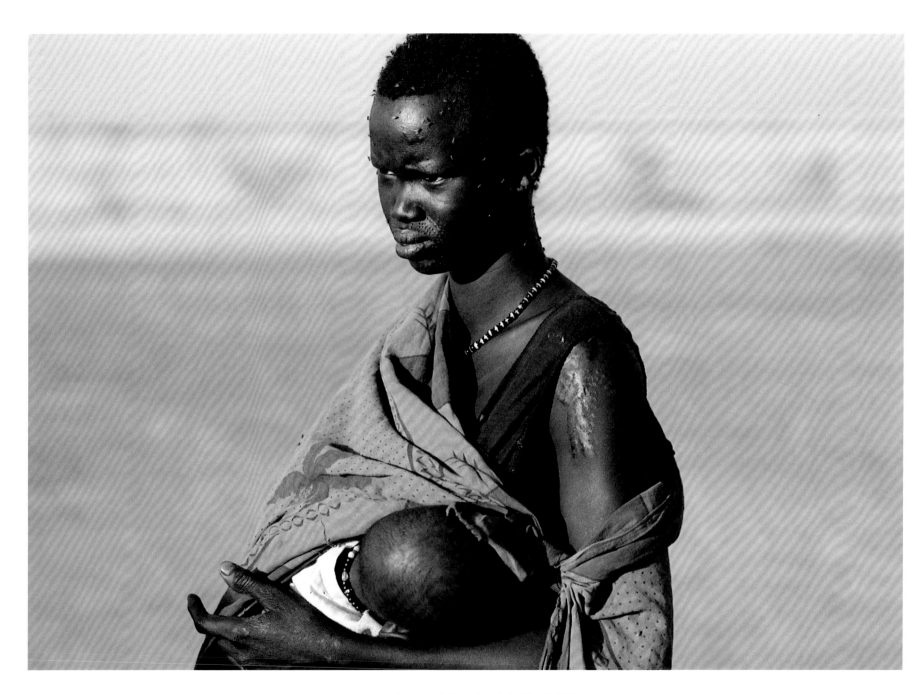

Nuer woman with a rare child in the oil field battlefield–NGOP.

A Nuer soldier–NGOP.

Nuer woman with flies denoting disease—NGOP.

Building a tukul in the temporary Ngop camp.

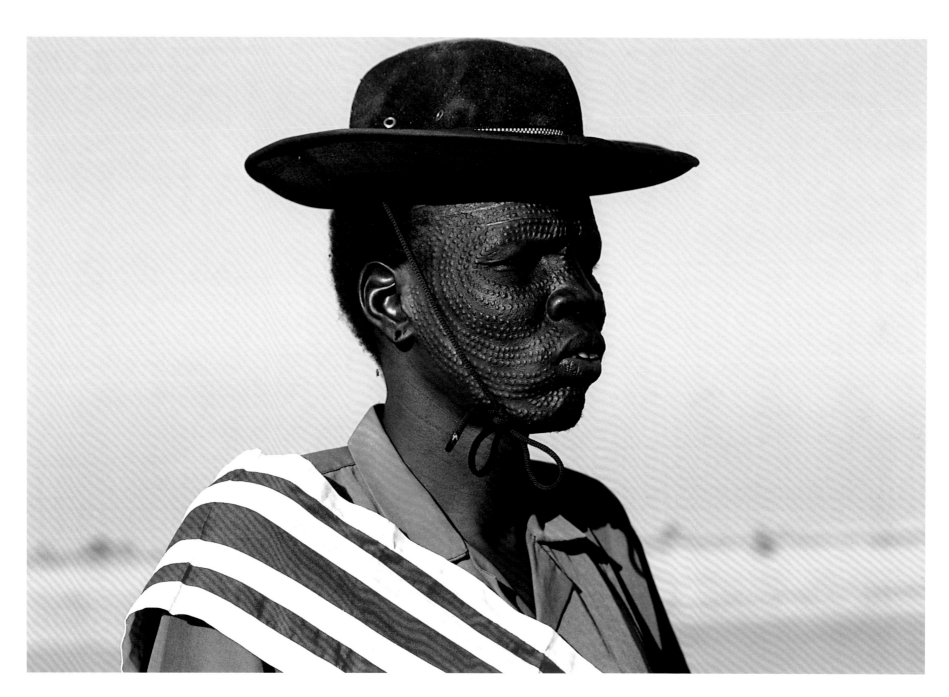

Seven-foot tall Nuer chief in Ngop.

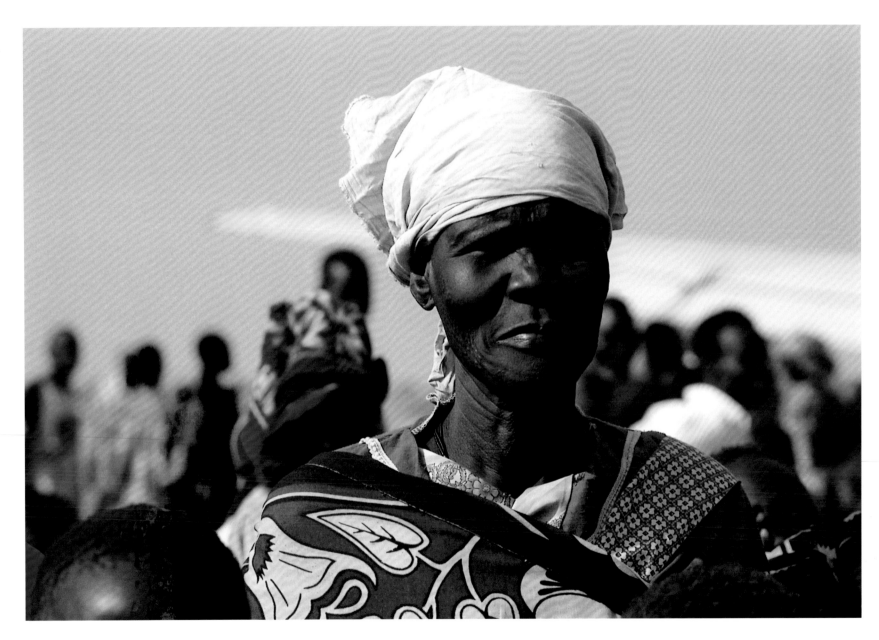

An elderly Nuer woman in Ngop.

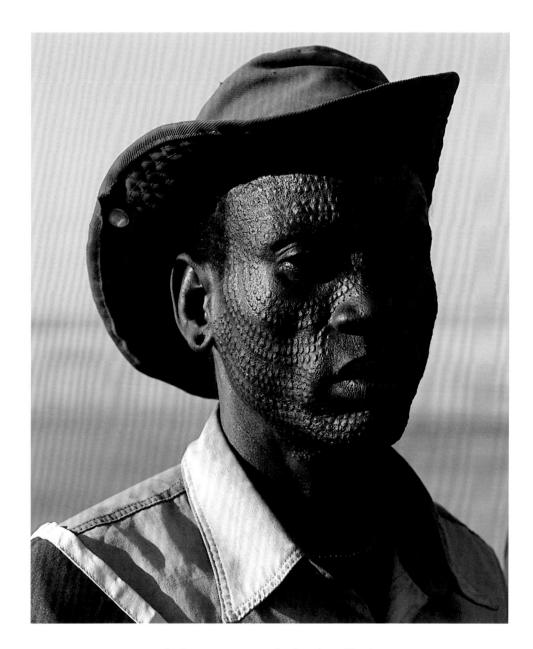

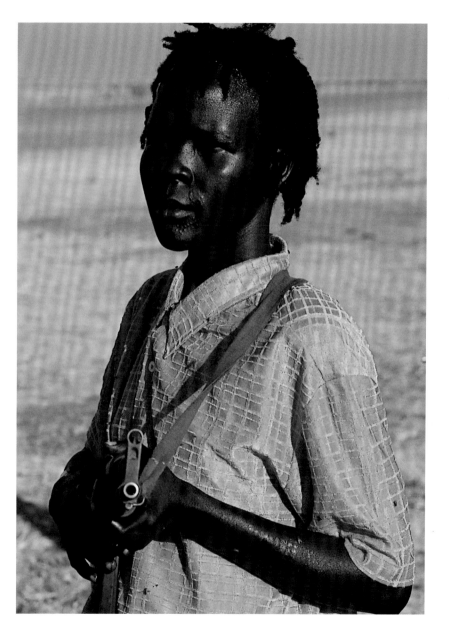

Nuer chief in Ngop camp on the front line of battle–NGOP.

A teenage SPLA girl soldier at Ngop.

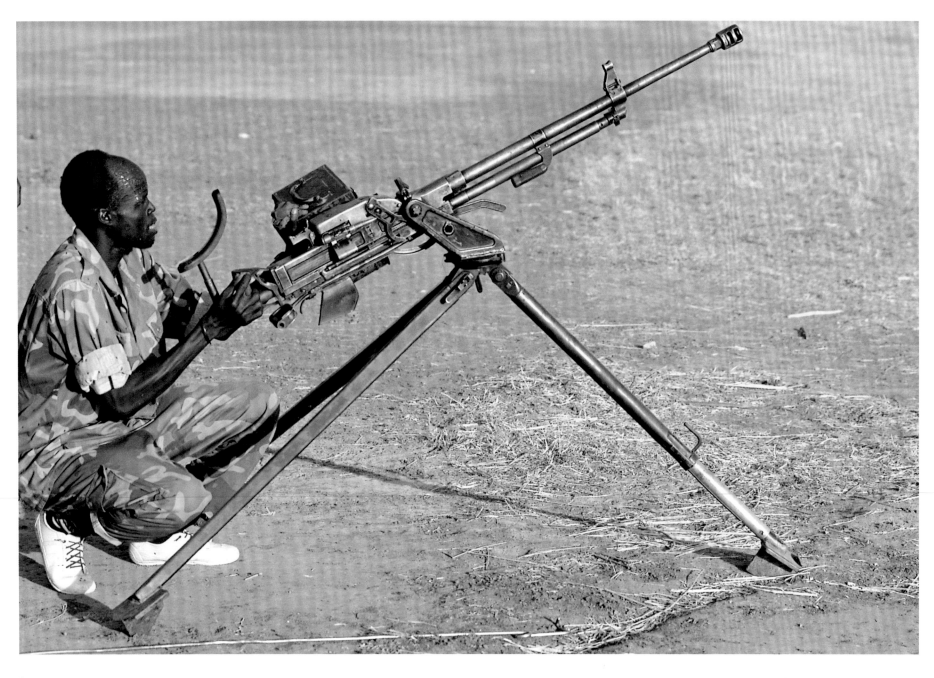

▲ A 50-caliber machine gun and its operator at Ngop.

Nuer woman smoking a pipe and carrying relief supplies in Ngop. ▶

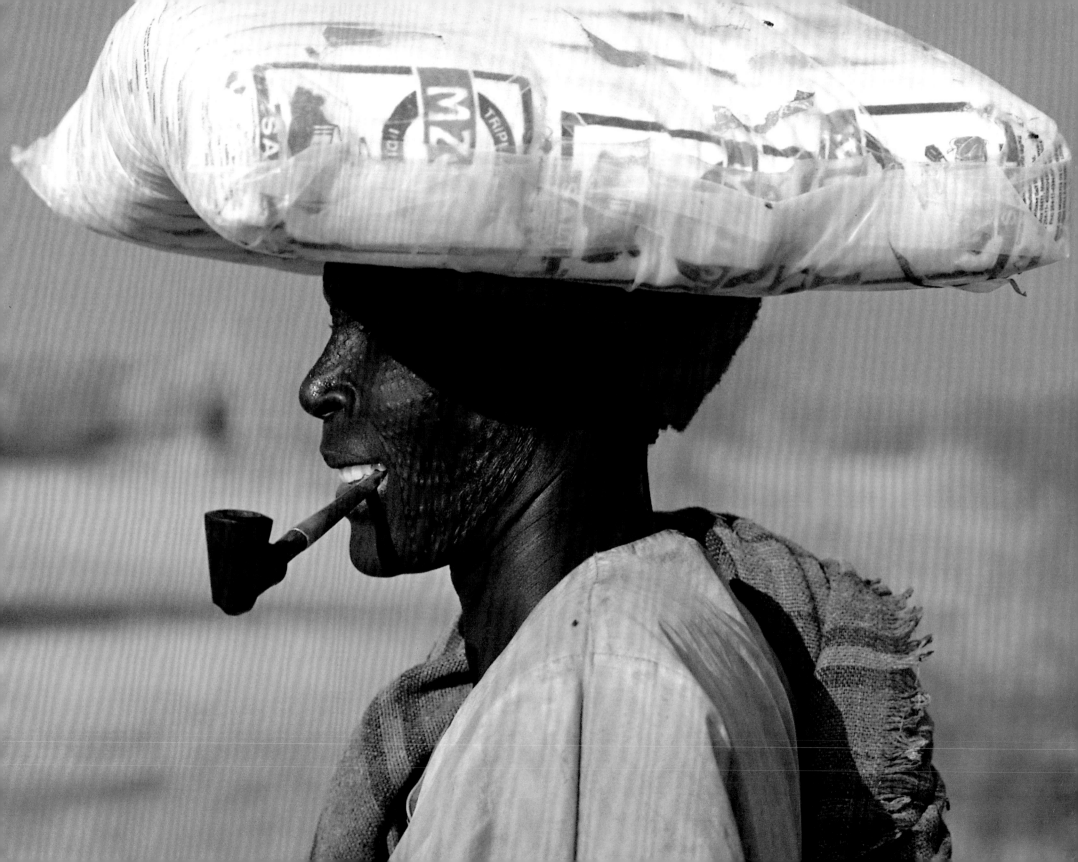

Rebecca Garang at her orphans'
school in southern Sudan.

WODRANS School in southern Sudan.

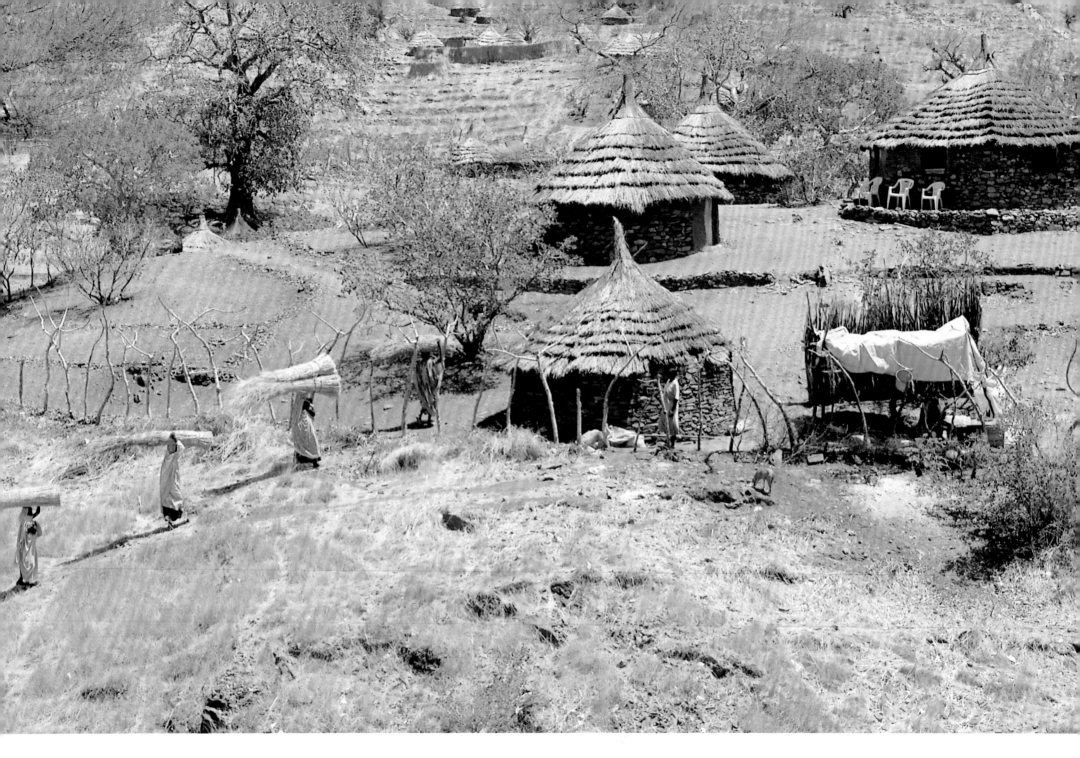

Governor's compound in Lowere–NUBA MOUNTAINS, SUDAN.

NUBA MOUNTAINS, SUDAN

Deep in the heart of Sudan lie the Nuba Mountains. In February of 2004 I traveled to the Nuba Mountains to learn about the troubled history of slavery, flight, holy jihad, forced religious conversion, and genocide of the storied people living there. It is one of the world's most compelling sagas, which has as its roots more than five thousand years of history, culminating in a torturous genocide in the last twelve years. Theirs has been a *culture of survival.* It is difficult to evaluate, but the best estimate is that 200,000 to 300,000 lives out of nearly two million have been lost in this small mountainous region over these past years.

Egypt was a powerful empire in 3000 BC, exercising its influence by extending its territory southward up the Nile. Snefru, the ruler of Egypt, left a detailed record of attacking the black "Nubians" in the upper Nile, taking seven thousand captives into slavery before the Great Pyramid was built. The land was called Kush. Over the subsequent two thousand years, Kush was a major source of slaves, cattle, and sheep for the Egyptians. As the Egyptian dynasties waned, the kingdom of Kush waxed strong, and the seat of power moved up the Nile to the southern border of Egypt and

the northern border of Sudan. King Alara, and subsequently his brother Kashta, created the dynasties and Kashta became a Pharaoh. Later, in 700 BC under Piye, the Kush conquered Egypt. From then on the "Black Pharaohs" wore the symbolic royal serpent on their headdress. They built large temples, and the Kush dynasty ruled from the Mediterranean to Meroe, north of Khartoum. But soon the kingdom came under attack from Assyrians from what is now northern Iraq. They created an Arab foothold. The lands they conquered followed a curve from Egypt down the eastern coast of Africa to Dar es Salaam in present-day Tanzania (known as the Red Crescent). So the Kush moved their capital to Napata in the Sudan and then were driven south to Meroe. They ruled for the next thousand years, holding onto their Pharaonic titles and worshipping their god *Amon*. In the Meroe dynasties many capable queens ruled. Some black Kushites, feeling the pressure of the Assyrians, moved farther up the Nile and into the Nuba Mountains. Toward the end of the fourth century AD, Meriotic rule gave way to the Christian Coptic power from Ethiopia. The Egyptians and the black Nubians had a tortuous history of slavery and domination that was exasperated by the plundering and destruction from Arab tribes from the near East.

In 600 AD continuing raids by Arabs from Egypt and the near East signaled the loss of independence for the Nubians, and many more families migrated further up the Nile and into the Nuba Mountains seeking safety. From 600 to 2002 AD, raiding for slaves from the Nuba Mountains by Egyptians and other Arabs, including the Mahdi and the Baggara tribes, was consistent. The fifty small, independent Nuba tribes could not resist the invaders. In addition, each of the tribes had its own language. It is said by the Nuba that in the mountains there are ninety-nine peaks and a separate tribe and language for each peak. Until recently many Nuba tribes had no knowledge of the wider community in the Nuba Mountains. They are all called Nuba now.

In more modern times (1821) the viceroy of Egypt ordered the conquest of Sudan. With the help of other Arabs, the Egyptians raided the Nuba Mountains for sixty years, taking slaves, herds, and gold. In the late 1870s the governor of Sudan, General Gordon Pasha, tried without success to suppress the slave trade. In 1881 the Mahdi chased out the Egyptian army with the British, and General Pasha was killed during the fall of Khartoum. But nothing changed in the Nuba Mountains. The Mahdi needed soldiers and food, so they invaded the Nuba Mountains with fervor. The Mahdists also impacted the Nuba tribes by bringing Islam and Arabic to the Nuba Mountains. In 1898 English General Kitchener defeated the Mahdists at Omdurman. British rule brought some peace to the mountains, but the administration was overburdened, and they gave authority to Arab cleric leaders in Khartoum. Even so, many British officers felt that the spread of Islam was a threat to the Nuba Mountain people, but it was too little and too late. Though the Nuba were Muslim, Christian, and animist, the mix of religions and cultures worked well in the Nuba Mountains, and they continued to resist the brown Arab slave raiders.

In the early 1950s the English merged South Sudan and North Sudan into one, creating Sudan with the capital in

Khartoum, which is located in the north. Sudan was then given its independence in 1956. The Christian south, as well as the Nuba Mountains, was then under fundamental Islamic rule with its code of law called the Sharia. The south and Nuba's strife with the GOS (based in Khartoum) commenced immediately. In the Nuba Mountains the Jellaba and the Baggara Arab tribes squeezed the farmers from their ancestral lands. Thus, when fighting broke out in Sudan between the Christian south and the GOS in 1983, the Nuba Mountain tribes forged an alliance with the SPLA in the south. The great Nuba Mountain leader Yousif Kuwa, a Muslim, and SPLA leader John Garang, a Christian, formed a partnership that provided a defense for almost all of the Nuba Mountain tribes as well as the Christian south. The GOS armed the Arab tribes, whose militia surrounded the Nuba Mountains. By 1988 systematic killing of civilians by forces operating with government approval had commenced in force. In 1992 the GOS, which had taken Muslim fundamentalism to new extremes, declared a holy jihad on the Christian south and the Nuba Mountains.

The genocide was on. Lists of important Nuba intelligentsia leaders were created. "Eradicating the Nuba," a report by a group of influential Muslim leaders, spread like wildfire and became the blueprint for killing, the destruction of villages, forced conversions, and forced removals, including slavery. A leader of the GOS army stated in a press conference in Bern that during a seven-month period in 1992 and 1993, the GOS had killed 60,000 to 70,000 Nuba people. He stressed that these ethnic-cleansing operations made no distinctions between Muslims, Christians,

or animists. The GOS sealed the Nuba Mountains off from the outside world during this ethnic-cleansing operation. They forced the Nuba to attend conversion to Islam programs upon the threat of death and destruction of their villages. Inhabitants told me that GOS Russian Antonov planes would fly overhead, circle back, and then drop their bombs. The bombing runs were not very accurate since the bombs were rolled out of the doors of the cargo planes, but because of the proximity of the small villages, they caused a great deal of destruction.

It was not until 2001, when President Bush sent Senator John Danforth to the Sudan and the Nuba Mountains, that the window to the atrocities in the Nuba Mountains of the Taliban-type government in Khartoum was finally opened and these actions sharply criticized. We heard stories relating horrific accounts of the terrible genocide: the bombing of a Catholic school; villages being razed if the people did not convert to Islam; the continued bombing. . . . We also heard stories relating bravery and kindness: Kevin Ashley of 748 Air Relief Services flying into the Nuba regularly, taking in supplies and bringing out stories with extreme risk; Brad Phillips of the Persecution Project Foundation risking death to take supplies, radios, and a vehicle to the Nuba people; Bishop Gassis and his nuns conducting classes in the Nuba Mountains; a hospital run by German doctors taking care of the wounded when no one else was in the Nuba Mountains; the small mission of the Dutch. But the United Nations, Europe, and the rest of the world were silent. A deafening silence . . . a cruel silence . . . a forgotten people under a death sentence from a rogue regime as the world stood by.

When I went into the Nuba Mountains, however, there had been peace for a little more than two years. NGOs had returned to the Nuba Mountains to provide assistance. An organization called MineAction UK was courageously removing the thousands of mines that were taking lives and limbs each day. I flew into Kauda in a 1940s DC-3 plane owned by Samaritan's Purse, a Southern Baptist NGO. We landed on a dirt landing strip with no amenities. The plane dropped me off and left. I waited for three hours in the hot sun, sitting on my bag under a sparsely leaved tree. There was no one around. Finally a truck came up from the distance in a cloud of dust. The driver, whose name was Simon Peter, said he had come to take me to the governor's village some miles away.

The Nuba Mountains are lush and fertile. They rise 1,500 feet to a gentle 3,000 feet from the plain. The land is rocky, yet crops grow easily and allow for plentiful food for herds. Grassy plains are interspersed with hills and valleys. It is a beautiful landscape, which is why Arab tribes surrounding the Nuba Mountains seek the land for themselves. The area of the mountains is approximately ninety miles long and forty miles wide. A few unpaved roads link the major (though small) towns, while many tribes live in very remote locations networked only by age-old paths.

Simon Peter and I rode through the Nuba Mountains over the roughest dirt tracts to a lovely village set between two mountains. Tukuls, the round adobe huts with thatched roofs, were built on the terraced hillsides as an artist would have placed them. I was taken to a group of three tukuls sitting on a small hill in the center of the village. On both sides the laughter of children and the bustle of women and men working were contagious. This was the governor's home village, and the three tukuls were for his guests. He was attending peace talks in Kenya, but an attendant showed me to a tukul where I could sleep.

An hour later an emissary from the deputy governor came and sat down in the shade and we began to talk. My visit had been preceded by a recommendation from respected sources and questions about why I was there were polite. We talked for hours. After a meal of goat, a pita type of bread, and water, we went outside to enjoy the night. We were joined by a group of elders and we talked for additional hours. Among these elders was the commissioner from Dilling. He had walked for days to discuss the peace talks with the governor. He updated me on the state of the Nuba people. He told me that the Nuba people, Muslim, Christian, and animist, were united. The recent years of fighting had pulled all the tribes together in an alliance created by an extraordinary leader, Yousif Kuwa. Each tribe had a chief, and the chiefs elected a commissioner for the different regions and elected the governor of Nuba. Only a few tribes to the east were aligned with the GOS in Khartoum. The government had garrisoned some of the larger towns, but the troops dared not leave the garrisons. The SPLA controlled 85 to 90 percent of Nuba Mountains. He told me the GOS continues to try to infiltrate the Nuba people, but that the Nuba are very wary of strangers and expel them. It also seems that the displaced Nuba who had been living in camps on the outskirts of Khartoum were returning to the mountains. Since they had

been brainwashed about their inferior status in the camps, they were asked by the Nuba leaders to reacclimatize themselves in camps for six months prior to rejoining their tribes. The commissioner told me that there had been an assassination attempt on his life just a few months before.

Among the group that night were Christian and Muslim Nuba people, though the Muslims had an overwhelming majority. Arabic was their common language, yet they all were bilingual. They had hired two hundred Kenyan teachers to teach the Nuba English as their first, or common, language because their history with Arabic was too painful. In addition, the Nuba were shedding their Islamic names for their given tribal ones. They explained that one of their major tasks was to preserve their fifty tribal languages and cultures. Religious tolerance was obvious and the slow, deliberate discussion was open and profound, revealing the concern that these leaders had for their people. Clearly, the Nuba people were enjoying a moment of peace after so many centuries of persecution. Peace is a very rare commodity for the Nuba. It was a wonderful evening under a star-filled night.

The next day broke early, and after a breakfast of tea, I asked tribal leaders if I might record what I saw with my camera. They told me I had to clear any photography with the local military commander. Very shortly a group approached us, including Isaac KuKu, the deputy governor of Nuba. He was quite commanding, but his gentle manner and voice belied his position and past military leadership. We talked for several hours about the Nuba and their history, as well as the current state of affairs.

I gave him my prior articles about my work in the Sudan and a book. After the meeting there was no more resistance to my taking pictures. In fact, KuKu requested pictures, including one of a woman who had been injured in a bombing attack.

I then walked into the village. A Kenyan schoolteacher asked me to come to her school some distance away, where adult women were learning English. Nearby were the market and the community well, where lively women filled their containers and visited. My presence caused some self-conscious laughter and was treated with curiosity. Here Muslims, Christians, and animists mixed easily. Camels, goats, chickens, dogs, pigs, donkeys, and cattle also milled in the marketplace. Further travel took me to a gasoline-powered mill. The women came here from miles around to pay for the grinding of sorghum, millet, and maize (corn) into flour for bread. An old man with a wonderful sense of humor ran the mill, and he handled the line of waiting women very well.

Even though I live in a similarly arid region in New Mexico, the blinding heat was exhausting and created a terrible thirst. I did not stray too far from the vessel containing cool water. The evening brought relief from the heat. The repast of goat, bread, and water from one cup was repeated. In the cool evening we talked for hours. In this place half way around the world, I felt joy and a peace that is rare. The people, even though they had suffered genocide, were at peace with themselves. I observed that each person had and understood his or her role in the tribe. People were happy. Children played, laughed, and went to school; women sang and men talked as they worked. The

women in the Nuba Mountains have equal status in running their society. I presume that this is a result of several thousand years in Nuba history when women ruled. (In fact, during the main gathering of the Nuba in 1992, it was two women who spoke up. They wanted to resist the Arab jihad and genocide. Their thoughts carried the day.)

The next days brought the same. As the means of transportation in Nuba is by foot most of the time, the extent of my walks was limited to the range I could go without water. I walked alone on various paths and visited another school with lively, learning children. They sang some songs for me. A small, shy young girl was asked her name and what school she attended. She spoke strongly and the other children applauded her. It was schooling at its very best. Another afternoon a vehicle appeared to take me into the countryside to the spot where, on a night in September 2003, a tank mine was placed in the middle of the road, presumably by GOS operatives. The next morning a vehicle carrying ten people blew up, killing eight of them. There are those who do not want peace. Later that day, I was taken to the mausoleum of Yousif Kuwa. With planted plumeria inside, it was lovely and smelled sweet. There was obvious love for the Nuba leader in the mountains, who had traveled by foot to all of the Nuba tribes and united them in a Nuba coalition.

At each end of this lovely valley was a narrow pass bordered by steep cliffs, easy to guard against attack. Therefore, this was where the military headquarters and the training camps for the Nuba SPLA were located. People were coming and going to the market and the community hand-pumped well. Up and down the streams were newly built dams, providing water retention and irrigation. On my last day, Isaac KuKu again visited me in full uniform. He wanted a picture taken of him. The last evening we again talked about the hopes of the Nuba people: peace and self-rule. They also needed help with a radio system that would keep all the tribes in communication with the governor, while also providing news. The radio they had was not set up correctly, though it did allow them to contact representatives in Lokichoggio to arrange for a plane to take me out the next day.

I had expected to go back to Lokichoggio via a U.N. plane on Saturday. Early that day I was told that there was a 748 Air Relief plane coming to pick up MineAction workers and myself. I was hustled quickly to the airstrip, where I boarded for the six-hour flight back. It was with great sadness that I left the Nuba people and their lovely hospitality. I have great respect for a society that works well, and we could learn a lot from the Nuba people. I believe it is up to the world to protect them.

The saga of the Nuba, buried in the heart of Sudan, must not be lost. For in this history are some of the world's worst atrocities, practiced for more than five thousand years. Here, in recent times, the fundamentalist Muslim regime initiated a holy jihad, practiced their Sharia, then commenced a total genocide along with ethnic cleansing. Here the brown Arabs look down on black Africans as less than human. Here slavery of blacks is an inherent right of brown Muslims. So it has been for millennia. Yet this *culture of survival* has won. The Nuba are intact and unified. Religious and gender equality exist in a way that every society

should strive for. There is wisdom about living together in these mountains that I have seen only in the Old Order Amish culture.

The world, led by the United Nations, Europe, the United States, and other world powers, must let the Nuba live in peace *with local rule*. If we don't achieve this, the world will be a far lesser place. Their rich and old cultures must be preserved. That the religious organizations, Muslim, Christian, Jewish, and others, have been silent about this carnage is totally inexcusable. What is their moral justification to exist as religions? President Bush sent Senator Danforth to report what he saw in Sudan. He chose the Nuba Mountains and gave a scathing report to the president about the GOS actions. The U.S. Congress then passed the Sudan Peace Act; Colin Powell had been the point person to negotiate peace, but it took the fall of Iraq to break the deadlock in the negotiations. Peace talks are now going on between the government of Sudan and the SPLA, which is speaking for the Nuba Mountain tribes. We should encourage the signing of the peace accord. Then we must insist that the peace be kept. We should demand it. The Nuba Mountain people have withstood enough persecution from the outside world.

A miller receiving money for grinding millet–LOWERE, SUDAN.

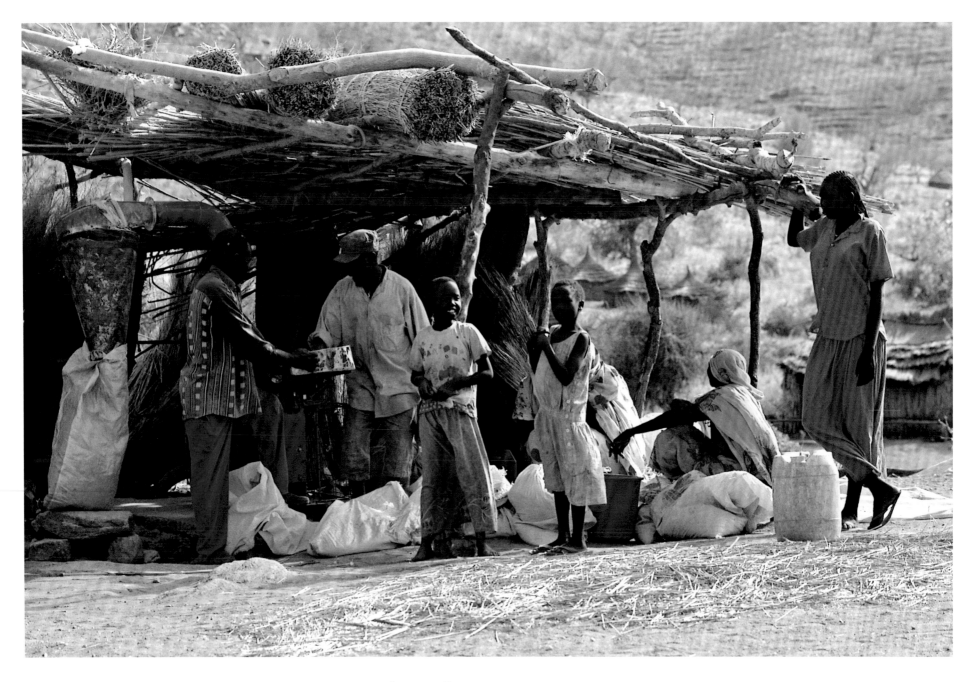

The grain mill in Lowere–NUBA MOUNTAINS.

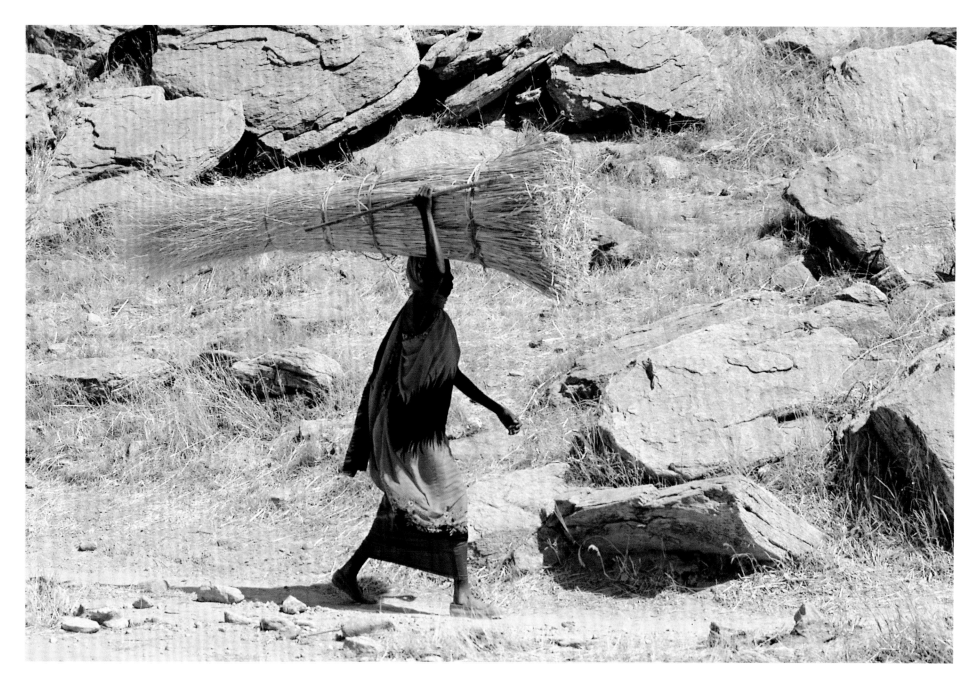

A woman carrying thatch for the roof of a tukul being built—SUDAN.

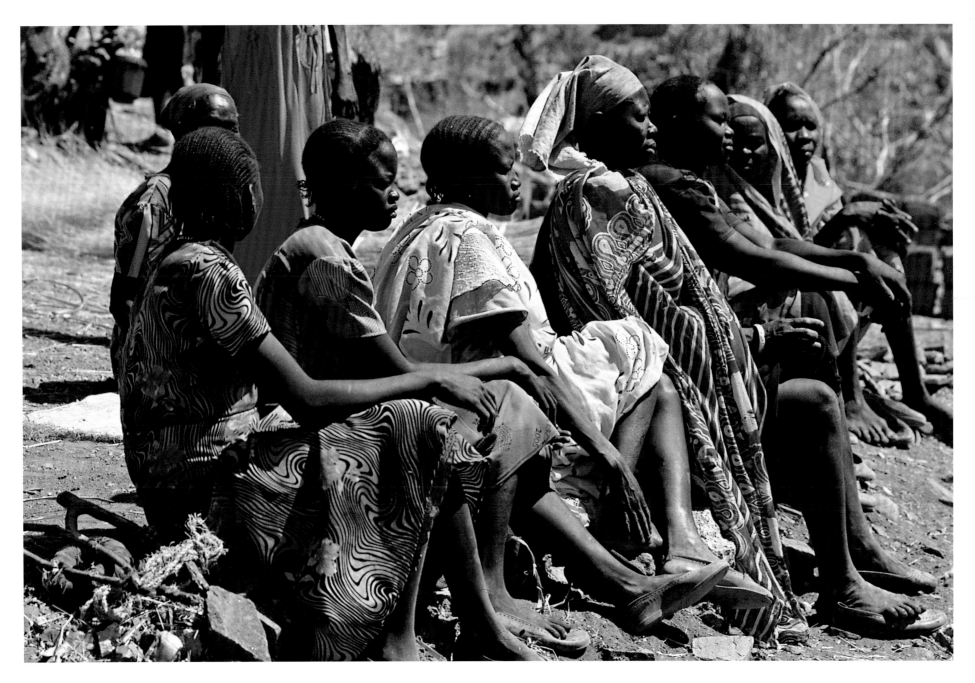

A close-up of a group of Nuba women–SUDAN.

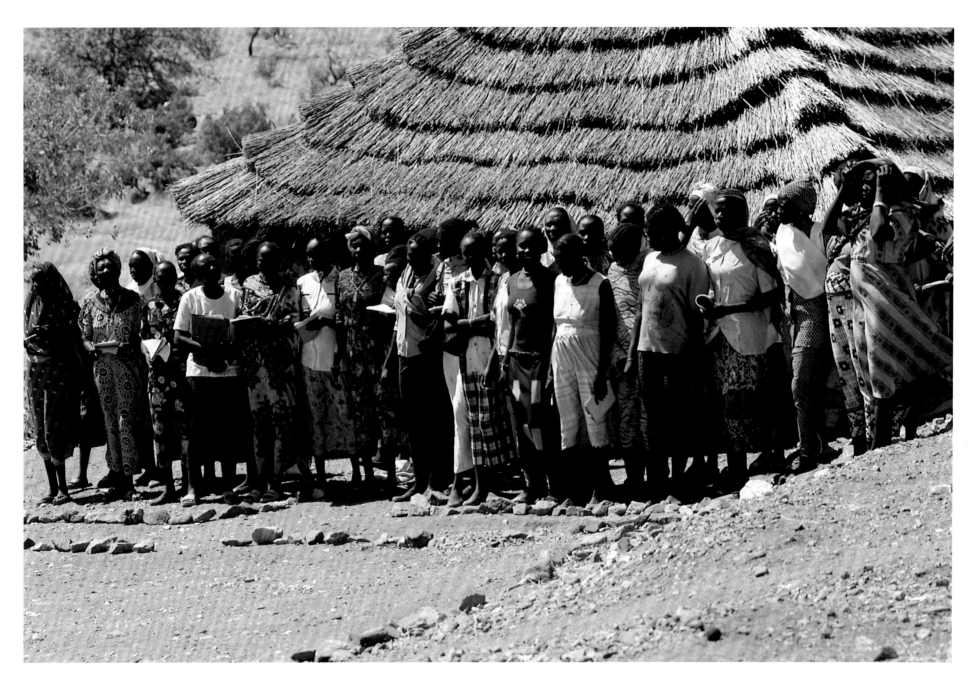

Nuba women being schooled in English in Lowere.

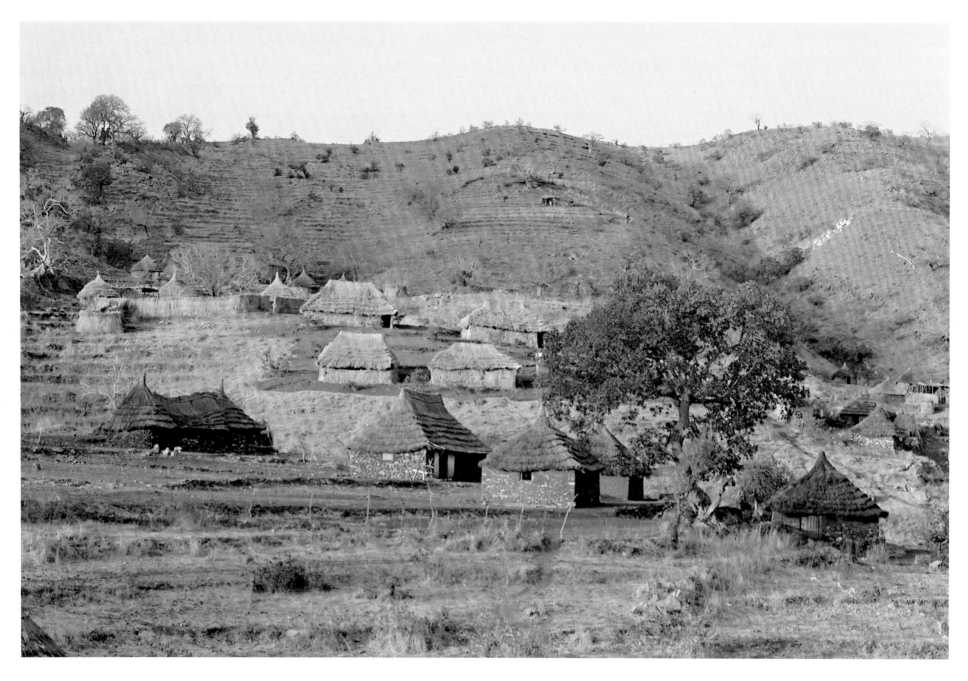

A group of tukuls in Lowere.

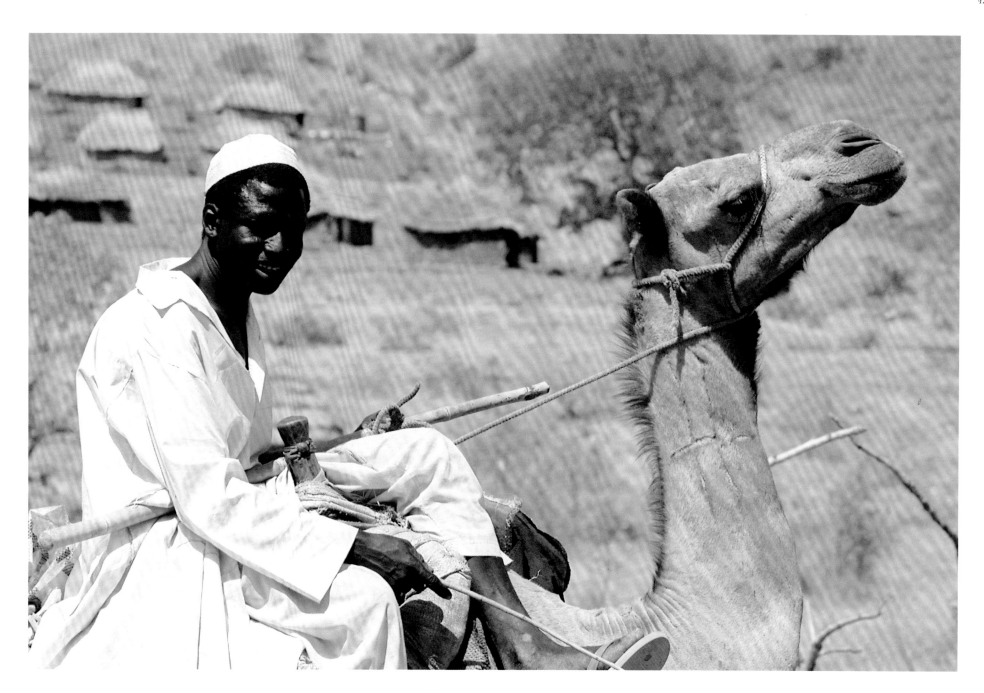

A Muslim man with his camel in Lowere.

Isaac KuKu, deputy governor of the Nuba Mountains; the commissioner of Dilling; and other Nuba leaders in Lowere.

A vendor in the Lowere marketplace.

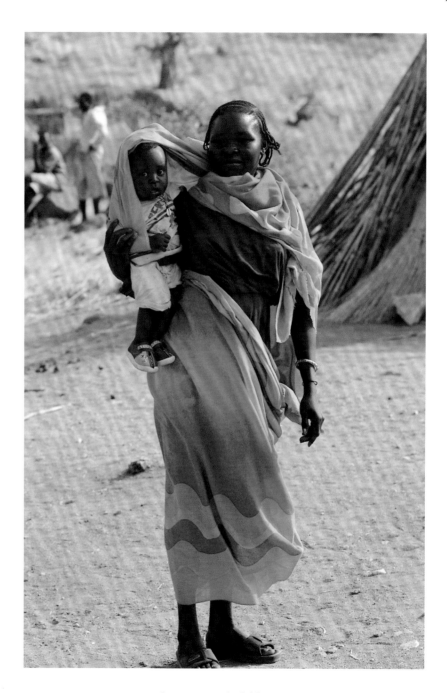

A Nuba woman with child in Lowere.

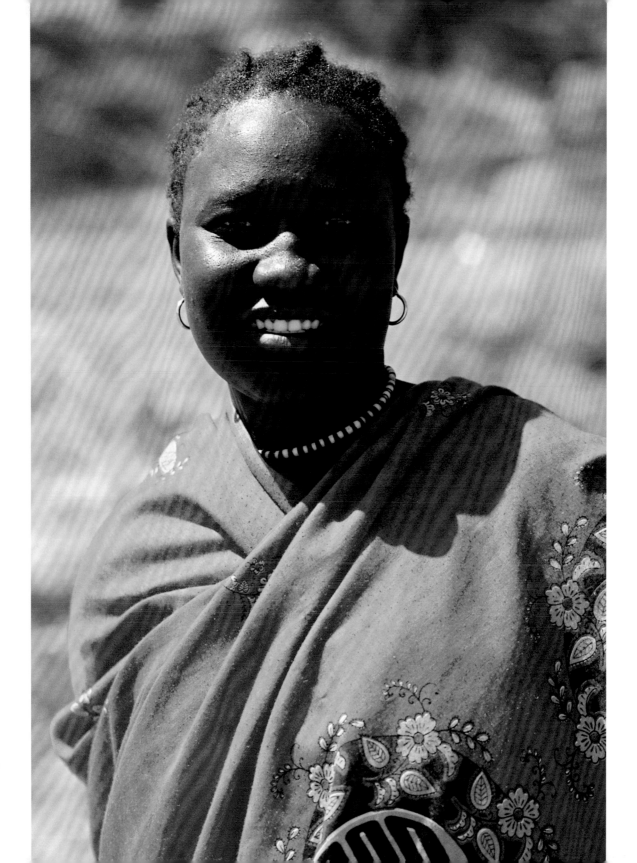

A Nuba woman–LOWERE.

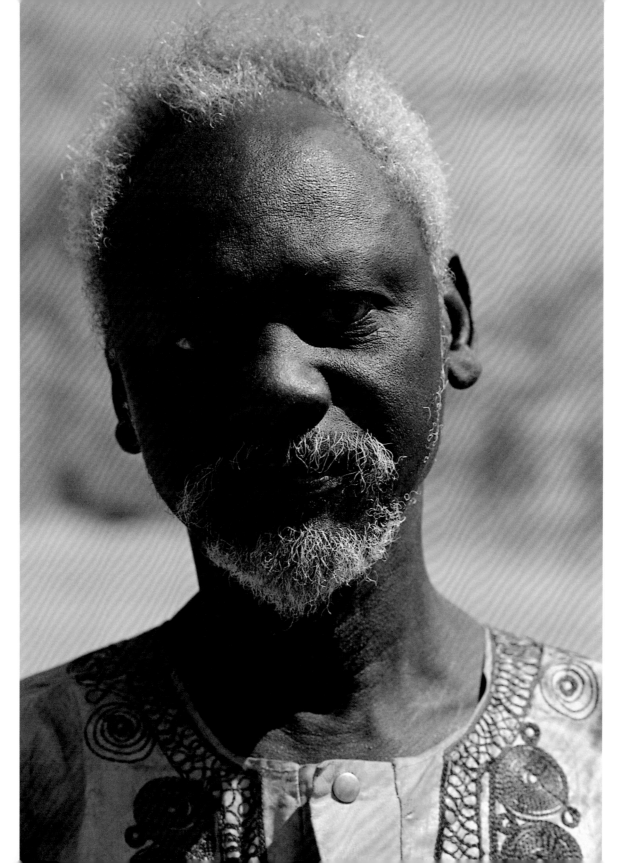

Nuba man in Lowere.

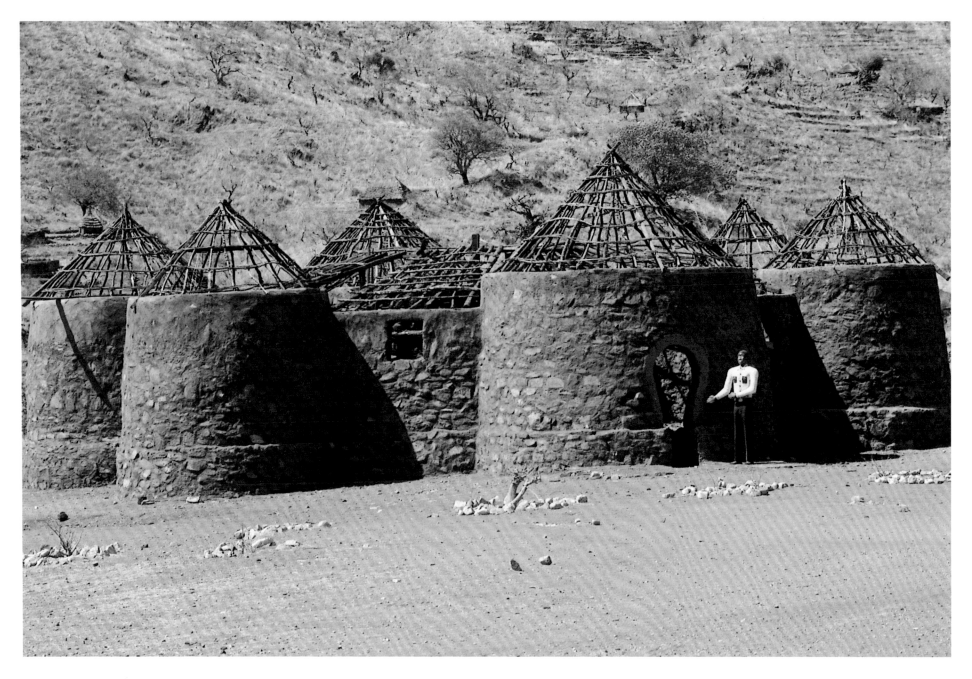

The mausoleum of Yousif Kuwa in Lowere.

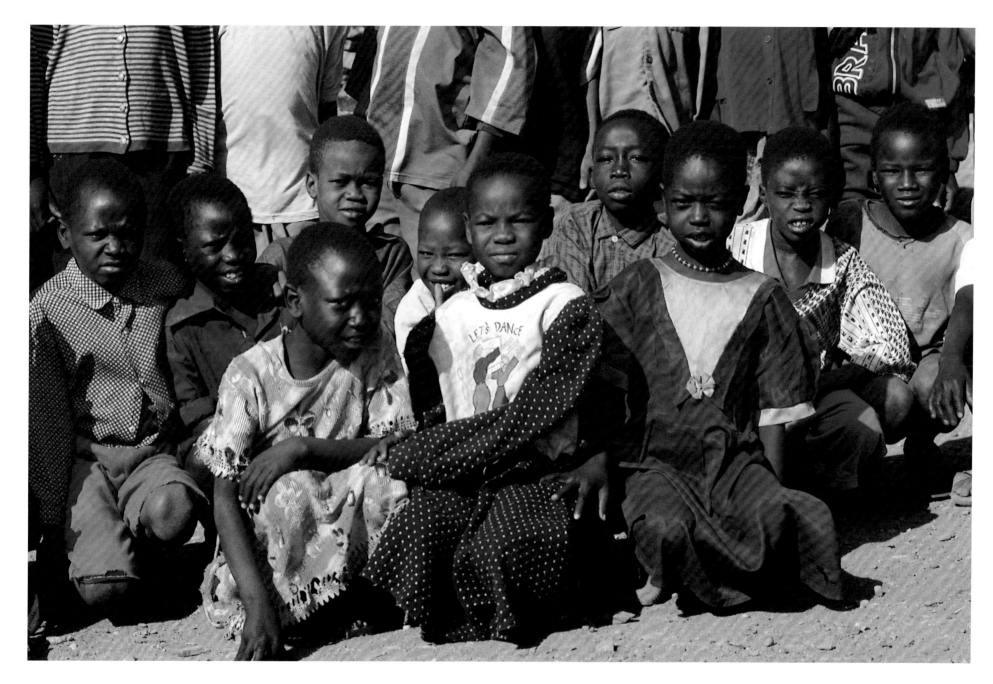

Schoolchildren in Lowere.

A close-up portrait of a Nuba woman with a shawl in Lowere.

A woman carrying water in Kauda—NUBA MOUNTAINS.

Hannah, a Nuba woman
serving at the governor's
compound in Lowere.

Isaac KuKu, deputy governor
of the Nuba Mountains.

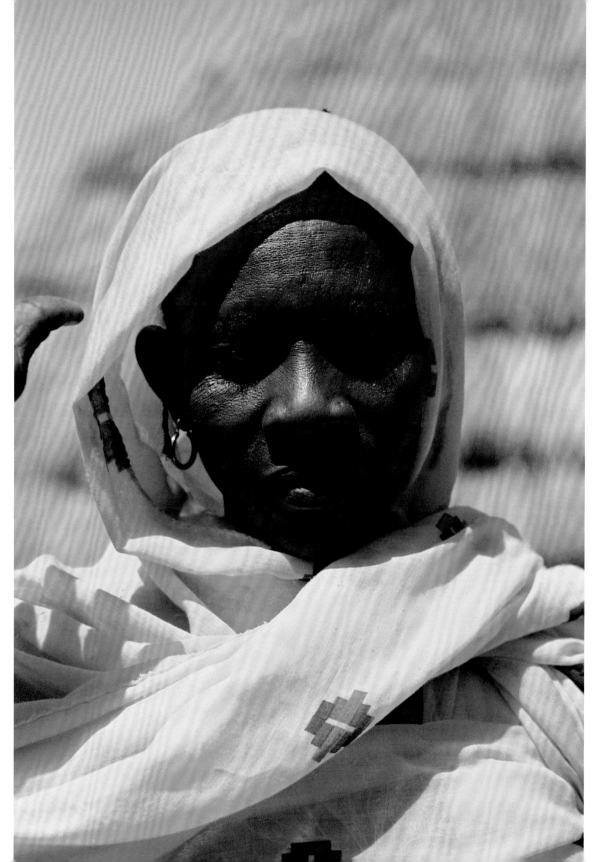

A Nuba woman in
yellow–LOWERE.

A pregnant Nuba
woman in Lowere.

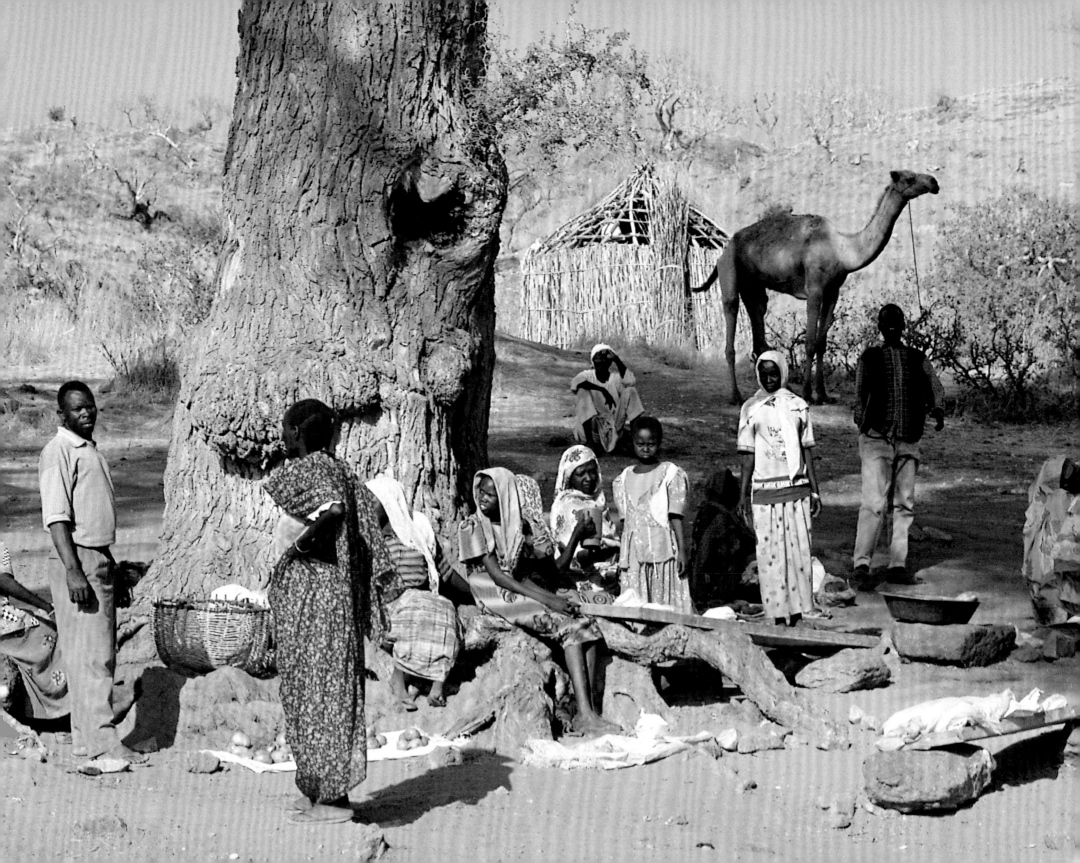

◄ Marketplace with camel and vendors–LOWERE.

▲ A tank mine blew up this car, resulting in eight deaths, just six months before.

Nuba man in Lowere.

A Nuba child in Lowere.

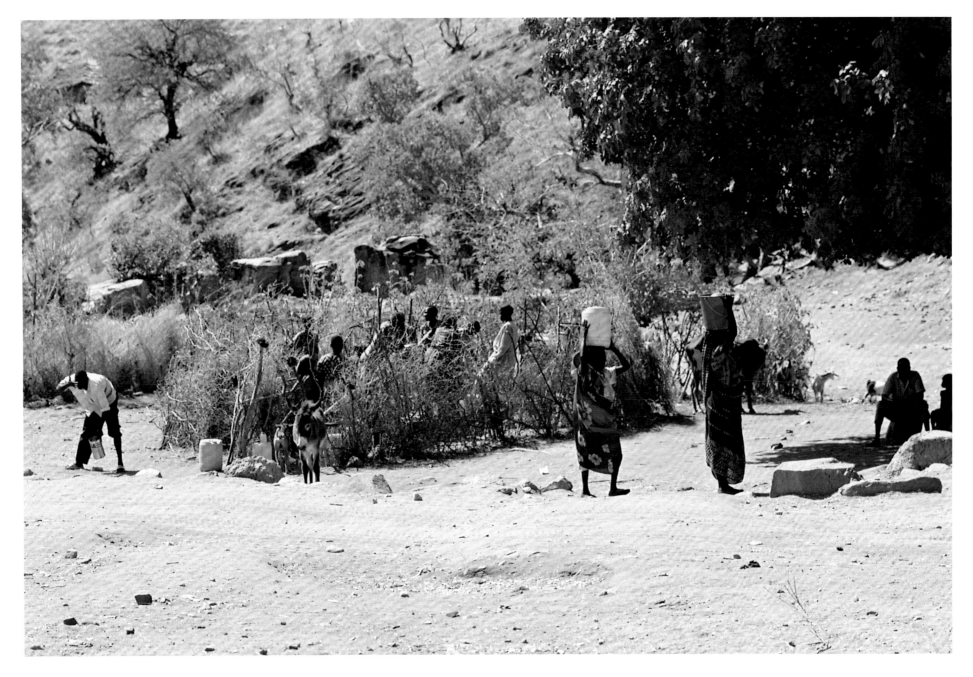

Village well in Lowere.

Nuba woman with a bandana over her head–LOWERE.

A Nuba woman with
wool cap in Lowere.

A Nuba woman—LOWERE.

Market in Lowere.

Adobe brick maker in Lowere.

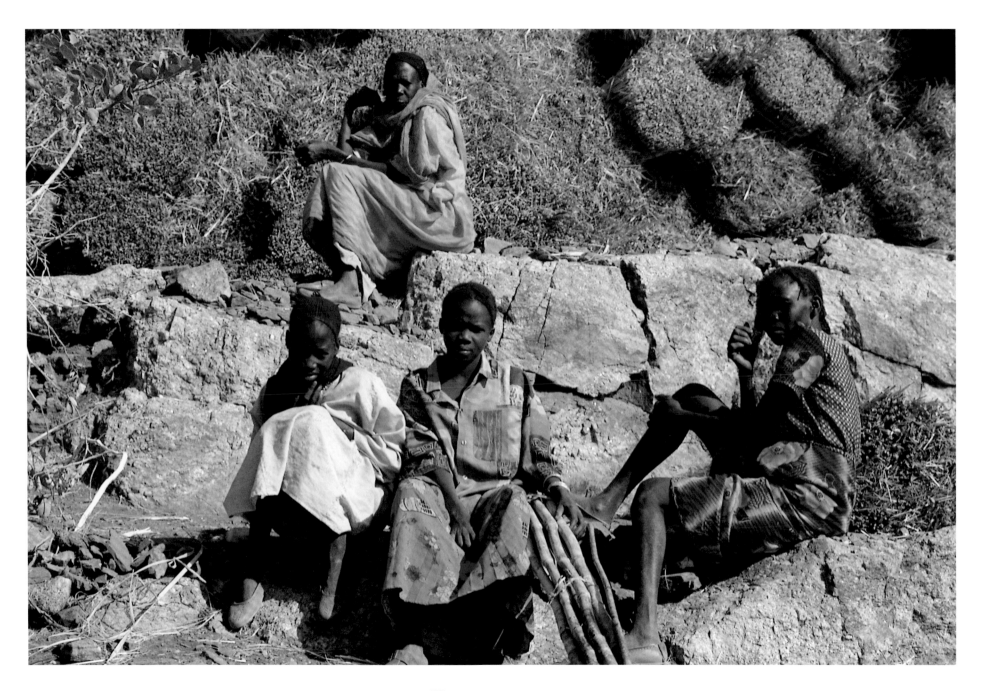

Women visiting–LOWERE.

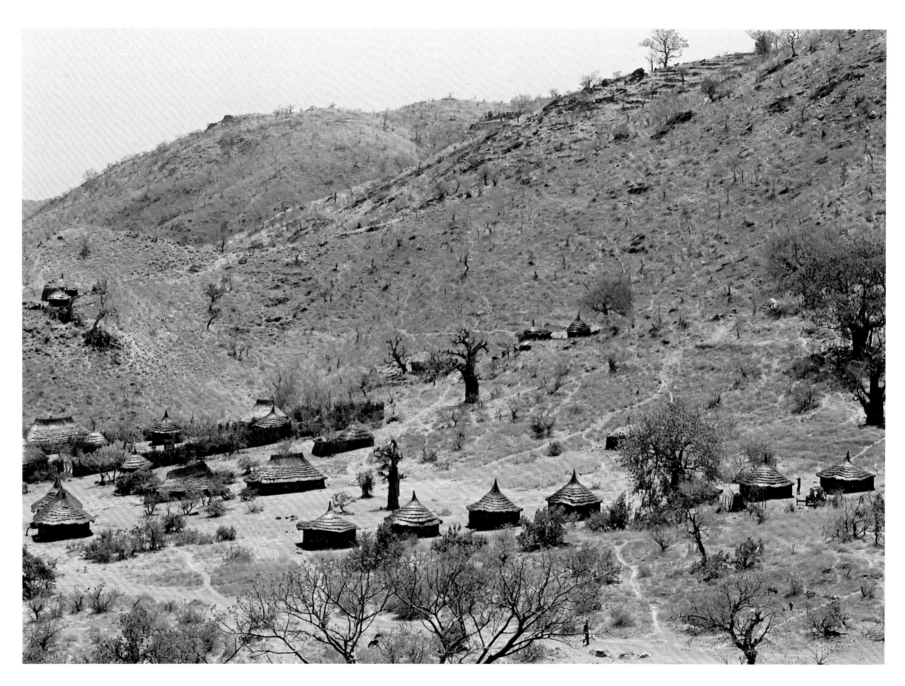

The village of Lowere.

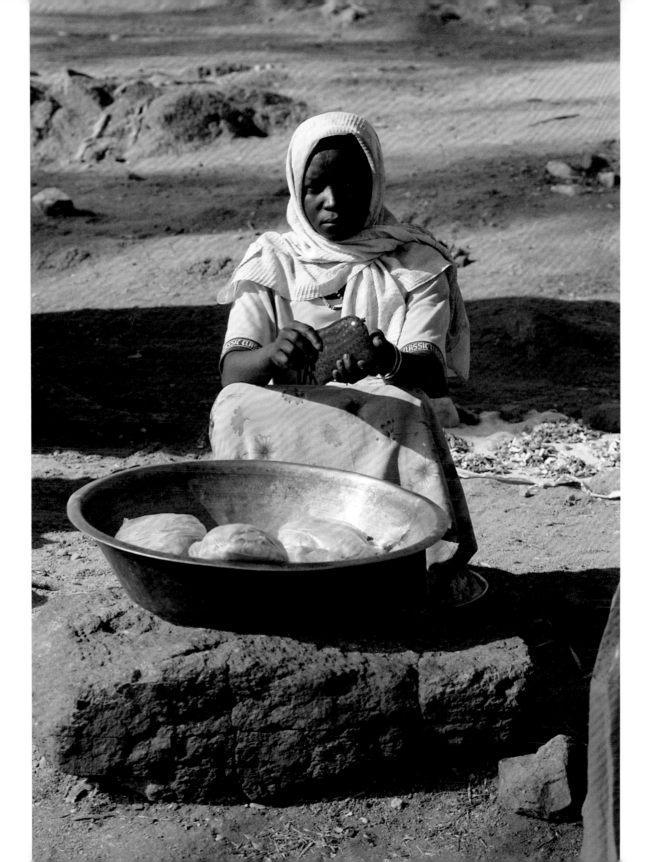

A woman selling bread in
the Lowere marketplace.

EPİLOGUE

It is June 2005. The peace accord between the Sudan government and the SPLA has been signed, and it includes the Nuba Mountains. The Darfur region of Sudan is in flames. The story of ethnic cleansing in which the Janjaweed, Arab militiamen, are fronting for the government is the modus operandi for the GOS. Even though a great deal of press and world concern has been showered on the struggle, it continues. The facts remain the same. The brown fundamentalist Muslims are killing black Muslims through explicit murder, rape (in order to create a whole new skin color), and death through displacement. The story is similar to what happened in the Nuba Mountains.

Each day that the Sudanese government states that it is complying with U.N. or world sanctions, there is another aggression that causes the NGOs or the United Nations to pull back. The duplicity continues until the goals of the government are met. One hundred thousand civilians have died in the last few months. Again it is the United States and Britain leading world efforts to stop the ethnic cleansing. The Sudan government is following the Taliban tradition of a fundamentalist Muslim regime with its Sharia, which is the rigid law that instructs people to look down on all outsiders (blacks in this case) as less than human. The churches and the United Nations give speeches with very little effect.

Again the NGOs are the front lines. The number of people killed by this rogue regime is well over two million (five years ago this was the number, and many have died since), almost all civilian. The number of enslaved people is also very high, which is an additional abomination. The human tragedy is incalculable as tribes and whole families are decimated and enslaved by the Muslims in Sudan. Yet the world has not had the will to stop it. Someday the consciences of knowledgeable people will be seared with guilt. They will say they did not know, or it was too far removed to be concerned—the standard excuses of apathy. It is a sad commentary on the condition of human morality that the tenets for which the United Nations was formed are not being enforced. Now the trials of those responsible for the genocide in Rwanda are taking place in Arusha, Tanzania. The horrors of the genocide are being relived each day and will continue for years. It will take generations of peace to heal the wounds of the devastation that took place in Rwanda. Sudan will be a repeat of the tragedy, with generations of fear and hate to overcome, and the call for justice will take decades.

These stories were brought to you so that you can visualize and read about people who could be you or me. The images give faces to humans who strive for the same opportunities that you and I have. They are not crying out for something extra, for they are very proud, but they cry for peace and the ability to maintain their tribes and families after the holocaust they have experienced. These are values that all responsible people aspire to.

President Bush has laid out the goal of freedom and liberty for all people in this small world in his inaugural address. That should be the goal of us all. That tyrannical governments continue to disrupt the world; kill, rape, and maim innocent people; and are allowed to perpetrate their destructive ways is an obstacle to any possible lasting world peace. That terrorists continue to bully to get their way by intimidating and killing innocent people is a crime against *all* humanity. The world is too small for responsible nations not to act against them in concert. The excuse of *they are not bothering me* has been voided by the horrific 9/11 catastrophe, the Bali explosion, and the Spanish train bombing.